backyard roots

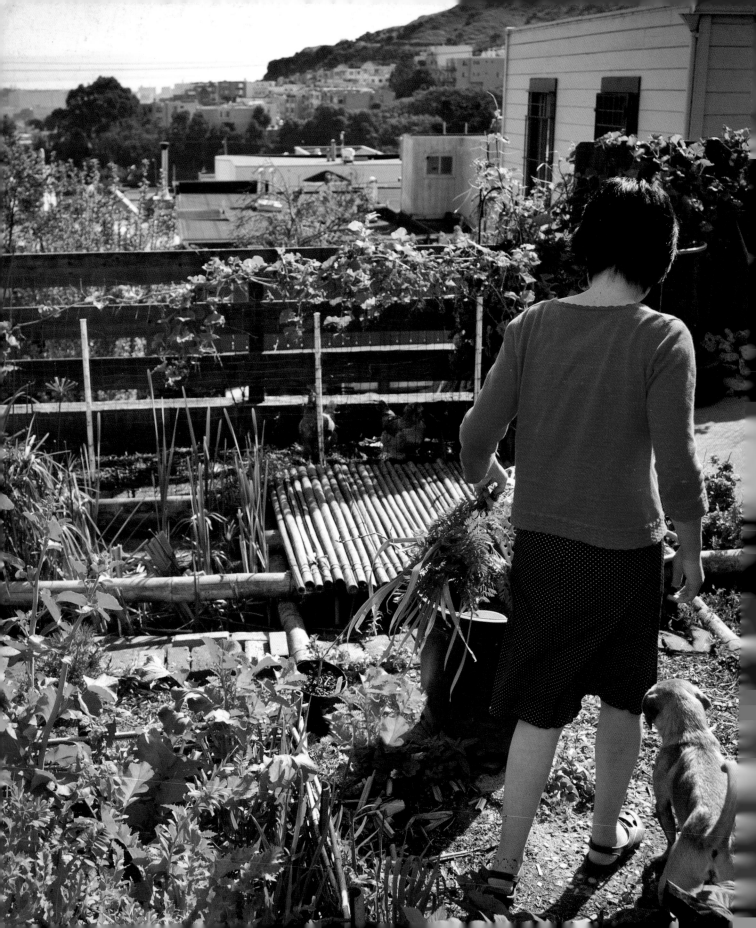

backyard roots

lessons on
living local from

35

urban farmers

lori eanes

SKIPSTONE

Published by Skipstone, an imprint of The Mountaineers Books
Printed in China
First printing 2013
16 15 14 13 5 4 3 2 1

Copy Editor: Sherri Schultz
Design: Jane Jeszeck / www.jigsawseattle.com
Cover photograph: Lori Eanes
All photographs by the author unless otherwise noted
 Page 2: *Tara Hui in her San Francisco backyard;*
 pages 4–5: *Chef Leather Storrs in his restaurant's rooftop garden*
 in Portland, Oregon; page 6: *Freshly harvested raspberries from*
 Farm Saeturn's P-Patch plot in Seattle, Washington
ISBN (paperback): 978-1-59485-711-9
ISBN (ebook): 978-1-59485-712-6

Library of Congress Cataloging-in-Publication Data on file

Skipstone books may be purchased for corporate,
educational, or other promotional sales. For special
discounts and information, contact our sales department
at 800-553-4453 or mbooks@mountaineersbooks.org.

Skipstone
1001 SW Klickitat Way
Suite 201
Seattle, Washington 98134
206.223.6303
www.skipstonebooks.org
www.mountaineersbooks.org

LIVE LIFE. MAKE RIPPLES.

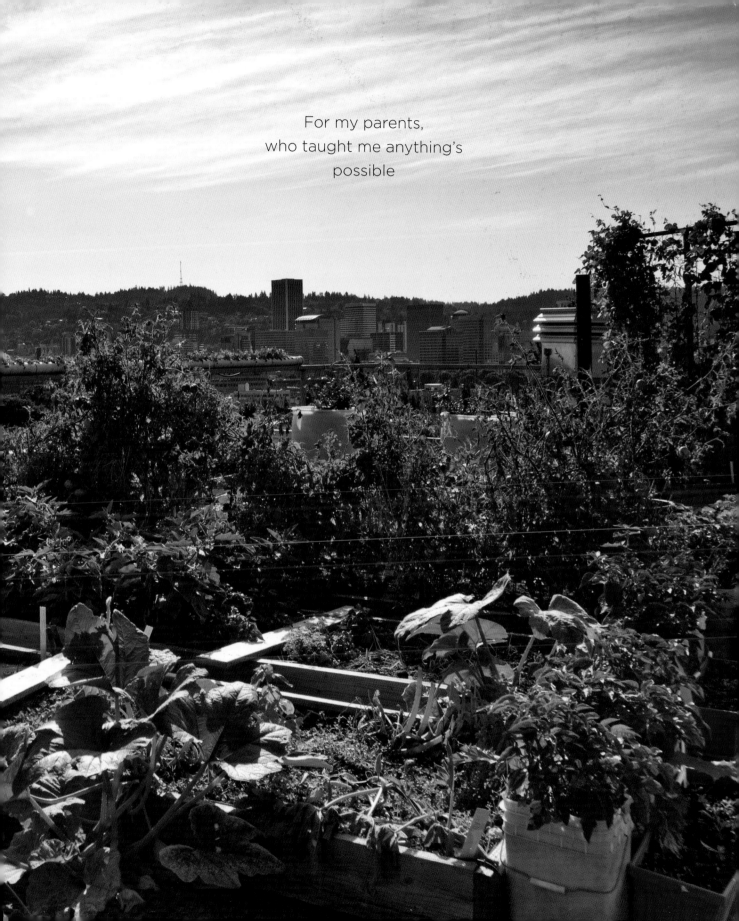

For my parents,
who taught me anything's
possible

Contents

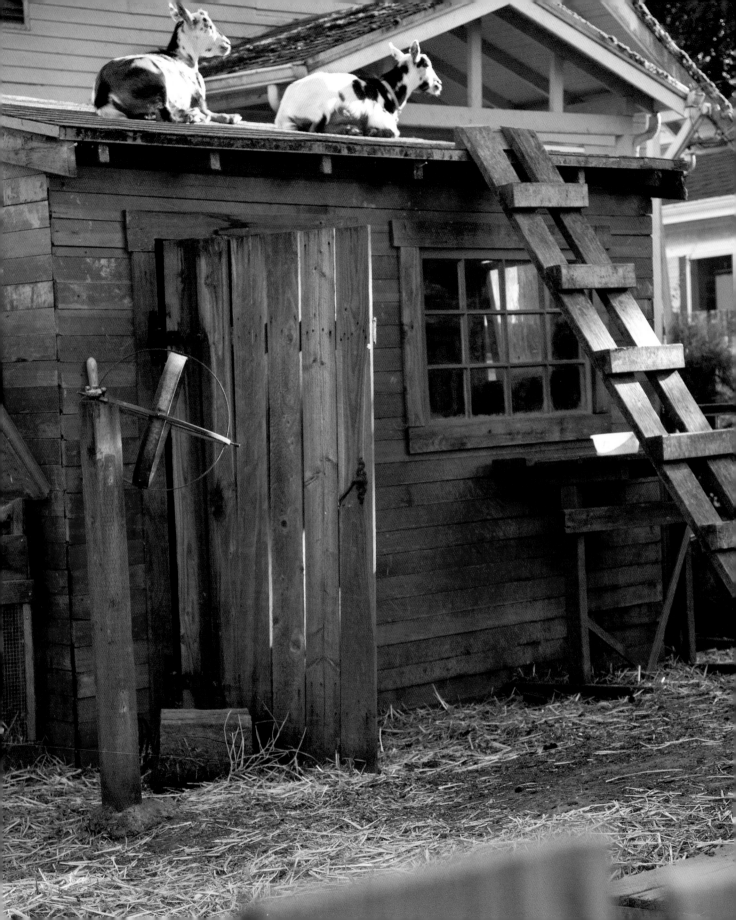

introduction
finding backyard inspiration

AS A FOOD PHOTOGRAPHER, I've taken pictures of all kinds of foods: drippy, sugary, grilled, sautéed, tossed, and frozen. Whatever the subject, my job is always the same: to make it look delicious. It's got to jump off the page and stop you in your tracks. I spend so much time looking at food that I can't help but be a little obsessed about it. I wonder what's in it, where it came from, how it was grown, and even who grew it.

Curious about the food industry, I started reading books about it, such as *Fast Food Nation, The Omnivore's Dilemma,* and *Food Politics.* They opened my eyes to the ugly side of pretty food. I read about animals kept in horrible conditions, poisonous pesticides, and monoculture on a massive scale. The state of industrial agriculture depressed me, and it seemed a growing number of people felt the same way I did. The idea of eating foods grown locally and without pesticides was taking root, and some

Kenya Spiegel and Seth Brown built their goat barn almost entirely from recycled materials. The siding, for example, was made from old flooring that a Portland neighbor was throwing away.

people were taking it a step further—turning their yards into backyard farms.

The project that eventually grew into this book started with an idea: find these urban farmers and see what they were up to. I had just read *Farm City,* Novella Carpenter's adventure in urban farming, and I had heard about other urban farmers. I was curious. I wondered who these people were and how they did it. How did they grow their own food and raise farm animals in the city?

I started in my own backyard: the Bay Area. In San Francisco, houses are packed together and space is a rarity, yet still I found farmers. As I worked my way up the West Coast to Vancouver, British Columbia, I found the movement wasn't limited to where I live. All kinds of people are involved with urban farming, from scrappy fighters willing to take on outdated legislation, to a young cancer survivor working with elderly immigrants at a community garden, to a couple who challenged themselves to grow all their own food for a year or buy it locally.

Although my original idea was just to take photographs, as I learned people's stories their dedication inspired me to write about them too. I loved hearing about their real-life experiences, and I found such a diversity

of farmers and approaches that I was always surprised. And the farmers not only recounted their stories but also generously shared practical tips with me.

Some of the people profiled in this book have worked to change outdated laws, thus making urban farming more accessible to all. Barbara Palermo's two-year odyssey to legalize backyard chickens in Salem, Oregon, was fascinating, and her dedication was amazing. She went so far as to learn filmmaking in order to make a documentary, which garnered the public support needed to change the law. Equally inspiring were Caitlyn Galloway and Brooke Budner, who started growing vegetables in an empty lot in San Francisco, began to sell their produce part-time, and then were forced to overturn a law in order to become the first legal small commercial farm within city limits.

I also met pioneers experimenting with innovative ideas, like Jodi Peters, who started an aquaponics project in Vancouver, British Columbia. Through her I vicariously experienced the trials and tribulations of learning to set up a barrel system to grow vegetables and raise tilapia. I also met people who keep their culture alive through their gardens, like Farm Saeturn, who immigrated to Seattle from Laos but continues to practice her traditional farming methods.

Some of these urban farmers have figured out ways to make a living from their passion, like Krista and David Arias, who started an urban farm stay in Portland, Oregon. The couple converted their large historic home into rooms for travelers looking to experience an urban farm. They had so much success that they turned it into a business. Or Joan Engelmeyer, who incorporates her urban farm into the art classes for kids that she teaches on the farm in Seattle. She recently started raising goats for wool and now teaches felting to her students.

In my own backyard, I discovered that growing food isn't hard, and it's creative and satisfying too. It's really a miracle that a seed can sprout in the dirt and, with a little luck, produce food so tasty that it may not last long enough to make the trip to the kitchen. As a photographer, I've found that urban farming has made food even more interesting to me. I love the imperfections, textures, and colors of the heirloom varieties that you can find only at farmers markets or grow yourself.

Meeting the people behind the food was the crucial element that brought the project together for me. Photographing them was a way to bring dimension to their stories. From rooftop gardeners and city beekeepers to mushroom growers and urban foragers, this book will introduce you to real, "everyday" people with innovative ideas for living and growing food in the city. They are the real heroes, and it's their ideas and moxie that have opened my eyes to what is possible. It's because of them that I see food in a whole new light.

acknowledgments

I OWE EVERYTHING TO EACH and every urban farmer who opened up their backyards and shared their lives with me. I visited more than sixty farms, and at every one of them I found knowledgeable people who were excited to share their urban farms with me. These inspiring people let me follow them around with my camera and then were patient enough to answer my endless questions. They did not make the editing process easy, and I wish I could have included them all.

I especially want to thank Krista Arias, who invited me to stay at her Tierra Soul guest house every time I came to Portland, and Brannan Wauters, who put me up in Vancouver. I also want to thank Lori Vail and Rebecca Hazard, and Jake Harris and Emma Klein, who fed me every time I visited, and Jennie Grant for connecting me to her network of farmer friends.

This book could never have gotten off the ground without Kate Rogers at Skipstone. Besides making my dream into a reality, she's been a dream to work with: encouraging, supportive, and a great editor. I also want to commend Giselle Smith and Sherri Schultz, the editing team, for their careful fact-checking and helpful feedback, and Jane Jeszeck for her beautiful design.

I am so indebted to my friends and family for their encouragement and support: my parents, my uncle Leonard, my brothers, John and Robert. I'm thankful for my kind friend Sharon Beals, who rallied me to get this project going, for Pamela Gentile, Peggy Ghertner, and Sharon Wickham for their thoughtful editing, and for Claudia Wornum and Pat Mazzera for listening to all of the details. Last but not least, I owe much to Barry Spencer for backing me up through it all, and for holding down the fort while I drove all over the Northwest.

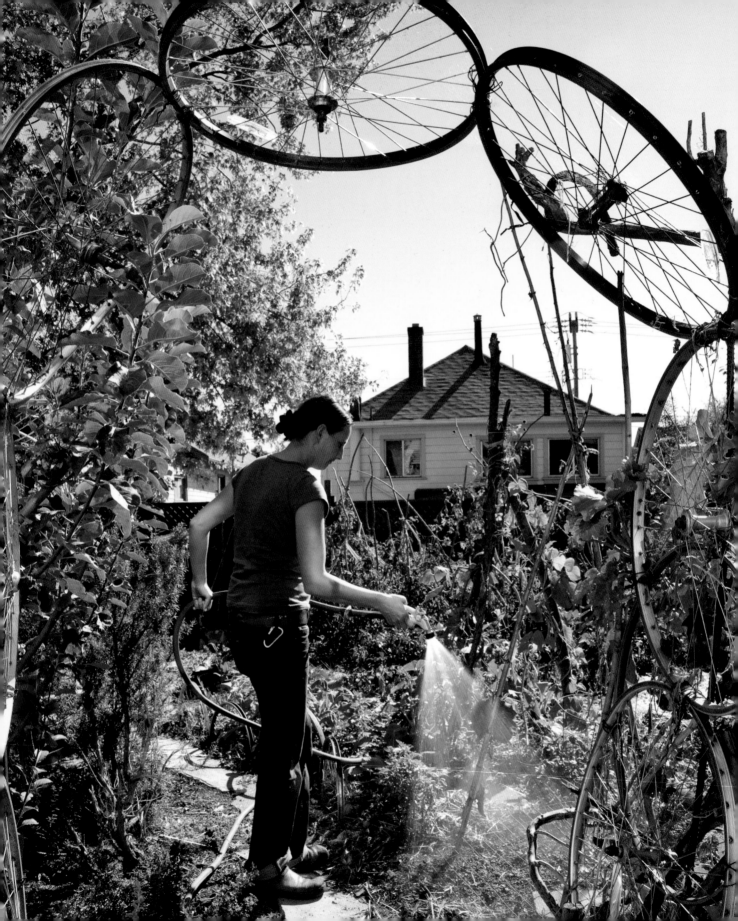

greywater guerrilla

laura allen
oakland, california

"WHY WASH PERFECTLY GOOD WATER down the drain?" Laura Allen wondered one day, never suspecting that her innocent question would lead to a four-year quest to change California's water policy. It all began with a garden she planted with her housemates in Oakland. When she realized how much water her household was using, she felt the least she could do was try to reduce her use. She and one of her housemates, Cleo Woelfle-Erskine, thought that reusing water from sinks, showers, and washing machines—called greywater, because it does not contain serious contaminants—to irrigate the garden made a lot of sense.

Laura had a background in environmental science, and Cleo had a background in permaculture. Laura took a plumbing class, and then she and Cleo experimented with various greywater systems at their house, filtering the water through a bathtub wetlands system they set up in the backyard. Eventually their effort paid off. With conservation, more efficient greywater systems, and a

An arbor made of bicycle wheels is one of the unique features in Laura Allen's Oakland backyard.

composting toilet, "we were able to cut our water usage in half," Laura says. "It was an empowering experience."

Back then, the State of California allowed greywater systems, but the code was very restrictive and expensive to comply with. As a result, almost no one could afford to install a system, and there were few professional installers to do the work. In addition, Laura says, "There was a huge amount of misinformation about the best ways to reuse greywater." The most common misconception was that greywater is dangerous; it's not, as long as no one ingests it.

After Laura and Cleo installed their system, the two made a zine describing what they had learned. It was widely distributed, and they got lots of attention. They later named themselves the Greywater Guerrillas, created a website, built an emailing list of 4,000, and worked to increase public awareness in order to change the code governing greywater systems. Laura says the recipe for change included attending multiple stakeholders meetings, mobilizing supporters, getting media attention, and collecting examples of greywater-friendly codes from other states such as Arizona, Texas, and New Mexico. Rising water rates and a drought helped, too.

In 2009 the California law was finally changed to encourage greywater reuse by making compliance easier and setting guidelines for safety. State residents can now install certain simple systems without a permit. Since then, other states, including Washington, have passed more greywater-friendly laws. The City of San Francisco now offers a *Graywater Design Manual*, a free in-depth booklet that covers many greywater systems.

The easiest and cheapest system is the laundry-to-landscape method, which can save 5,000 to 10,000 gallons of water a year. It's designed to water trees, bushes, and perennials, and works well in yards that slope down from or are level with the washer. The system uses a three-way valve with a vent at the highest point that allows you to decide whether the water should go to irrigation or down the drain. The valve is an impor-

Rainwater Harvesting

Besides conservation, which is the easiest way to save water, harvesting rainwater is a simple way to reduce your water bill. The roof of a 1,000-square-foot house can collect 600 gallons from an inch of rainfall. Here are some tips from the Greywater Action website:

- *Rainwater-harvesting tanks can be plastic, metal, or cement. They come in various sizes, from 55-gallon barrels to cisterns that can hold thousands of gallons.*
- *Place them along the house, under decks, or wherever there is space. Use your existing gutters to direct water toward them. Fifty-five-gallon tanks can be "daisy-chained" together with pipes at the bottom so the tanks all fill simultaneously.*
- *Be sure to include a diversion method so that water from the first rain of the season will not go into the tanks, since it will be the dirtiest.*
- *Use dark tanks to reduce algae, and place screens on top of the tanks to keep mosquitoes out.*

tant feature in case you need to use bleach or the soil is already saturated from a recent rain; in that case, you can send the water down the drain. There are considerations such as amount of water, soil absorption, and property setbacks, but basically the water goes through pipes underground to where it is needed. It's much easier to use than the system Laura and Cleo originally used, which required a wetland filter system.

Laura's group now calls itself Greywater Action and continues to work for sustainable water policy. They work with water districts and community groups, offering workshops, presentations, and installations. Laura says it's much easier to use greywater now than it was when she and Cleo set up their first system. She says it's always better to design the simplest system possible, one that relies on nature to do the work without pumps or filters that require maintenance. She also says it's best to plan a garden that can make the most of the system. Plant fruit trees and perennials in an area that will take advantage of the greywater, she urges; plant native and drought-tolerant plants elsewhere.

At her Oakland home, Laura and her housemates use greywater and rainwater-harvesting barrels to support a creative and sustainable backyard. The yard has interesting features such as an arbor made of bicycle spokes and a shed painted with a mural, as well as vegetable beds, a beehive, fifteen fruit trees, and six chickens. The chickens are kept in a side-yard coop that connects to a

OPPOSITE, CLOCKWISE FROM TOP LEFT Water from the gutters drains into a rain barrel covered with a screen to keep out mosquitoes and debris. Laura checks her backyard rain barrel. Her new greywater system uses a three-way valve that diverts water from the washing machine to fruit trees and perennials. She can flip up the valve, as shown, to shut it off when she doesn't want to use greywater.

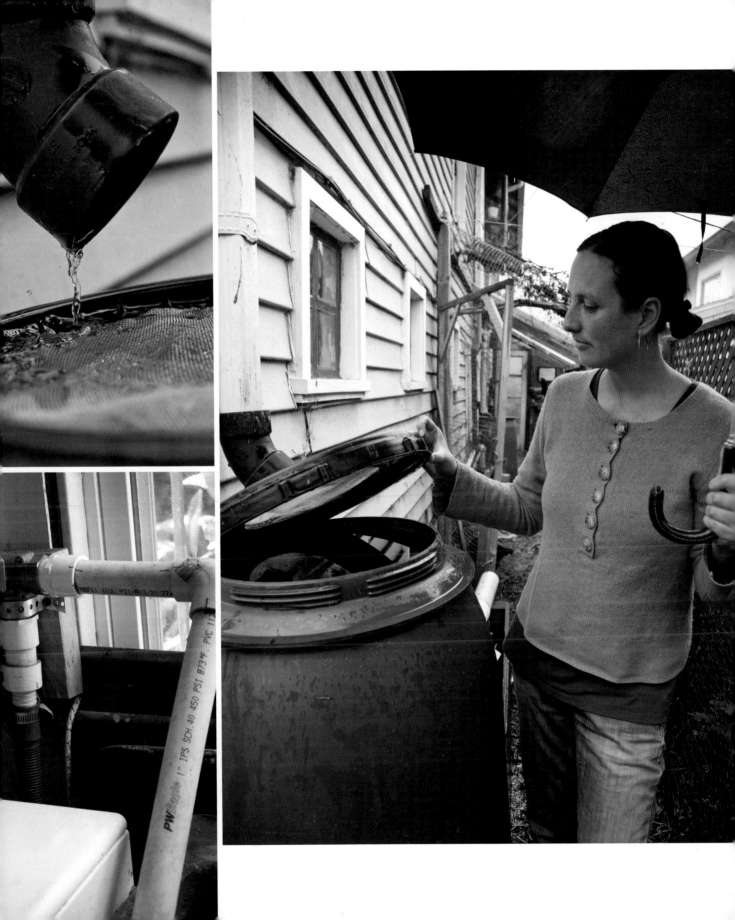

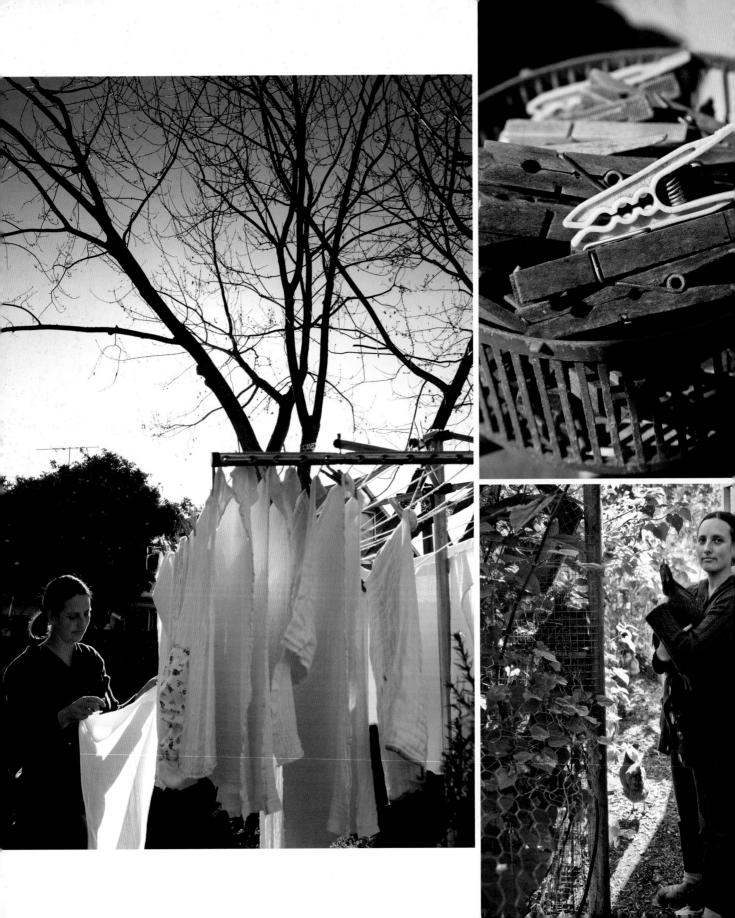

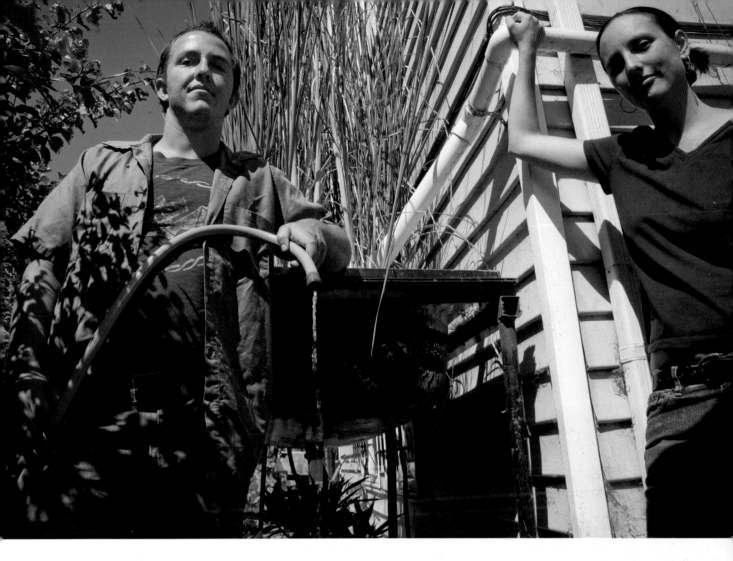

sunnier back pen by way of a wire tunnel. They love having the extra space, and the tunnel takes up hardly any room. Laura recommends planting fruit trees; they are low maintenance and produce fruit year after year. And if you install a laundry-to-landscape greywater system, there will be no need to water them.

OPPOSITE, CLOCKWISE FROM LEFT Laura line-dries her laundry. Clothespins. Laura with one of the six hens in their side-yard coop. ABOVE Cleo Woelfle-Erskine and Laura with their first greywater system at their home in 2007. Their early-diversion plan sent greywater to a filtering system of cattail reeds in a bathtub and then to tanks used to irrigate the yard.

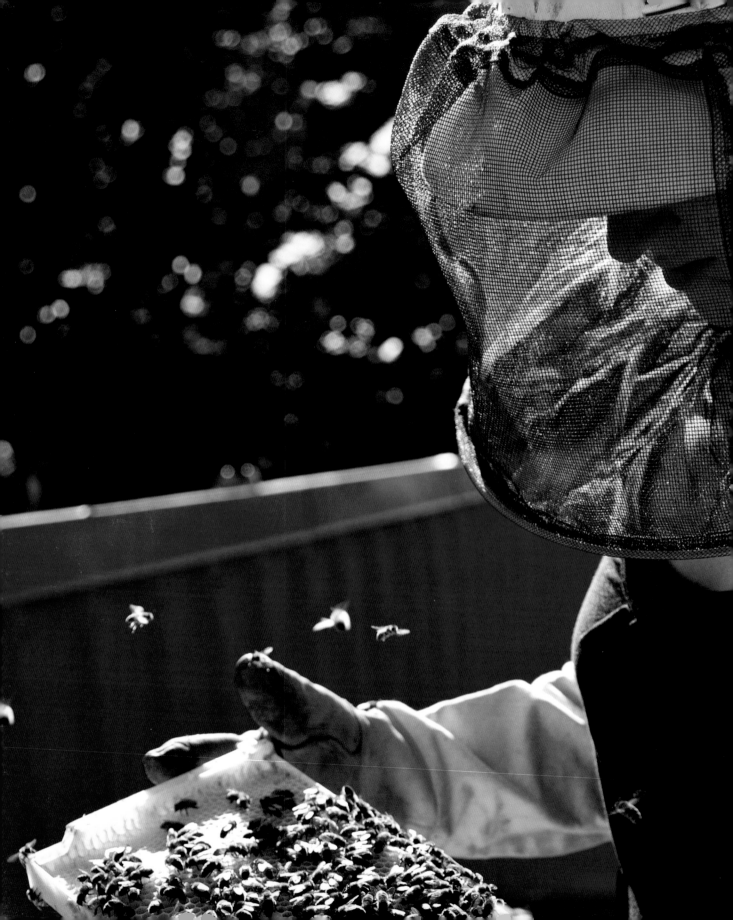

urban rooftop beekeeping

lindsay dault
delta, british columbia

LINDSAY DAULT FIRST GOT INTO beekeeping through her husband, Jay, who had two hives back when they were dating. "Maybe I was trying to impress him," she laughs, "but it turned out I was really good at it, maybe better than him." Always the daredevil, she's never been afraid of bees. She finds them fascinating to watch, and she's noticed that their presence makes a big difference in the garden.

One of the most researched creatures on Earth besides humans, bees may have existed for as long as 150 million years. They are responsible for about 80 percent of all insect pollination. Honey is what they make from the nectar they gather from flowers, and its health benefits for people are well documented. It's a natural energy booster, but unlike sugar it has trace minerals and compounds that act as antioxidants, and it has other medicinal qualities as well. If you have allergies triggered by local pollen, eating locally produced raw honey can help strengthen your immunity.

Lindsay harvests honey once a year, usually in August. She uses a queen excluder to keep the queen from laying eggs in the upper boxes. This barrier allows worker bees to fill the cells with honey and cap them with beeswax, but without the queen, so the honey stays free of eggs. The method allows for a clean harvest of honey, while leaving plenty more for the bees in the lower boxes. Each full frame holds about 8 pounds of honey. After harvesting the honey from the upper boxes, Lindsay and Jay remove the top caps, heat the honey, and extract it. All the hives are different, but an average harvest is 40 pounds of honey.

Harvesting honey makes many people nervous, but it doesn't bother Lindsay, who is so confident around bees that she usually wears only a veil and gloves rather than a full body suit. "As long as you stay calm, they stay calm," she says. Bees react to pheromones; if you are fearful, the bees can sense your alarm and will react. Remember that bees always travel in a path, and different hives have different personalities. "If they bother you, stay calm and walk away," she says.

Lindsay Dault checks the bees at one of the rooftop hives she keeps above her husband's warehouse in Delta.

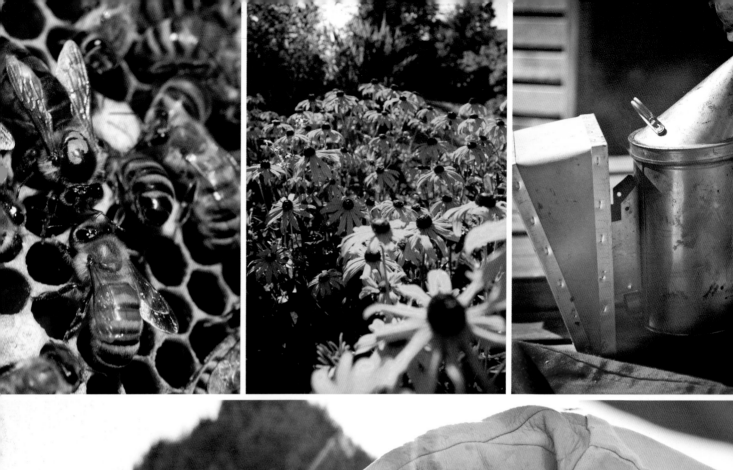
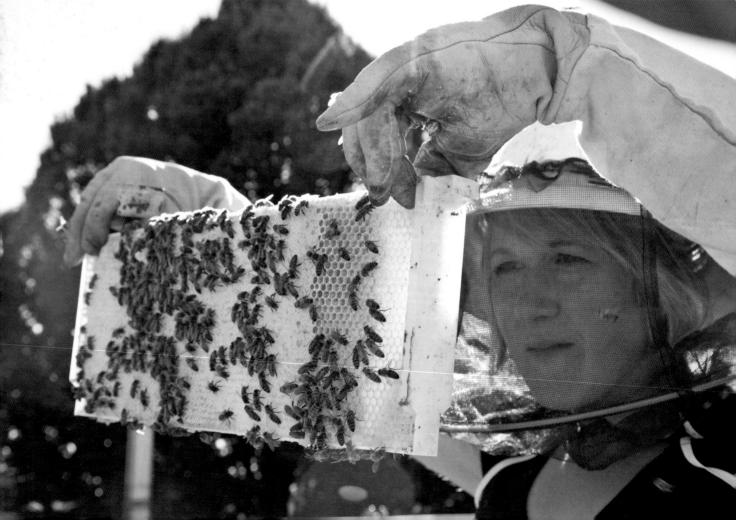

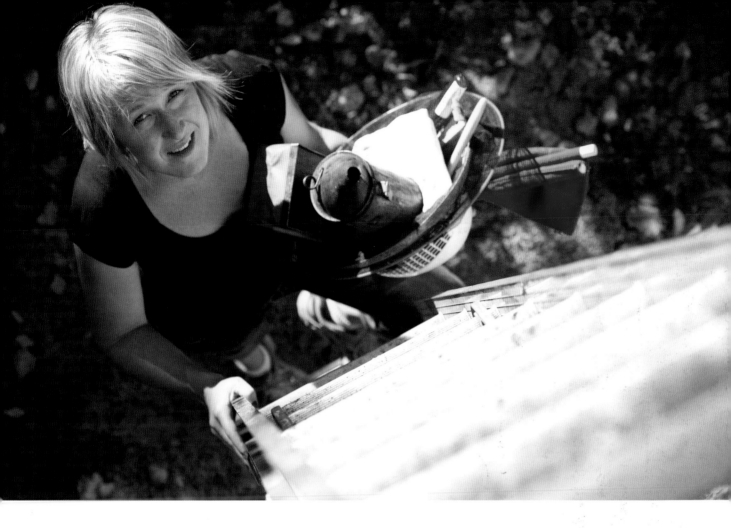

During the summer months, it's important to check the hives regularly. Lindsay checks hers once a week. She makes sure there are plenty of eggs and the queen is present. She also looks for mites, which appear as red or brown spots attached to the bees. Mites spread viruses and weaken the bees by sucking away their fluids. They have also been implicated as a possible cause of colony collapse disorder (CCD), a serious threat to honeybees that causes entire hives to die without apparent cause.

OPPOSITE, CLOCKWISE FROM TOP LEFT The queen bee is marked with a red dot for easy identification. Coneflowers provide food for the bees in a native garden below the rooftop beehives. Lindsay uses a hive smoker to calm the bees when she checks the hives. ABOVE Lindsay prepares to climb the ladder to the roof.

Lindsay has lost one hive to mites. If you catch them quickly, she advises, you can treat the hive with nontoxic medications—either mineral oil or icing sugar.

Lindsay and Jay have three hives in their backyard and one in a neighbor's yard, and Jay keeps two more on the roof of the recycling center he manages. Keeping hives on roofs can work well, Lindsay says, especially in urban areas, because then the bees are out of the way of people who may be fearful of them. The air circulation is good, too. As long as access is not too difficult and it doesn't get too hot, rooftop hives can be successful.

When figuring out hive placement, Lindsay says, make sure the entrance to the hive faces east. "Bees want to wake up with the sun." It's also important to make sure that the hives are not in a damp area and to place them where the bees' flight paths won't interfere with people.

Lindsay says keeping urban bees makes a lot of sense. Cities often offer more varieties of flowers, available in more seasons, with fewer pesticides, than do country settings. City bees are said to work harder than country bees, because cities tend to be warmer and, with all the artificial lighting, the bees can work late.

When Lindsay and Jay couldn't find the supplies they needed locally, they started an urban bee supply business. They offer classes, provide support to new beekeepers, and encourage people to plant bee-friendly gardens with a wide variety of flowers, including natives. Lindsay says you can also help bees in your own community by providing a fresh water source and by not using pesticides. If you ever see a swarm of bees, she says, call a local beekeeper; he or she can put them safely into a new hive and often will do it for free. Most swarms have little chance of survival in the city without a beekeeper's help.

"Beekeeping is one small way that I can help the world," Lindsay says. "With beekeeping you can actually see the difference your bees are making. At the end of the season you're rewarded with a giant bowl of honey, and nothing beats the taste of that."

ABOVE AND RIGHT Lindsay checks the health of her hives regularly.

RESOURCES

Urban Bee Supplies (Lindsay's website): www.urbanbeesupplies.ca
Studio G (inspiration for building creative bee houses): www.studiogblog.com

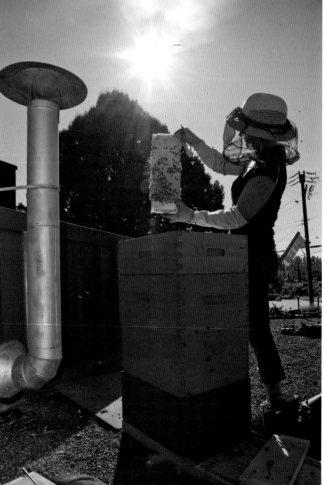

Building a Native Bee House

A few easy ways to help native bees are eliminating pesticides and providing them with native plants and a water source. Giving them housing gives you the added benefit of being able to observe their domestic life. In addition, native bees will help your flowers bloom. They are hardworking and nonaggressive pollinators that don't sting.

All you need to build bee houses are scraps of untreated wood and a drill with ¼-inch and ⁵⁄₁₆-inch bits. Drill ¼-inch holes for leafcutter bees and ⁵⁄₁₆-inch holes for mason bees. Make the holes in the wood 3 to 5 inches deep, but don't drill all the way through. Use different types of wood, glue them together, and drill the holes into patterns if you feel creative. The bee house shown is made of three 2x4-inch wood scraps of graduated lengths and has a small plywood roof. Face the open ends of the holes outward and sand any splinters. Add a roof on top to keep it dry, or place it in a protected location. Position the bee house on a wall or fence at least 3 feet off the ground, in a sunny location in your garden that faces south or southeast. It will attract mason bees, which will use a bit of mud to plaster up the holes. Leafcutter bees may come later in the summer and line the holes with bits of leaf.

BELOW, LEFT TO RIGHT First, glue together graduated lengths of wood scraps. Drill ¼-inch and ⁵⁄₁₆-inch holes 3–5 inches deep. The finished bee house is ready to be installed in a sunny location in the yard.

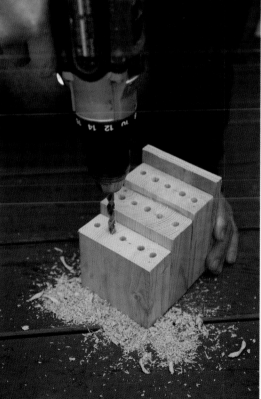
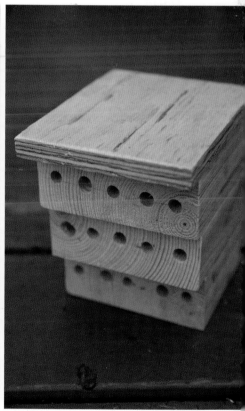

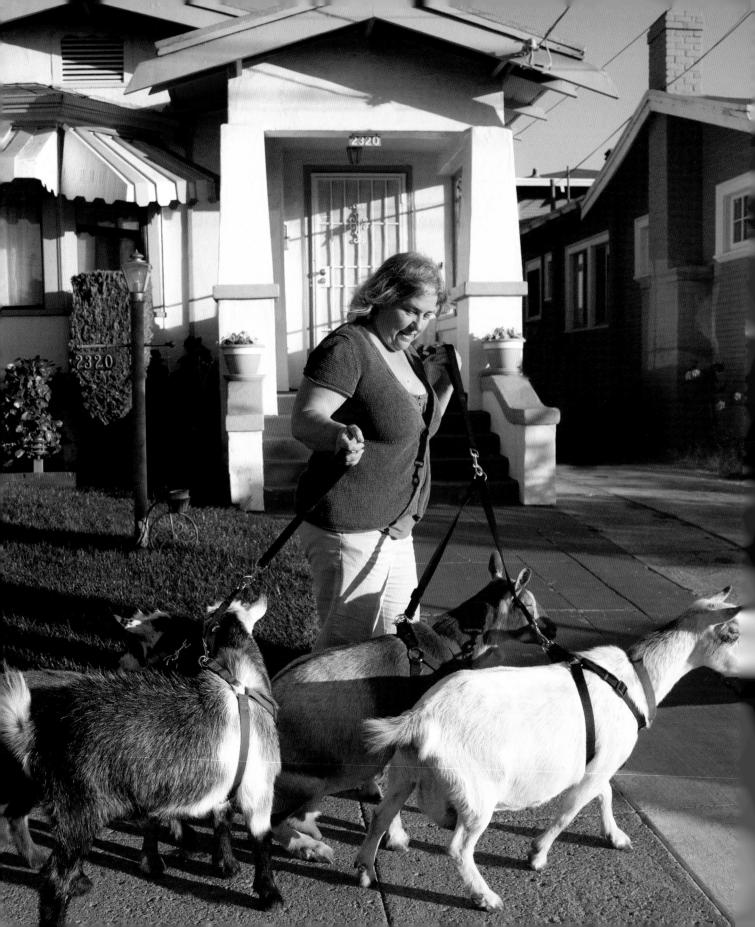

goats, gardens, and gratification

kitty sharkey
oakland, california

"I WANTED TO SURROUND myself with life," Kitty Sharkey says, describing her Oakland urban farm, which she calls Havenscourt Homestead. It's on an average-size city lot—4,000 square feet, including her house—but beyond that, nothing about it is average. She's packed four goats, a dozen chickens, several rabbits and various other poultry, a large vegetable garden, and an orchard into a well-designed urban farm. The backyard has an enclosed barnyard for the livestock, shaded by a large plum tree. The barn she built runs along the side fence and includes a milking parlor and loafing shed for her goats, a chicken coop, and storage. Her wide side yard, the former driveway, has a studio in the back with two beehives on the roof and vegetables growing along the sides. Her front yard is landscaped with drought-tolerant native plants that provide a food source for pollinators, including her honeybees.

Her Nigerian Dwarf goats have advantages for the urban farmer: because of their small size (a maximum of 23½ inches at the withers), they need less food and

Kitty Sharkey walks her four Nigerian Dwarf goats in her East Oakland neighborhood.

space than other breeds, yet each lactating goat produces about a quart of rich milk a day for up to a year and a half. An interesting fact about Nigerian Dwarfs is that unlike other goats, they can be bred at any time of the year, so if you keep several goats, you can stagger their pregnancies to ensure that you have milk year-round. The goats can be bred each year until they retire at about eight years. Nigerian Dwarf goat's milk has a higher butterfat content than that of other goat breeds, ranging from 6 to 10 percent, which makes it ideal for cheese making.

Kitty says raw goat milk is probiotic and much easier to digest than cow's milk. She uses the milk for all her dairy products, from yogurt and cheese to ice cream. The goats also live side by side with the chickens, and protect them from possums and raccoons. Her goats are as affectionate and social as dogs, but they have a slightly different temperament, since they are not predators. They don't chase squirrels or bark, and they can be easily trained to walk on a leash. Another advantage of keeping goats is that their manure doesn't have to be composted and is a great source of nitrogen for the garden.

Kitty recommends that anyone interested in getting goats do a lot of research first. "Don't dive right in. Goats

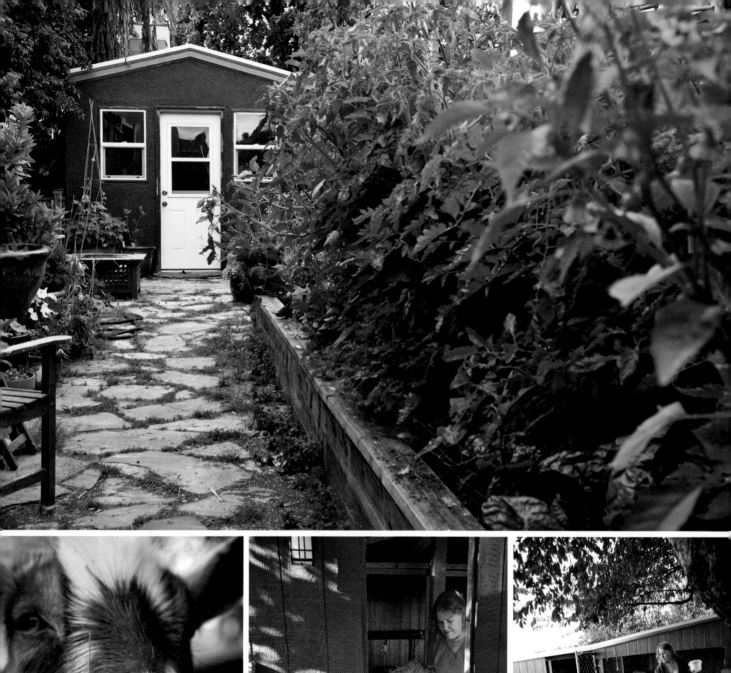
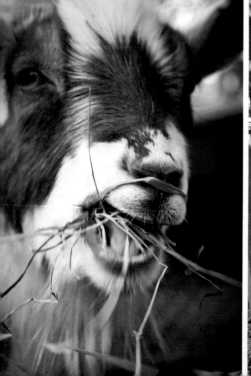
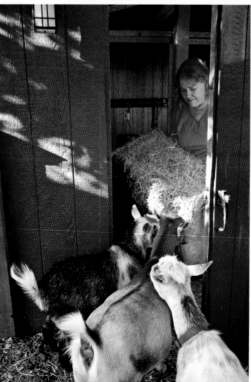
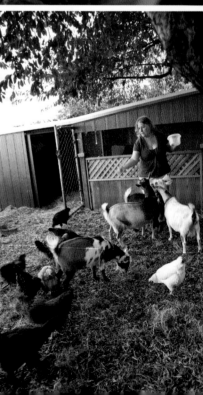

are a big commitment." Like the family dog, the goats need basic care that includes vaccinations and deworming, as well as special care like hoof trimming and disbudding (dehorning). Kitty has learned to do most of these things herself. In an emergency, the nearest goat veterinarian is over an hour away.

Although Kitty says she has not saved money by owning goats, she feels she has probably broken even. More importantly, her life is richer, she has a healthy food source, the goats are her companions, and they even help her garden grow.

OPPOSITE, CLOCKWISE FROM TOP Kitty converted her driveway into a productive garden. She feeds the goats and chickens in their backyard pen. Nigerian Dwarf goats are known for their colorful markings. BELOW, LEFT TO RIGHT Kitty's milking parlor is part of the barn she built out of recycled lumber. Her lactating goats each produce about a quart of milk a day.

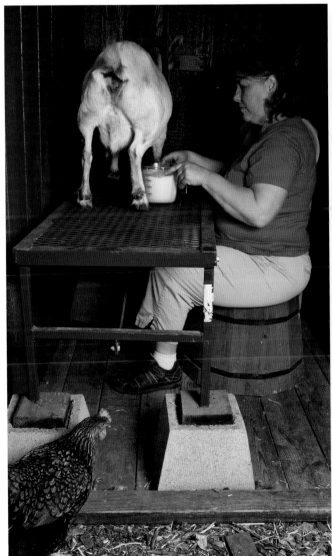

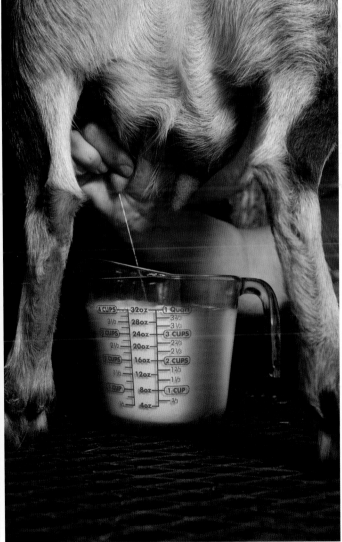

Choosing Goats

You've done your research, taken a class, and perhaps done a little volunteer work at a local goat farm or urban homestead. Now you want to bring goats into your life. Which breed should you get?

Don't make the mistake of falling for a breed because you love their floppy ears, or lack of earflaps. Think about your needs. Do you want goats for milk, for meat, or just as companion animals? How much milk does your family drink? Do you want to learn to make cheese, yogurt, or other dairy products?

Large breeds produce more milk, but they also require more space and are not allowed in most cities. Nigerian Dwarfs are true miniature goats and are good milk producers. Some say they are louder, but Kitty's goats have never caused a problem in her neighborhood. Mini LaManchas are a cross between Nigerian Dwarf and LaMancha goats. They are a little larger than Nigerian Dwarfs and are known for their lack of earflaps and their milk production. If you're raising goats for meat, pygmies are great for small spaces. Evaluate your space and needs, and then pick the breed that is right for you.

After you decide on a breed, don't cut corners. Do research and find a reputable breeder with quality stock. As an added bonus, your breeder will become an invaluable resource for you, answering questions, offering advice, and providing stud service. Think of it as a partnership or long-term relationship.

Finally, remember that goats are herd animals, so you can't have just one. You need at least two, but preferably three. Starting up requires a substantial investment of money, and their care takes a lot of time, but Kitty says they're well worth it. "Goats are truly amazing animals. Enjoy!"

RESOURCES

Havenscourt Homestead (Kitty's blog):
www.havenscourthomestead.com

ABOVE Kitty's Nigerian Dwarfs let her know when they need some attention. OPPOSITE She says she sometimes finds chickens, such as these pullets, catching a ride on the back of a goat.

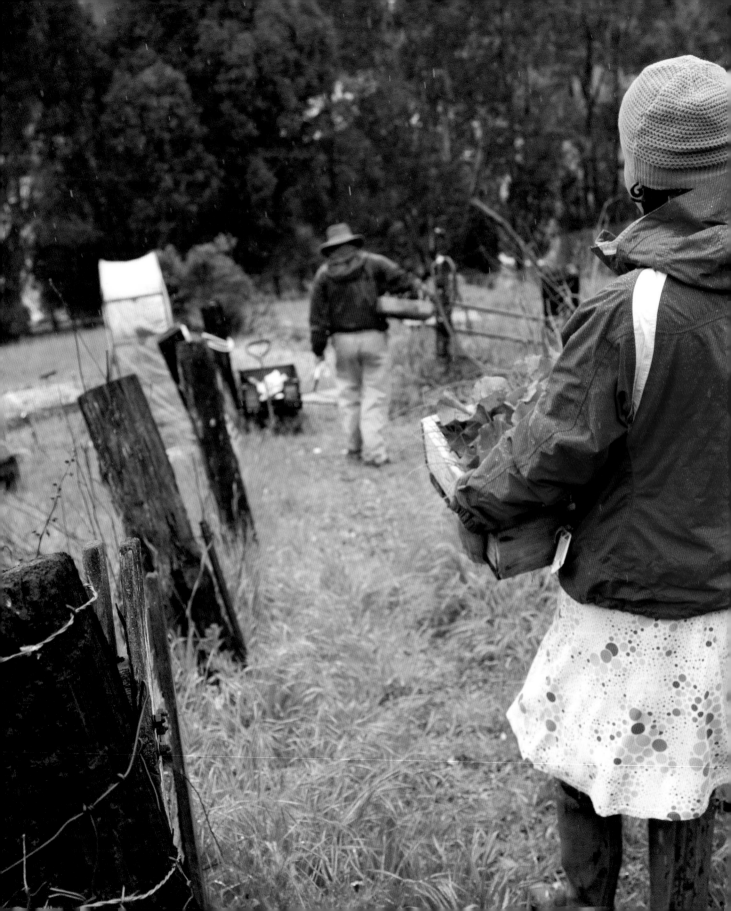

acres of potential

maya blow and nevada cross
el sobrante, california

WITH 2½ ACRES OF LAND JUST outside Berkeley, Maya Blow and Nevada Cross are creating the urban farm of their dreams. They were thrilled to find the property after a year and a half of searching for a space that was both affordable and close. Perched on a hill, the house was structurally sound, came with an old stable, and was surrounded by tall trees that hid the busy street below. And despite the rural feel, it was only ten minutes from Berkeley, so Nevada would have a short commute. They and their two sons moved in a year and a half ago.

Their new home came with unexpected gifts. Maya and Nevada, who both have some Native American ancestry, discovered that a tribe of Ohlone Indians had once lived in the area. They felt a natural affinity with the land that made them feel at home right away. Wildlife was abundant; they encountered many different animals, including a 5-foot-long gopher snake, a flock of thirty wild turkeys, and plenty of deer.

They were also pleasantly surprised by their new community. The neighbors were warm and hospitable, and gave the family an old-fashioned welcome. Their 93-year-old neighbor had been one of the first people to live in the area, and was able to tell them the history of their land—including the fact that the former owner had kept the occasional steer.

As Maya and Nevada got settled in their new home, they started planting gardens and acquiring livestock. The first thing Maya planted was a medicine wheel, a way to pay homage to the original inhabitants of the land. The wheel has sacred plants in each direction, symbolizing the circle of life. Next she put in a kitchen garden beside the house. The couple uncovered an old orchard that was buried in weeds, discovering over twenty different fruit and nut trees, including plums, apricots, oranges, walnuts, and apples. They had gotten chicks in anticipation of their move, and Nevada built a chicken coop. Goats came next, then rabbits and ducks.

The family joined a nearby gardening club and met other newcomers with the same dreams of farming. Maya found enough interest in her immediate neighborhood to start a five-family work cooperative. The group meets

Maya Blow and Nevada Cross transplant seedlings to their hillside garden during a drizzly spring rain.

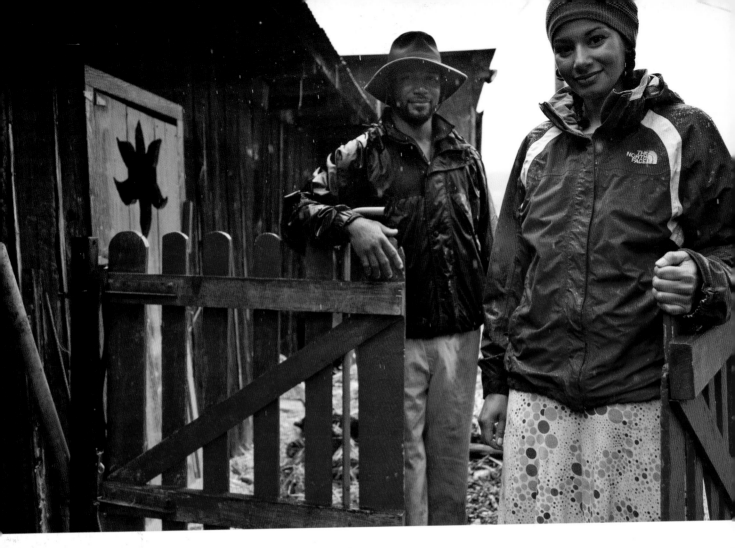

once a month for three hours at rotating yards, and the host provides lunch afterward. At the most recent work party at Maya and Nevada's home, the group prepped beds, weeded, and got a head start on spring planting.

The couple used permaculture techniques when they began staking out large 5x20-foot beds that wrapped the hill. To prepare the beds for growing, they sheet-mulched them in January, taking advantage of the winter rains. They laid down cardboard, then added grass clippings, old hay, and manure. They let the layers break down till they began planting in the spring.

They used a technique called double digging to increase soil drainage and aeration. It involves loosening two layers of soil and adding organic matter. First a shallow trench is dug with a spade; this is the top layer. Then the bottom of the trench is dug with a fork, and organic matter is added. A second trench is started, backfilling the first trench. The process is repeated until the whole bed is treated.

To help prevent erosion in their hillside garden, Maya and Nevada used a permaculture technique of

ABOVE Nevada and Maya's property came with a barn. OPPOSITE, CLOCKWISE FROM TOP LEFT The two start their seedlings in a greenhouse made from recycled windows. Nevada prepares to transplant the corn seedlings. Maya and Nevada belong to a five-family work-party cooperative. Planting corn starts.

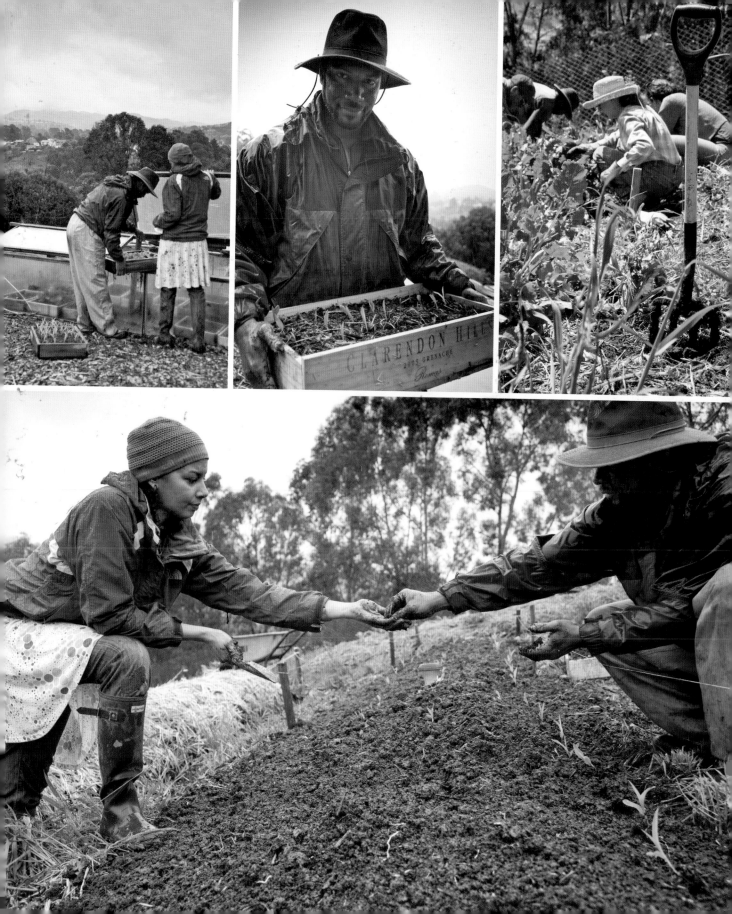

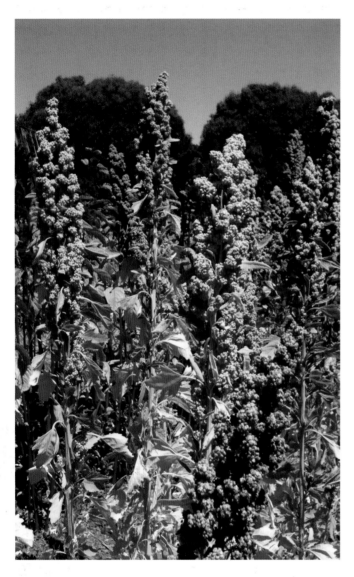

ABOVE Maya's first crop of quinoa, with its multicolored flowers, produced an abundant harvest. (*Photo by Maya Blow*)

With all the space on their new property, Maya is experimenting with growing grains. Her goal is to grow grains for animal feed as well as for the family.

Quinoa was one of the first grains she grew. "I am amazed by this plant," she writes in her blog. A complete protein, quinoa is 16 to 23 percent protein. The leaves are also edible, and she describes them as "shockingly delicious." They can be eaten raw or sautéed. "We barely tilled the soil and barely watered, and still got more than an abundant harvest," Maya says. She also loves the plant's "breathtaking" beauty.

Quinoa is an annual and prefers cooler weather—where temperatures do not exceed 90 degrees F and nights are cool—making it well suited for northwestern growing. Sow the seeds in early spring, when the soil has warmed to about 60 degrees F. Plant them in full sun, 1/4 inch deep, in loosely tilled, weed-free rows. The seeds germinate in 4 to 5 days and should be thinned to about 10 inches apart.

Quinoa is closely related to lamb's-quarters, a common but much smaller weed, so be careful not to accidentally pull it. It needs minimal water and takes 90 to 120 days to harvest. Unlike grassy grains, quinoa produces numerous flowers before going to seed, and its leaves are edible raw or cooked.

Harvest the seeds when the leaves of the plant have dried off and the plants are just seed heads on a stalk. Hang them inside in a warm, dry place if you want to harvest early. A good shaking releases most of the seeds. You will get roughly 1 pound of grain from every 10 plants, depending on your growing conditions.

After harvesting the seeds, wash them thoroughly to remove the saponin, a soapy coating that the plant uses to deter birds. The saponin will foam when washed, so keep washing till all the foam is gone. After washing, let the seeds dry completely before storing them.

digging swales, or long horizontal trenches, along the natural contours of the land. Dirt from the trenches is piled on the downhill side of the ditch to create a berm. Swales prevent the rainwater from washing down the hill and allow it to soak into the soil. Eventually the couple plan to dig ponds that will feed into the trenches and irrigate the plants.

Maya and Nevada are striving for sustainability with their urban farm. Their first year's harvest was "amazing," Maya recalls. They had luck with everything except green beans; the seedlings were eaten by insects before they could grow. They couldn't believe the 75-pound harvest of potatoes that lasted through the winter, and were sad when they finally ran out; store-bought potatoes didn't taste nearly as good. With the bounty of fruit from their trees, Maya and a friend preserved fruit for a week. They enjoyed tomatoes, two types of corn, lima beans, black beans, garbanzos, winter and summer squash, artichokes, zucchini, and much more.

Having recently celebrated her second anniversary on the farm, Maya sees great potential ahead. She's interested in starting a CSA with their bountiful harvests and trying a herd share to share the fresh milk. Nevada is interested in trying aquaponics, and they'd like to build a Superadobe in-law unit. Given the extra space, the family dreams can grow too.

RESOURCES

Soul Flower Farm (Maya's blog):
http://soulflowerfarm.blogspot.com

BELOW, LEFT TO RIGHT A scarecrow made by one of Maya's sons watches over her medicine-wheel herb garden. The chicken coop is made from recycled pallets. Maya holds day-old goat twins.

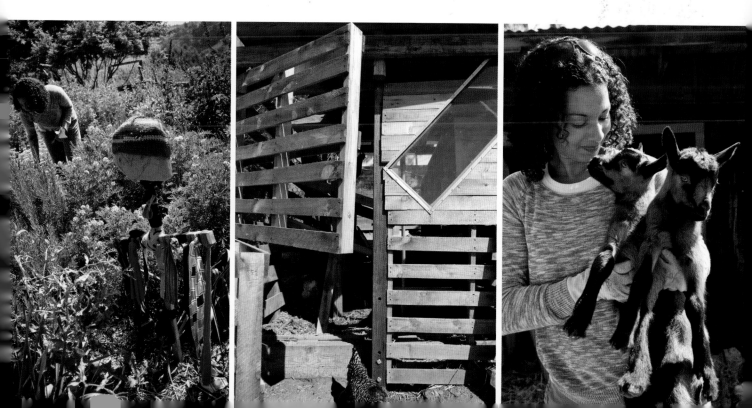

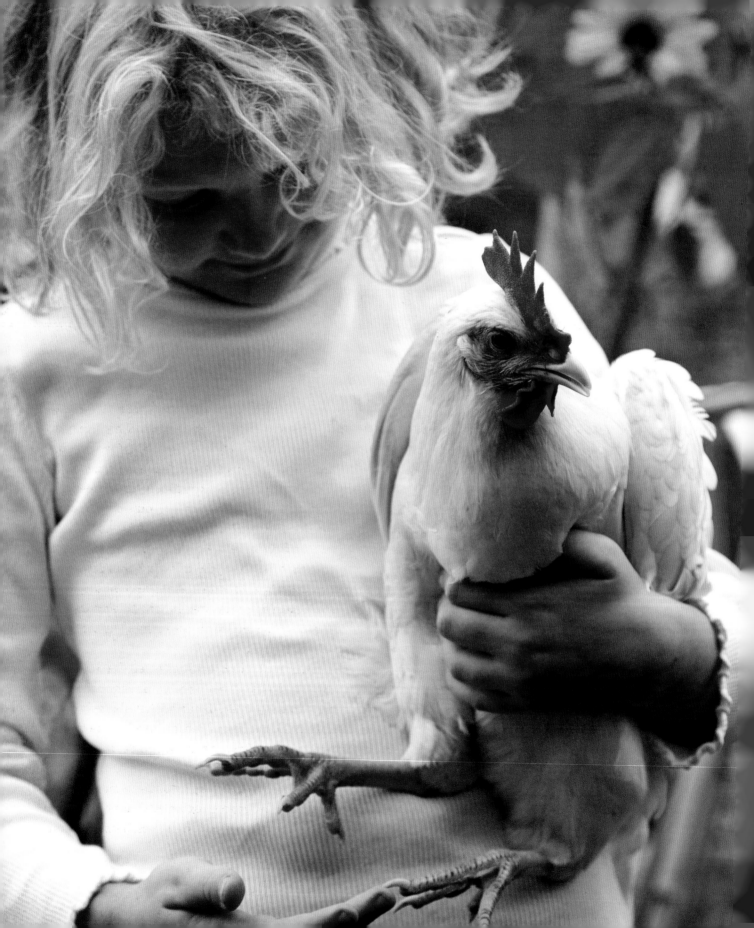

a northwest garden blogger

erica strauss
edmonds, washington

WHEN ERICA STRAUSS BEGAN growing vegetables, she never dreamed that her pastime would take over her life. She started out as a chef interested in getting better produce for her family. "I knew I wanted to grow vegetables. We started with eight raised beds. My daughter was just a toddler, and she would eat the peas right off the plant. It was very rewarding. I was hooked!" Eight years later, her impressive backyard has been taken over by thirteen 4x8-foot raised beds, with five more in the front. There's a mini orchard of twenty-nine dwarf fruit trees, a greenhouse, a balcony of tomatoes, and lately even chickens. The abundance here goes way beyond a casual urban garden: lettuce, beets, kale, carrots, artichokes, tomatoes, strawberries, blueberries, beans, squash, and more, all grown without any chemical pesticides. Her beets are in Technicolor, her onions perfect globes. Not only does she grow all her family's vegetables, but she also writes about her efforts on her popular blog, Northwest Edible Life.

Bella, Erica Strauss's seven-year-old daughter, with one of her favorite hens

"When I first started growing plants, I imagined it would be like having a greengrocer in my backyard accommodating my every need," says Erica. She has since found that the plants call the shots, revealing the truth in the saying "The key to being a good gardener is to think like a plant." Start by walking outside and facing south, she advises, and "feel the track of the sun the way a plant would feel sunlight over the course of the day. Pay attention to natural timing clues to guide your gardening actions." Plum blossoms don't bloom because they have looked at a calendar; they are reacting to warmth and light. If you take the time to observe plants, you can learn what they want and need.

Growing vegetables has also affected the way Erica cooks. She used to start with a recipe, but now whatever is growing in the garden dictates what she will make that night. Her cooking has become much more improvised and simple. Some of that has to do with having kids, but it stems mostly from her desire to use what she's harvesting. Another saying she's found useful is "if it grows together, it goes together." Classic examples of this adage include basil and tomatoes, peas and mint, and beets and dill.

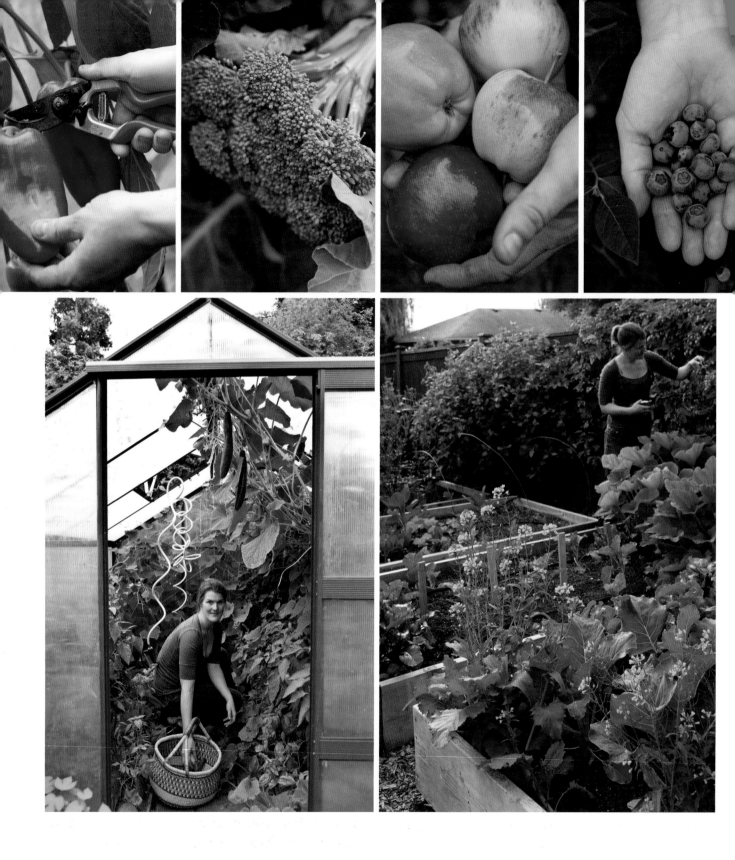

Becoming a Successful Garden Blogger

Craft your posts to either educate or entertain your readers; ideally, do both.

Readers are busy; write posts that are of value to them if you want them to take the time to read your blog.

Readers value feeling involved in a blogger's life, but don't bore them with minutiae. Don't blog about going to the grocery store.

Focus on a certain kind of content, so readers know what to expect. Erica's topics are gardening with a splash of cooking, motherhood, and food politics. She's not going to be reviewing software—unless it's garden-planning software.

Always write with your own authentic voice. There are few topics that haven't been done, but with your unique voice and perspective you can make any topic fresh.

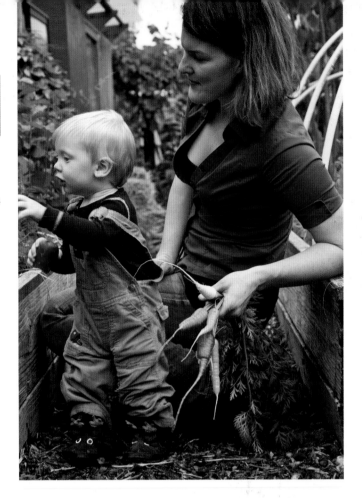

She recommends greens as good gateway plants for those new to Northwest gardening. "They're easy and rewarding. Lettuce responds to our cool, drizzly weather by growing verdant and tender. Say what you will about our crappy, sunless weather: the lettuce loves it."

Erica's cooking background is what first got her interested in growing edibles. She went to culinary school and interned for Jerry Traunfeld, a well-known chef who at the time was head of the award-winning Herb-farm restaurant in Woodinville, Washington. Traunfeld taught her what quality produce looks like and also about

OPPOSITE, CLOCKWISE FROM TOP LEFT Bell peppers; broccoli; Gala, Akane, and Sentinel apples; and blueberries—all from the garden. Erica prunes the hopvine for her husband's homemade beer. She grows cucumbers and peppers in her greenhouse. ABOVE Erica's toddler, Oliver, tries a rainbow carrot.

using interesting and exotic produce such as quinces, sea beans, and maple blossoms. She later worked for 10 years in restaurant kitchens and as a personal chef in and around Seattle.

She started her blog in 2011 so she wouldn't drive her friends crazy. "Who would be my friend if I talked about gardening nonstop?" The blog allowed her to share all the dirty details with fellow gardeners. Having a background as a chef, as well as some writing experience, made it easy to begin. Her first post was the result of her own struggle to figure out a planting calendar and choose the right seeds. Garden planning can be tricky; for example, winter crops must be started in June.

Another early post enthused about her favorite seed company, Territorial Seed, which conducts field tests in Oregon and really knows Northwest growing conditions. In a post called "Seed Starting 101," she wrote about the

best ways to raise seedlings: use high-quality seeds; put strong, cheap, open-tube fluorescent lights on a timer to kick-start seedlings; use only sterile potting soil; and provide adequate moisture, ventilation, and fertilizer.

Always opinionated, she wrote a post in that first year called "Don't Be an Urban Homesteader Asshole"—and that's when the blog went viral. The post was about how, even though you may be a homesteader—growing food, raising chickens, doing your part to save the world—you shouldn't belittle the people who have just started growing basil in a small pot on their porch. Her message was "be welcoming, and don't scare people off." A CNN food blog linked to the post, and suddenly she had thousands more followers.

OPPOSITE Erica has success growing tomatoes on a balcony off her bedroom that gets full sun and heat all day. ABOVE, LEFT TO RIGHT Erica holds some freshly harvested onions and washes freshly picked beets.

Today Erica's gardening obsession has paid off by saving her family lots of money and providing a rewarding way for her to contribute to the family yet still be at home with her kids. "Last year I saved hundreds of dollars a month off our food bill, and we ate so well." Their Thanksgiving was a true harvest feast, with everything but the goose coming from the backyard. "Call us the new guard of domesticity, urban farmers, radical homemakers: we're out there trying to grow a little food, live on a little less, have some fun. It's a job that takes work, but it's flexible, the commute is awesome, and I can always bring the kids along."

RESOURCES

Northwest Edible Life (Erica's blog):
www.nwedible.com
Territorial Seed Company: www.territorialseed.com

tierra soul urban farm and guesthouse

krista and david arias
portland, oregon

SHARING THEIR URBAN FARM with others was the inspiration for Krista and David Arias's Tierra Soul guesthouse. Visitors can rent a room in the couple's large two-story 1900s farmhouse and even help with farm chores, if they choose. Tierra Soul, located in the historic Mississippi Avenue neighborhood of Portland, features a permaculture garden with goats, ducks, and chickens.

Krista and David had always been interested in sustainable living, but it wasn't until they saw a film called *The Power of Community* that they felt an urgent need to start their own farm. The film documents how Cuba has survived with less than half of the oil it once imported. The people of Havana grew 50 to 80 percent of their own food, Krista and David learned, right in the city. "The smaller the farm, the more productive it was."

The film really spoke to them. "We went right out and got ducks, goats, and eventually bees." They had thought of moving to the country, but because of the economy and the film's inspiration, they decided to stay in Portland.

Krista and David Arias's Tierra Soul Urban Farm and Guesthouse is located in the historic Mississippi Avenue neighborhood of Portland.

They tried several locations, eventually ending up in their current home. They brought their animals with them and further expanded the farm, getting rid of the 70-foot driveway and putting in planting beds and fruit trees. They began making their own goat's-milk soap, plum wine, and fig chutney, to mention a few favorites.

They never made a definite plan to start an urban farm stay, but Krista liked the idea of a bed-and-breakfast. They were living in their big house with lots of roommates. In 2010 they decided to try renting out a vacant room via Airbnb. They fixed up the room, painted it, bought a new bed, and advertised it as a room on an urban farm. Krista says the response was encouraging. "We were meeting people who were interested in sustainable living and actually making a little money doing it." As their roommates moved out, Krista and David converted more rooms into farmhouse accommodations.

Krista says Tierra Soul appeals to visitors looking for something a little different. Each of the four rooms is a different color and theme, with books and artwork to match, and all have what the pair call a "DIY Portland arty edge." The Barn Dance room features farm-themed books; the Bluebird room is dedicated to the literary arts,

with local art and poetry; the Blue Lotus room celebrates spiritual traditions from around the world. The ground floor of the farmhouse has a bright, open feel, with a large kitchen, a common space with a piano, and a big farm table where guests often hang out.

They advertise on Airbnb, Yelp, Facebook, Neighbor-hoodNotes.com, FarmStayUS.com, and other sites. They also get many visitors via word of mouth. They try to encourage the right kind of visitors by freely admitting that "we don't offer air-conditioning, doilies, and syrupy-sweet hospitality." Theirs is a clean, simple, affordable farmhouse without a lot of bells and whistles. Most rooms have a bathroom down the hall, although the upstairs loft has a kitchenette and private bath. A hearty breakfast featuring the farm's eggs is available for a modest extra charge.

RESOURCES

Tierra Soul Urban Farm and Guesthouse:
www.tierrasoulpdx.com

Guests receive a farm-style welcome, including handmade soap and a tour of Tierra Soul. If they are so inclined, they can help with chores. One guest said that having five-year-old Fia give her the farm tour was her favorite part of the stay. "She's very young, but knows quite a bit and can confidently handle the family cat, chickens, or even a goat that's twice her size."

Krista says that having guests has helped fund some of their urban farm experiments. They love having goats, for example, but were spending a lot on feed. The farm stay has helped them bring in a more steady income. It also allows David and Krista to be at home with their kids. Hosting guests can be a lot of work, of course, and they've had to invest in a state-of-the-art washer and dryer. It was necessary for the summer, when they sometimes go four months without a day off. In addition to hosting guests, Krista now offers healing retreats and classes. One guest wrote of her stay, "I fell in love with the house, its people, and the energy flowing through it. . . . For someone living in a city, it is an amazing escape to another reality."

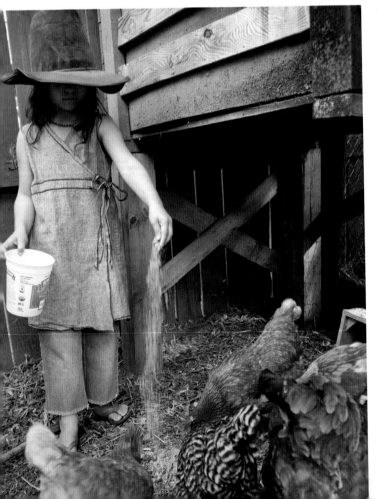

LEFT Fia, Krista and David's five-year-old daughter, is very knowledgeable about chickens. OPPOSITE, LEFT TO RIGHT Each of the guesthouse rooms has a different color and theme; the Bluebird room is dedicated to literary arts. Krista serves a farm-style breakfast to her guests. The house features recycled and repurposed furnishings that create a folksy, relaxing atmosphere.

Converting Your Home into an Urban Farm Stay

Before investing a lot of time and money in the idea of renting out rooms, look into your local landlord-tenant laws and planning regulations; some communities limit temporary rentals. Then do a test run by having a guest for a night, to make sure you're up to meeting new people and sharing your home and urban farm.

To set up a room, declutter it and clean it thoroughly. The closet should be empty; knickknacks should disappear. Remove valuables and irreplaceable objects.

Paint the room a soothing color. Krista gave each of her rental rooms a different theme, and each has books and artwork to go with its theme.

Invest in new bed linens and possibly a new bed. Provide a place to put clothing, and a nightstand with a lamp, at a minimum.

Try to give the room some farmhouse charm. Krista uses rustic pieces she finds on Craigslist to accentuate the 1900s feel of her house. She decorated one wall with

old hats. She uses a vintage school chalkboard by the front door for messages.

Provide guests with easy access to guidebooks, maps, public transportation schedules, and menus from nearby restaurants upon arrival. Krista leaves a welcome note with handmade goat's-milk soap and bath towels in the guest's room prior to arrival. She also gives tours of the farm and lets visitors participate in the work of the farm. She keeps plenty of books on sustainable living in common spaces.

When listing your room rental, describe it as accurately as possible. Be sure to include the general location of your house, house rules, and expected behavior. Krista and David have strict quiet hours from 10 PM to 7 AM because of their kids. You may want to ask for a security deposit and cleaning fee. You will need to have a policy for no-shows. Put everything in writing. Then let the adventure begin.

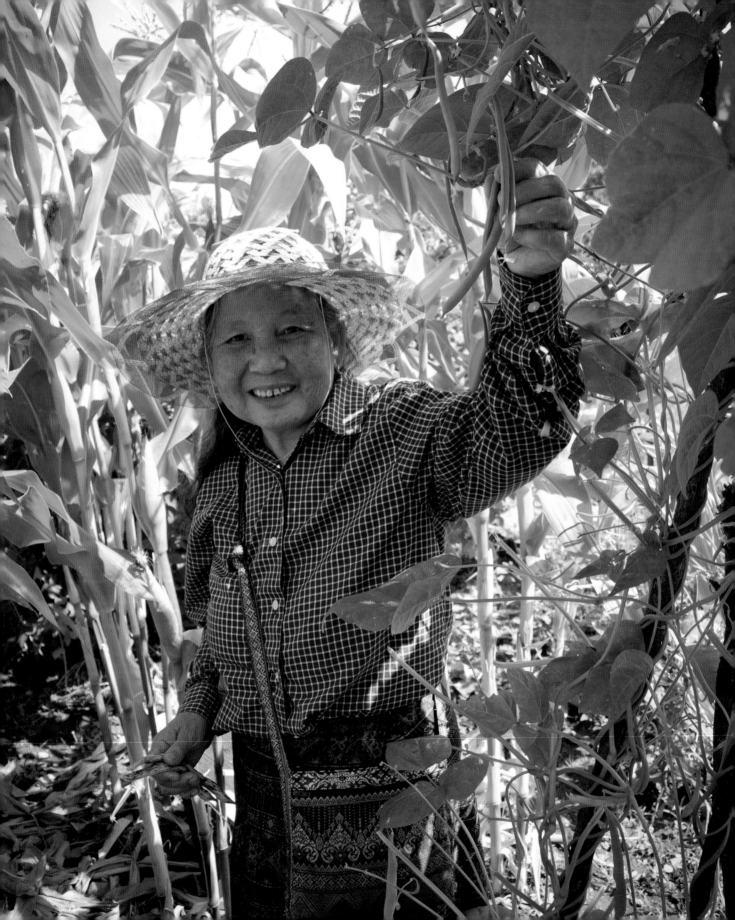

7

from a laotian jungle to a city garden

farm saeturn
seattle, washington

NOT MANY URBAN FARMERS get their start in the jungles of Laos—but Farm Saeturn did, working in the fields with her family. She belongs to an ancient tribe, the Mien, whose members live in the highlands and are known for their colorfully embroidered clothing.

Farm's life in Laos was centered on agriculture. From the village each day, the family would walk to their fields to tend their vegetables. Sometimes the walk took over an hour. Each family had two fields, and they grew everything they needed to survive; there were no supermarkets or corner stores. Rice and corn were the main crops, but they grew many other vegetables too. After harvesting the rice, Farm and her family would carry the heavy bags back to the village. If it was a really good year, they might have two rooms full. To winnow the rice from the hull, they used a basket to throw the rice up in the air. The wind blew the husks away.

At her home in the village, they kept chickens and a

pig. At the end of the year they butchered the pig, rendered the fat, and dried the meat so it would last for the entire year. Rich villagers had two pigs. They also had several chickens that they used mostly for eggs. They didn't eat chicken often—only if someone was sick or if someone died.

Every few years they would move to a new field. They practiced slash-and-burn agriculture, the only technique they knew: an area was burned, and the ashes would fertilize the soil. Plant rotation helped them get the most they could out of the soil, but after a while the farmers needed to move on.

Despite their limitations they were expert farmers, growing certain plants together to increase production, much as Native Americans do. Beans, squash, and corn grew together; cucumbers were planted with rice. Sometimes after a really long day, they would just sleep in the field in a small cabin. In the winter they grew *gai choy* (Chinese mustard greens), cabbage, and green onions. Each spring the neighbors would help each other plant, the men digging holes with stakes, the women planting seeds from bags they carried.

In Seattle, Farm Saeturn grows the vegetables of her native country, Laos, in a Bradner P-Patch plot.

47

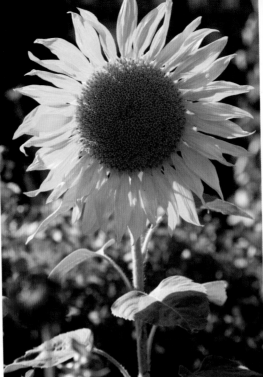

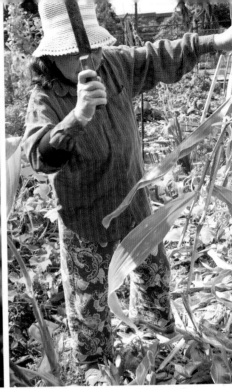

Farm's life changed in the 1970s when her young husband, along with many other Hmong and Mien, was recruited to fight the communists. She and her family fled Laos when the Pathet Lao took over in 1975, walking at night to the Mekong River on the border of Thailand. Farm had one child by then. When the family crossed the river, Thai soldiers at the border took all their money. When they arrived at the camp, they had nothing. Farm says there were many people fleeing the country.

Farm and her family lived in the refugee camp for four years, and there she had two more children. It was a hard life; they had almost nothing to eat but rice and canned meat that they were given every ten days or so. Farm made embroidery to sell, so she could buy vegetables.

CLOCKWISE FROM TOP LEFT Joyce Moty made all the scarecrows at Bradner Gardens Park P-Patch. A sunflower grows nearby. In September, after harvest, Farm cuts the corn with a machete. In December, Farm weeds her winter greens.

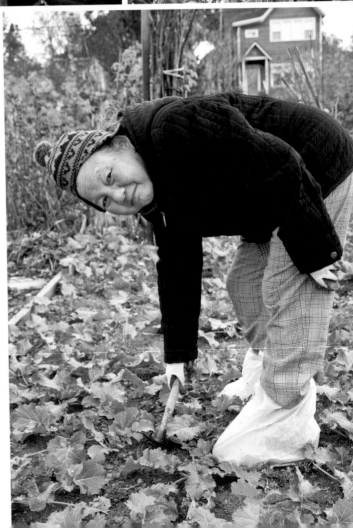

Farm came to the Seattle area in 1980, following her brother, who was the first of her family to come. Five more of her siblings eventually came with their families. Her parents arrived in 1992.

Farm and her family experienced great culture shock in Seattle. She walked everywhere until she learned how to ride buses. She began growing vegetables when she first got a P-Patch plot in 1985. She missed the food of the old country. Store-bought produce "looks new but doesn't taste fresh," she says.

Seattle's P-Patch program is a hugely popular community garden network with a total of 23 acres of space throughout the city. It provides 4,400 low-cost plots for community gardeners in 75 different locations. The gardens are especially important to city residents who have no access to growing space. They are open to everyone, regardless of ability to pay. Farm has had several plots in different P-Patch gardens since her first plot in 1985. She and her family now share plots at Bradner Gardens.

Farm still remembers her traditional upbringing in Laos. She saves seeds and grows different plants together: squash and greens with corn, medicinal plants along the edges. After harvesting corn she cuts down the stalks with her machete, breaking them up to compost. She collects raspberries in a big leaf and eats them with a little salt. She grows sweet white corn, boiling it just a little so it's still crunchy, and eats it plain, without butter. She prefers eating squash when it's young; she boils it, then adds a little sugar. In the winter she plants kale and chard, but she doesn't eat the leaves; she prefers the tips just before they flower, steamed. After all her years in the United States, Farm still prefers to grow and cook the food of her homeland in the timeless ways of her people, keeping her culture alive for the next generation.

Finding a Community Garden Near You

- *San Francisco has about 50 community gardens. Some have plots available, but most have waiting lists. To check availability or get on a waiting list, visit www.sfgro.org.*
- *Sacramento has five community gardens: www.cityofsacramento.org/parksandrecreation /parks/community_garden.htm.*
- *Portland has 43 community gardens. Some have plots available. Fill out a request form here: www.portlandonline.com/parks/index.cfm?c=39846.*
- *Eugene, Oregon, has six community gardens: www.eugene-or.gov/index.aspx?nid=496.*
- *Seattle's P-Patch program has 75 community gardens: www.seattle.gov/neighborhoods/ppatch.*
- *Tacoma, Washington, has six community gardens with plots available: www.metroparkstacoma.org /community-gardens.*
- *Vancouver, British Columbia, has 70 community gardens. Some have plots available, but most have waiting lists: http://vancouver.ca/parks/parks/com-gardn.htm.*

RIGHT Farm makes tea from this nasturtium-like herb that she grows around the borders of her garden.

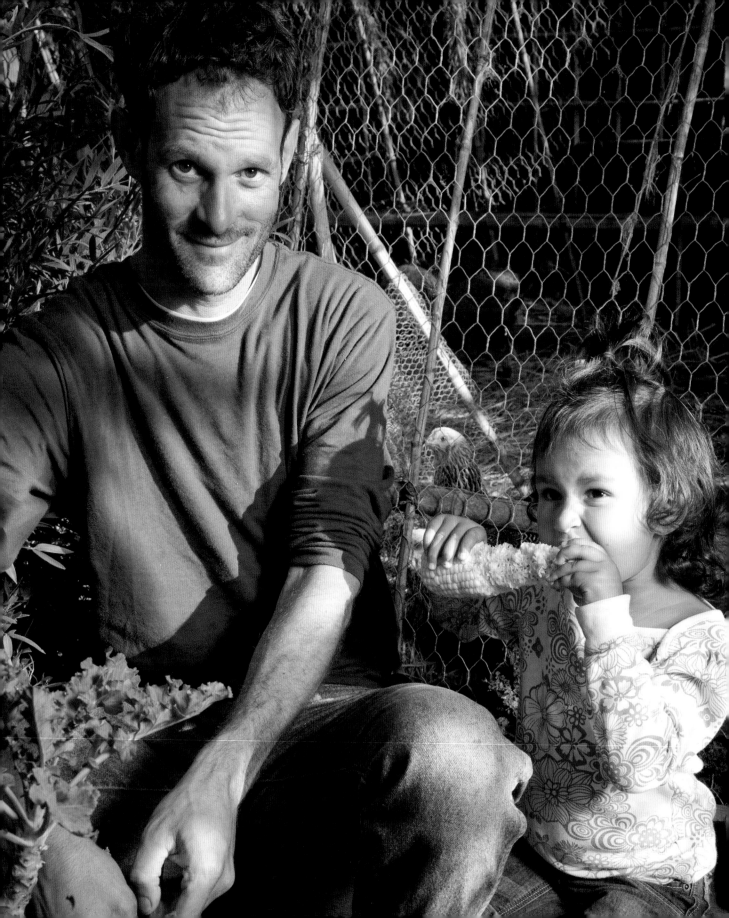

backyard permaculture

christopher shein
berkeley, california

CHRISTOPHER SHEIN CALLS permaculture "a 10,000-year-old cutting-edge technology." It's both a philosophy and a way of life for him. The dictionary defines permaculture as "an agricultural system or method that seeks to integrate human activity with natural surroundings so as to create highly efficient self-sustaining ecosystems." Christopher sees it as a combination of permanent agriculture, applied ecology, and good common sense.

He's always been interested in growing things. His mom was a lifelong gardener, and he started his career with an internship in the agroecology program at the University of California, Santa Cruz. He went on to help start a dozen community gardens in Oakland, then did a permaculture farm apprenticeship at the famous Linnaea Farm in British Columbia. Now he teaches permaculture at Merritt College in Oakland and runs a landscape business that has built 100 permaculture-based gardens in the past ten years. He has recently published a book, *The*

Vegetable Gardener's Guide to Permaculture: Creating an Edible Ecosystem (Timber Press).

It's all about thoughtful observation and working with nature, Christopher says: integrating design to make a sustainable garden. His 6,500-square-foot South Berkeley lot is a lush oasis that you might not guess is full of edibles. With 16 fruit trees and dozens of perennial vegetables, the backyard is designed to grow the most food with the least impact. It's organized by crisscrossing paths with a large patio in the center. He uses deep mulch to make the paths and keep the weeds down. He grows bamboo to use as a renewable building resource to make supports for vines, fences, and the chicken enclosure. A large L-shaped pen runs along the exterior, where he keeps a couple of dozen chickens and ducks. His office studio, in a back corner, is made of straw bales, local clay, and recycled wood. He has a 1,000-gallon rainwater catchment system that collects rainwater from the roof to water the plants. The tiny front and side yards are planted with natives that require little watering and encourage pollinators and beneficial insects.

Christopher likes growing perennial vegetables because they're so easy. They last season after season,

Christopher Shein prepares to feed his chickens some collards while his daughter, Gitanjali, has a snack in his North Berkeley backyard.

- *Lovage* (Levisticum officinale): *A perennial celery-like plant. The entire plant is edible, but the leaves and stems are used most commonly in soups and salads. It can grow up to 6 feet tall after a few years. It dies back after frost.*

- *Mashua* (Tropaeolum tuberosum): *A South American perennial that looks similar to nasturtiums, with an edible tuber that tastes peppery when raw. It's an easy-to-grow vine, even in poor soils. Water well late in the season to encourage tuber growth.*

- *New Zealand spinach* (Tetragonia tetragonioides): *A leafy ground cover grown for its edible leaves that taste like spinach. Thrives in the hot sun and likes moist conditions. Frost will kill it.*

- *Oca* (Oxalis tuberosa): *A South American tuber that can be eaten raw in small amounts or boiled. It has a taste that ranges from tangy when raw to starchy when fully cooked. The leaves and young roots can also be eaten. Grows in poor soil and harsh conditions.*

- *Tree collards* (Brassica oleracea var. acephala): *High in calcium, they offer a steady supply of greens, can grow over 6 feet tall, and last for three to five years. They are frost resistant and easy to grow from cuttings.*

- *Tree tomato* (Cyphomandra betacea): *A fast-growing South American tree that produces egg-shaped fruit. The yellow varieties are sweeter, the red more acidic. Requires lots of water and does better in warmer environments.*

- *Yacón or Bolivian sunroot* (Polymnia sonchifolia): *A 6- to 8-foot South American plant with large furry leaves. It has edible tubers that are crisp and juicy, and can be sweet. Can be eaten raw or cooked. Does well in areas with mild winters.*

CLOCKWISE FROM TOP The many vegetables growing in Christopher's garden include oca, tree tomatoes, yacón, mashua, New Zealand spinach, lovage, and tree collards.

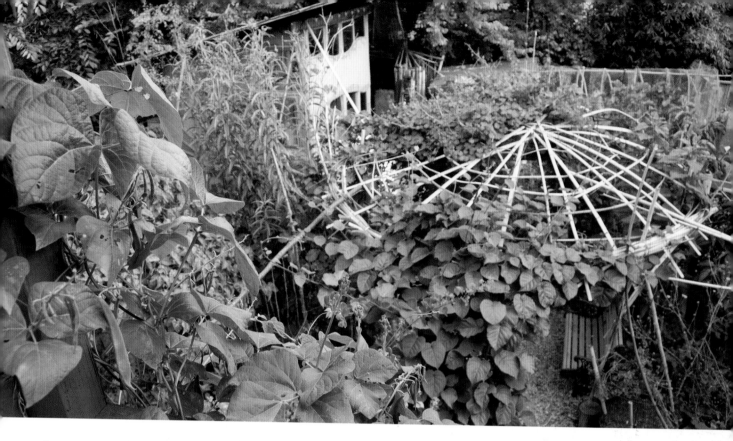

and many have more than one part that is edible. Chayote is a good example. It's a completely edible vine that produces squash-like fruit, stir-fryable stems, and starchy tuber roots. Permaculture avoids monoculture: it emphasizes plant relationships and diversity. Christopher plants vegetables in groupings called guilds. They're so well integrated, it's hard to tell that you're looking at a vegetable garden. He also thinks of the garden as vertical layers, planting shade-loving greens underneath the tall sun-loving crops and trees. For instance, tree collards, a perennial vegetable, grow over 6 feet tall and can last for years; underneath, low-growing oca and New Zealand spinach make an attractive, edible ground cover.

Permaculture mimics biodiversity in nature. It's about using renewable resources and producing no waste. Christopher has bins for compost all over his backyard. He produces 8 to 10 cubic yards of it a year, returning it to the garden as fertilizer and using it in his landscape business.

The biggest appeal of permaculture for Christopher is the idea of true sustainability. With his growing family, he thinks about the future for his kids. What sets permaculture apart, he says, is its ethics. Its core values go back to three principles: care for the earth, care for people, and fair share, or equitable use of resources. "Permaculture is really about meeting our needs and the needs of our children." What's more sustainable than that?

ABOVE Christopher's backyard features perennial vegetables and fruit trees, a studio made of straw bales, and a large L-shaped coop and pen for his two dozen chickens and ducks.

RESOURCES

Wildheart Gardens (Christopher's website):
www.wildheartgardens.com

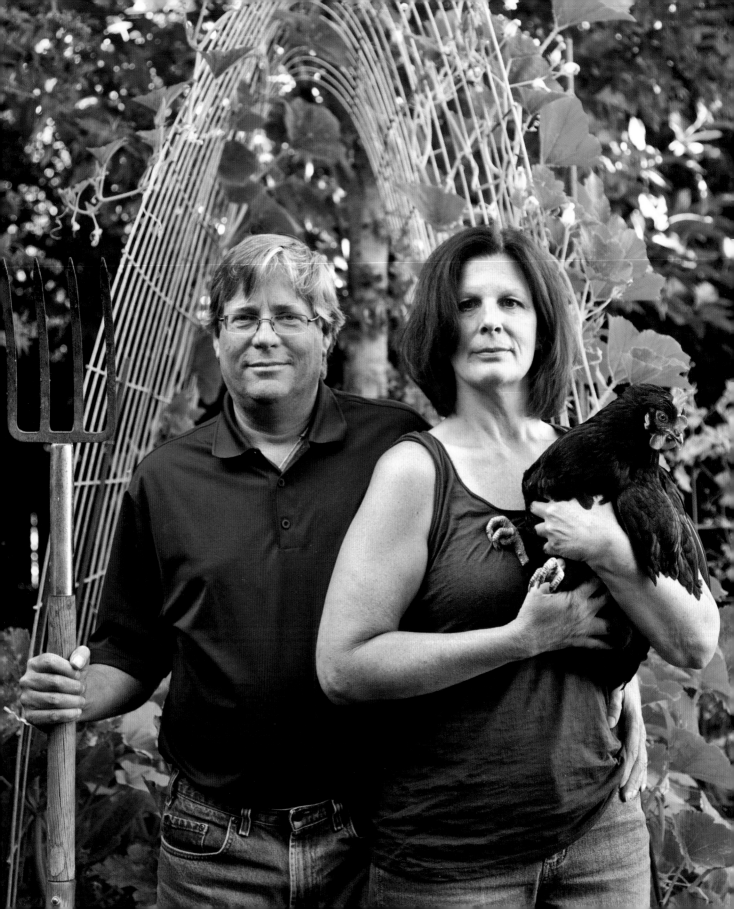

chicken revolution

barbara palermo
salem, oregon

HOW MUCH TIME would you devote to making back-yard chickens legal in *your* city? Barbara Palermo never thought it would take two years of effort, including organizing over 300 supporters, writing a 60-page thesis, attending 16 meetings at city hall, and even making a documentary film—all just to legalize backyard chickens in Salem, Oregon.

Her saga began in 2008 when one of her neighbors was working on his roof and happened to notice Barbara's four chickens in her yard below. Without talking to her, he filed a complaint with the city. Barbara got an official visit, and a nice young man from the department of code enforcement gave her only a few days to get rid of her hens or face fines of up to $250 a day.

The idea of getting chickens in the first place was the fault of her husband, Ken. "We were soaking in the hot tub one evening, admiring all the work we had done converting our traditional yard into a productive ecosystem with garden beds, a composter, and a small greenhouse,"

Ken and Barbara Palermo with one of their hens in their backyard vegetable garden in Salem

explains Barbara. Ken, who grew up in Texas, realized they were missing something. "There's one more thing we need . . . chickens!," he insisted.

After the two got hens, Barbara came to really enjoy them. Not only did they provide food and fertilizer, but they were also entertaining. She and her husband would often relax with a glass of wine after work by the chicken coop, watching the hens and their antics.

After finding out that she'd have to get rid of her chickens, Barbara says, "I was devastated. But then I started reading." She had no idea chickens had become so popular. She found a number of websites dedicated to chickens, including BackYardChickens.com, which had over 100,000 members. She found that chickens were legal in many cities, including nearby Portland, Eugene, and Corvallis. She also researched Salem's official website, where she learned that chickens were considered livestock and thus not allowed in the city, but due to a special exemption, 100-pound potbellied pigs were okay. "I thought to myself, This is not right. I'm going to fight this. I think I have a shot.'"

Barbara started by posting on a BackYardChickens.com forum, looking for fellow Salem chicken supporters

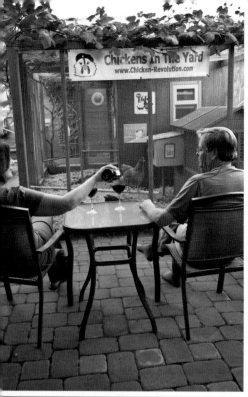

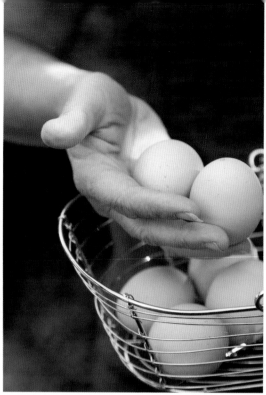

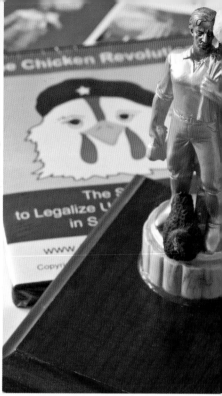

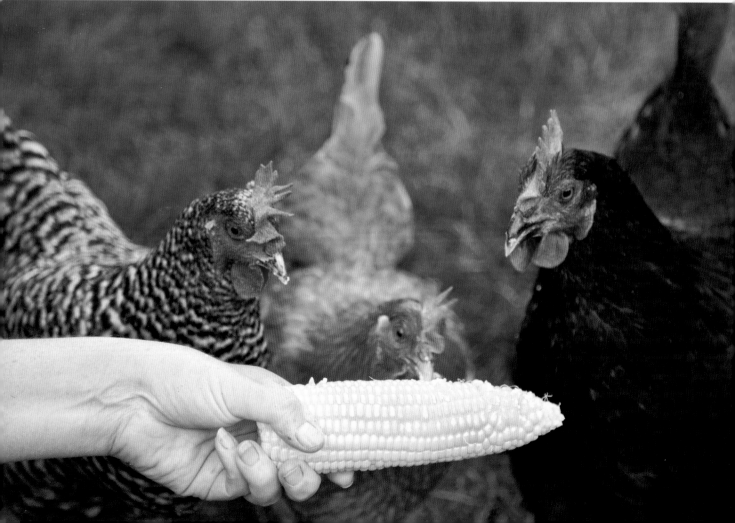

who'd be willing to join forces and try to legalize hens. With three other supporters, she formed a group called Chickens in the Yard (CITY). At their first meeting they decided on a plan of action, with their main goal being to present their case at an upcoming city council meeting. They spent six months preparing, and Barbara wrote a sixty-page paper refuting all the arguments against chickens. In February 2009 they were ready to make their presentation, but they were blocked by Barbara's local council member. "He told me nobody cares about chickens, and he wouldn't put it on the agenda."

The group found a more sympathetic council member, who suggested that they bring up the subject at the end of the meeting, when public comment was permitted. Barbara and the members of her group, which by then numbered over fifteen, each spoke for the allowed three minutes. "We basically read the entire research paper. We covered all the issues: noise, property values, odor, etc. We were professional and polite, but we basically had to force it down their throats."

And that, Barbara says, was the "beginning of two years of hell." Most of the council members were against the chicken advocates. "They wanted us to go away. They told us that the neighborhood associations were against it, and so one of our members called every one of the Salem neighborhood associations and presented

Legalizing Chickens (or Other Livestock) in Your City

Here are some tips from Barbara's website:

- *Enlist the help of others: **Use the internet to find like-minded people and form a group. Post in a forum such as BackYardChickens.com. Give your group a name and a website, blog, or Facebook page.***

- *Understand your city's current laws: **Most cities post their ordinances on their websites. Look under code enforcement or zoning, and check every possible section. Get help from a code compliance officer to verify your interpretation of the code.***

- *Find out what nearby cities are doing: **Find chicken-friendly cities and ask about their chicken-keeping policy. This information may strengthen your case and give you ideas about what kind of policy you should ask for.***

- *Put together an informational packet: **Include a summary of current laws and what nearby cities are doing. Use the packet from the CITY website as a base, and modify it accordingly. Include letters of support, charts, graphs, pictures, and a table of contents.***

- *Recruit local support: **Once you have your packet ready, send it to local neighborhood associations and offer to give presentations. Email it to the heads of agencies that promote gardening, sustainability, and the like, and ask for an endorsement.***

- *Involve the media: **Contacting them is risky because you may find opposition, but Barbara says you'll get more support once the word gets out.***

- *Take it to city hall: **Contact your city councilor and ask that your issue be put on the agenda. It's best to have the discussion hosted by a council member, but if that isn't possible, take advantage of the public comment period to introduce it.***

- *Follow through: **It will probably take months to get your city's code changed. Be persistent and don't give up.***

OPPOSITE, CLOCKWISE FROM TOP LEFT Barbara and Ken often relax after work by enjoying a glass of wine and watching the chickens. Freshly gathered eggs from Barbara's three hens. Her first-prize trophy at the annual Salem Film Festival for her documentary *The Chicken Revolution*. The chickens enjoy a fresh ear of corn.

Chickens in the Yard (CITY):
www.salemchickens.com
BackYard Chickens:
www.backyardchickens.com

council's treatment of the chicken issue, and enrolled in a moviemaking class at a local community television station. Then she created a 75-minute feature documentary that included city council meeting footage, interviews, and even a rap video that "pokes fun at those who actually suggested chicken coops would lead to meth labs." The movie was a huge success, winning the top prize at a local film festival. It also turned a public spotlight on the mayor and council members, who were up for reelection. "As a direct result of the movie, we eventually got our chicken-keeping ordinance," says Barbara.

Today, CITY has more than 800 members—and the respect of the city council and mayor. The chicken ordinance was recently modified to make it cheaper to comply with and less restrictive. It's now legal to have up to five chickens in Salem. Barbara's website, which has a mascot called Che Chicken, is dedicated to helping promote the legalization of backyard chicken keeping in cities around the country. Barbara has made her original research packet available for free downloading to help others legalize chickens in their cities. The group recently hosted its first coop tour, offers classes on chicken keeping, and has even started the Habitat for Hens project, which builds coops for people who want to keep chickens but can't afford a coop.

our cause." The volunteer ended up getting thirteen of the nineteen associations—representing 80 percent of Salem's population—to support and endorse CITY's referendum. They also had over 1,200 people sign a petition. They went to fairs and libraries looking for support. One member paid for prestamped postcards that he handed out to mail to the mayor, urging her to allow backyard hens. The group's struggle even made the front page of the *Wall Street Journal*. Still, the group had no success.

At this point, Barbara and her group were exhausted and frustrated. They were taxpaying citizens, and their elected officials weren't interested in representing them. At about the same time, Barbara discovered that city council meetings were recorded on video as part of the public record. She decided it was time to publicize the city

ABOVE Barbara picks beans in August. OPPOSITE In September, she harvests tomatoes and cucumbers.

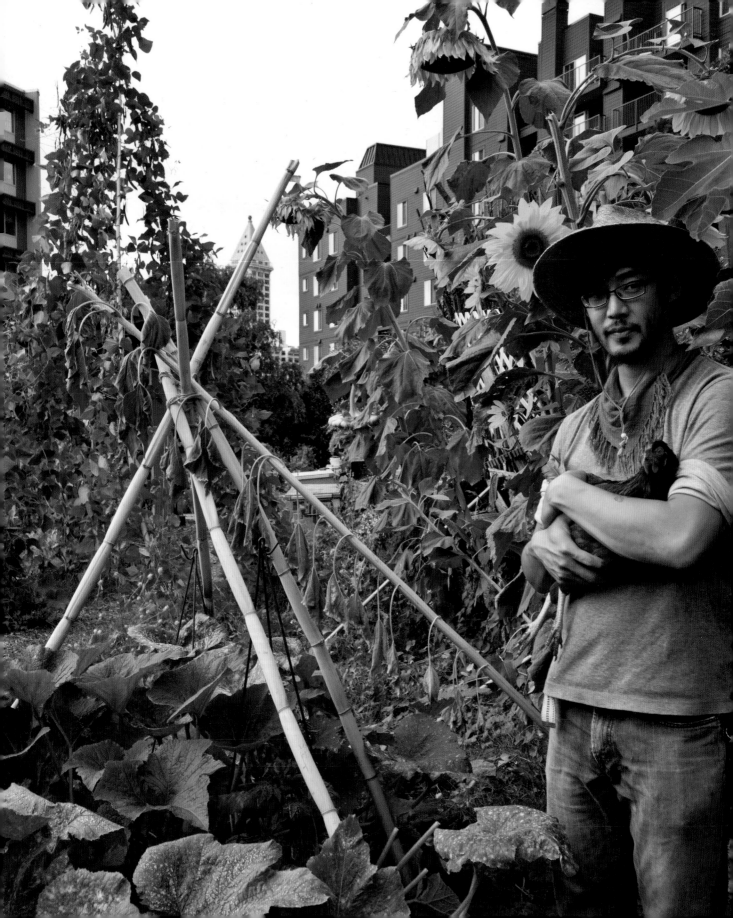

from cancer to a community garden

jonathan chen
seattle, washington

CANCER HAS A WAY OF TURNING your life upside down. At age twenty-one, Jonathan Chen thought he had everything figured out. His childhood dream was to be a professor, and he was working his way toward it as a biology major at Oberlin College in Ohio. Then, during his sophomore year, he found blood in his urine. After months of tests, and an unsuccessful surgery, he was diagnosed with bladder cancer and rushed into surgery on Christmas Eve. While the surgery was a success—he recovered and went back to school—he found himself questioning everything he had once taken for granted.

After graduating with his bachelor's degree in 2006 as planned, Jonathan was still dealing with post-treatment shock. He had lost his direction and no longer had any interest in pursuing the additional schooling required to be a professor. "I wanted to do something that made a difference," he says, "but I had no idea what that was."

Jonathan Chen is the garden manager at Danny Woo Community Garden in Seattle.

He bought a one-way ticket to Europe to try to find answers, signing up with an organization he'd learned about in college, World Wide Opportunities on Organic Farms, which connects organic farmers around the world with volunteers willing to work in exchange for meals and accommodations. On a small family-run organic farm in France, he learned how to grow food. His epiphany came in the form of a perfect tomato. "One morning I went to harvest and, feeling hungry, I ate a tomato. I could not believe the complexity, the depth of flavor. It was like I had never tasted a tomato before." Jonathan is drawn to farming because "I am fully in the present, in the moment, when I work with soil. In modern society, everything is rushed. We used to be in sync with the natural rhythms of seasons, but we've removed ourselves from our agrarian lifestyle, and now we don't know how to eat. We don't even know when vegetables are in season."

Coming back to the States, he felt more directed. He knew he wanted to experience all of what life had to offer. He found employment at Slide Ranch, an educational farm north of San Francisco that teaches kids about the

- *Garland chrysanthemum* (Chrysanthemum coronarium)*: Also called chop suey green, garland chrysanthemum is an annual leafy herb that grows well from seeds in mild or cold conditions. When temperatures rise, it flowers and goes to seed. Young leaves and stems are used in soups and stir-fry dishes. It has a slightly mustardy flavor and a crisp texture.*

- *Prickly chayote* (Sechium edule)*: A native of Mexico, hup jeung gwa has sweeter and firmer flesh than the smooth-skinned chayote. It likes warm weather and is easy to grow on a vine from the fruit. (Plant the fruit with the seed inside.) Chinese cooks use it raw or cooked, in the same dishes for which they would use a cucumber or squash.*

- *Sweet potato leaves* (Ipomoea batatas)*: Known as* fun shee yip *in Cantonese, the leaves from sweet potato plants are tender, with not a hint of bitterness. They grow best in sandy soil and full sun, but will adapt to less than optimum conditions. It takes four months of warm temperatures to grow full-sized tubers, but you can grow just the greens instead and cut them in a few weeks. They are easiest to grow from cuttings. Cook sweet potato leaves the way you would other greens; the nutritional content is similar to spinach.*

- *Water spinach* (Ipomoea aquatica)*: Known as* kangkong *in Tagalog, this leafy vegetable is characterized by long, narrow leaves and hollow stems. A perennial, it grows well in warm, wet conditions and is easy to grow in containers. Start it from cuttings that you can find at Asian markets. It is commonly used in stir-fry dishes.*

- *Winter melon* (Benincasa hispida)*: Dong gua is a long-season, warm-weather vine that grows on the ground like a pumpkin and produces a large melon with white flesh. The fruit can grow very large or can be harvested young. It is easily grown from seeds. Not sweet, it is used in stir-fry dishes, stews, and curries.*

BELOW, LEFT TO RIGHT Garland chrysanthemum, water spinach, winter melon, sweet potato leaves, and prickly chayote

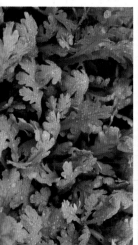

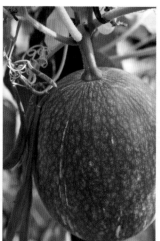

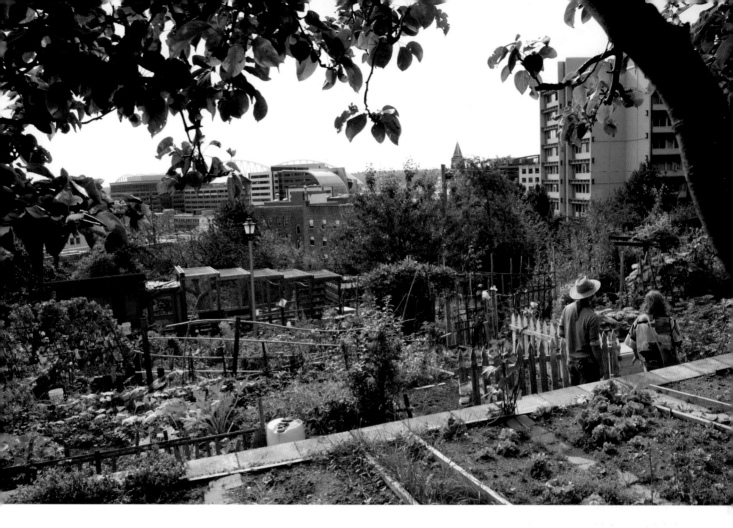

environment and where food comes from. He says it felt good to help kids learn that milk actually came from an animal "with four legs and a brain."

Then he took up swing dancing and, after attending a dance event in Seattle and falling in love with the dance community there, decided to move. His original plan was to stay for about six months, but he quickly found a job as garden manager at the Danny Woo Community Garden in the International District, a predominantly Asian American neighborhood on the southern edge of downtown. The garden was started in 1975 with the vision of

providing a community space for elderly Asian immigrants who lived in the area. Today the steeply terraced 1.5-acre garden has 100 plots where gardeners can grow the food of their homelands. Jonathan says the typical gardener is a 75-year-old grandmother who comes to the garden often. He says the garden helps many of the elderly find meaning in their lives.

Jonathan didn't plan to stay long at the garden, but he was hit with a second brush of fate. About six months after starting his job, he had a near-fatal bike accident that left him unconscious for two weeks. "I'm still trying to figure it out," he says. He credits his quick recovery to healthy eating and his own stubborn survival instinct.

He returned to his job after eight months of healing and has forged ahead with projects there. In the two

years that Jonathan has worked at Danny Woo, he's most proud of starting the children's garden and introducing chickens. The children's garden is his way to bring in the next generation. "The demographics are changing, and to keep the legacy going, the kids need to learn how to grow the food of their culture." The chickens have been popular with everyone; they provide eggs and entertainment. Some people stop by the garden just to see them.

The job is demanding and sometimes frustrating because the elderly gardeners resist change. "They see me as a little boy trying to tell them what to do." At times there are cultural tensions between different ethnic groups. "A lot of my job is being a peacemaker," he says. But the job has also taught him new respect for the elderly, including his own 96-year-old grandmother in San Francisco: "I now know how much they hold." He's the only grandson who has helped her garden, even though he has never been able to live up to her standards. Many visitors ask him if he teaches the gardeners. "It's the opposite; they teach me," he says.

With the children's garden he hopes to come full circle, helping to teach the newest generation to connect with their roots. Next year Jonathan plans to return to his family in the Bay Area, where he will once again help his grandmother in her garden.

OPPOSITE, ABOVE AND LEFT A gardener plants turnips. Freshly harvested tomatoes and greens

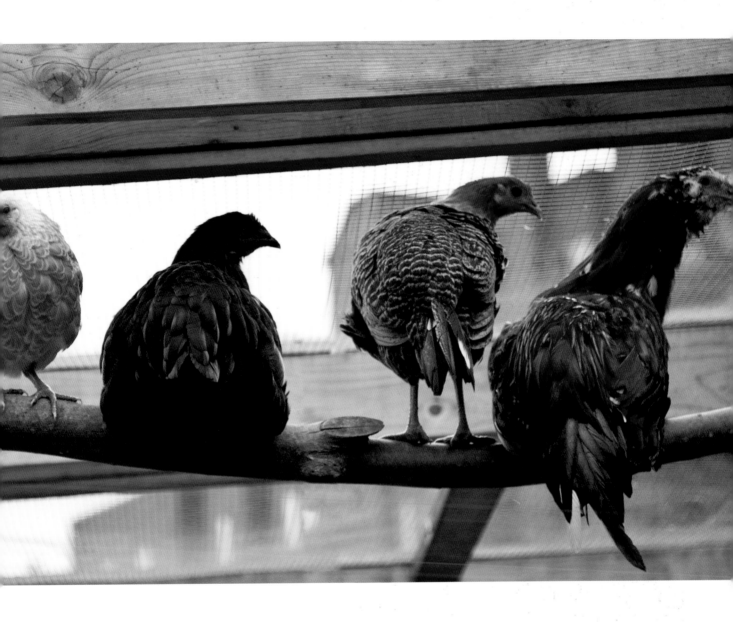

ABOVE Jonathan was responsible for introducing chickens to the community garden.

World Wide Opportunities on Organic Farms: www.wwoof.org
Slide Ranch: www.slideranch.org
The Earth Knows My Name, by Patricia Klindienst

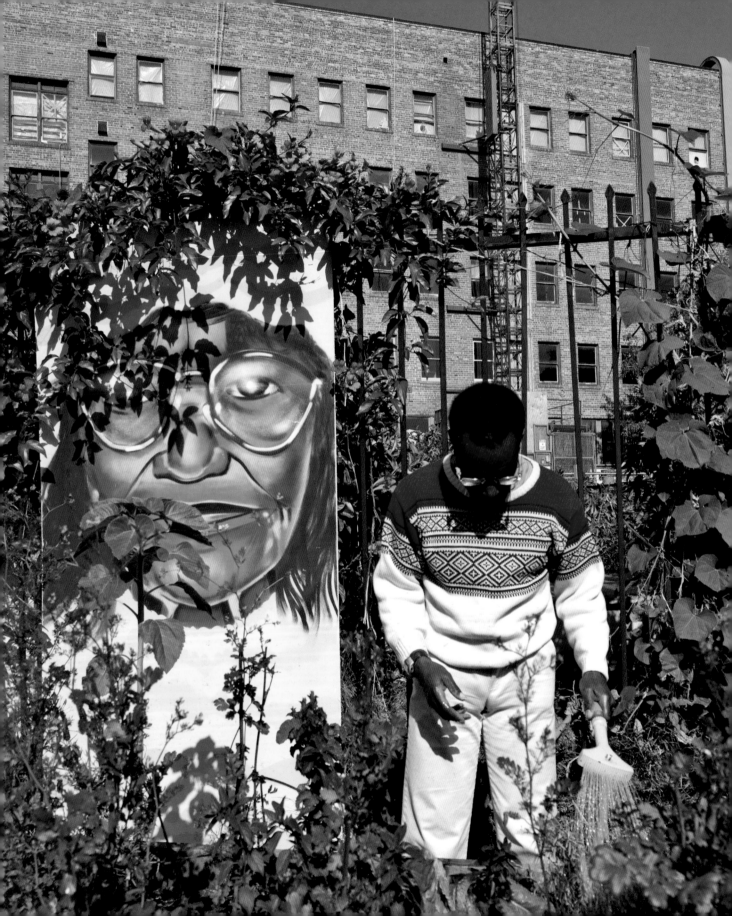

building a neighborhood by raising food

people's grocery garden at the california hotel
oakland, california

WHEN IT OPENED IN 1930, the California Hotel was the premier motoring hotel in West Oakland. Located in the heart of the entertainment district and along major transit lines, it offered all the modern conveniences new to its era, including an elevator, beauty parlor, restaurant, parking garage, and more. But the hotel's glittery past had an ugly footnote: the hotel was segregated.

As the demographics of Oakland changed, city residents demanded that the hotel change. Finally, in 1953, the new operators ended discrimination at the hotel and had a grand reopening to welcome all guests. The date marked a new era. Club Zanzibar opened at the hotel, hosting rhythm-and-blues and gospel greats such as Little Richard, Sam Cooke, and Mahalia Jackson, and becoming one of the premier African American

Nol Goodrum, a fifteen-year resident of the California Hotel, waters the garden boxes that line the street behind the building. The mural features Mother Wright, a local activist, and was painted by the Community Rejuvenation Project.

entertainment spots in the 1950s and '60s. The area developed a vibrant art scene and was known as the Harlem of the West.

In more recent years, the neighborhood hit hard times. Urban renewal projects built freeways that fragmented the area and destroyed businesses. Much of the middle class left for the suburbs, taking the good economy with them; 60 percent of residents now live below the poverty line. The California Hotel stood vacant for sixteen years, and came close to being torn down in the 1970s. Later it became low-income housing, and in 2007 the management tried to evict the residents. But after a lawsuit, the tenants won their stay, and the hotel finally found investors who are in the process of renovating it.

When People's Grocery came to the hotel in 2009, the garden behind the building was largely abandoned. Just Cause, a tenant-advocacy group with offices at the hotel, asked People's Grocery to work with the hotel's tenants to create an urban farm. A nine-year-old organization whose mission is to "improve the health and economy of West Oakland through the local food system," People's Grocery has focused on bringing healthy food to the area,

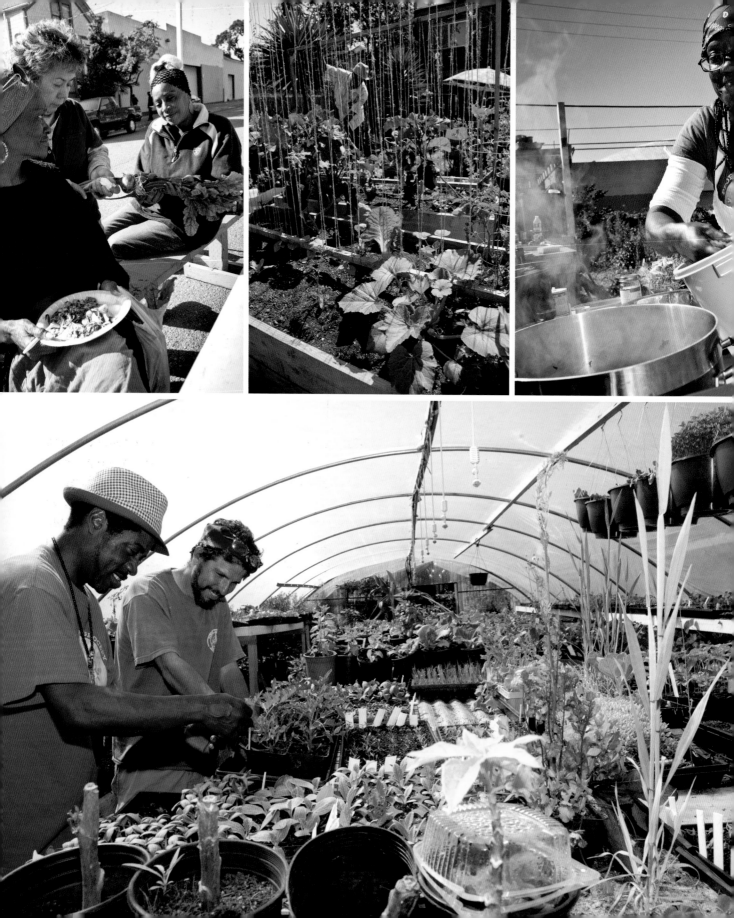

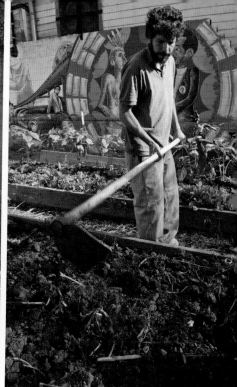

which has been called one of the worst food deserts in the country. Liquor stores and fast food are easy to find, but for years there was not a single grocery store for eight square miles. Lately two stores have begun selling produce.

Max Cadji, who began working with People's Grocery at that time, had spent three years on a farm in Madagascar, where he learned to grow subtropical perennials. Working with the tenants, he helped transform the lot into a vegetable garden with a large greenhouse and chickens. The group recruited local artists to help design murals and got the tenants involved in painting them.

It was Max's idea to sell vegetable starts at the local farmers markets. Sliding-scale pricing makes the plants affordable for everyone, and the sales generate income and encourage locals to grow vegetables. Most of the plants sold are tried-and-true varieties that are perfectly adapted to the local climate, but Max also sells unusual permaculture vegetables. He likes introducing backyard farmers to perennials such as tree collards, oca, and one of his new favorites, a perennial pepper from South America.

Every Thursday during the growing season, People's Grocery hosts "Flavas of the Garden," a free meal open to tenants and neighbors that features freshly harvested vegetables and greens. The group also hosts cooking classes and workshops to help build community. On Fridays they give away eggs.

Max's coworker, Larry Davis, became friends with Max when seeking advice about growing vegetables in

OPPOSITE, CLOCKWISE FROM TOP LEFT Neighbors and California Hotel residents stop by for a free "Flavas of the Garden" dinner offered every Thursday during the summer growing season. Larry Davis works in his West Oakland backyard. Jacqueline Thomas prepares garden-inspired dishes for the dinner. Larry Davis and Max Cadji work in their California Hotel greenhouse. ABOVE, LEFT TO RIGHT Vegetable starts to be sold at the Berkeley Farmers Market line a mural-covered wall at the California Hotel garden; the mural was painted by Trust Your Struggle collective with help from hotel residents. Max prepares a bed for planting.

his nearby backyard garden. Eventually Larry became so knowledgeable that Max hired him. Larry now does everything Max does, including selling at the farmers markets, fielding gardening questions, and cooking for the weekly dinners. He will be taking over Max's position next year.

Larry never thought about gardening until he started getting older and thinking about his health. He wanted to lower his blood pressure by eating better. He started his own garden two years ago and now has a backyard overflowing with edibles. He likes sharing the abundance by putting on free dinners for the needy in his neighborhood.

He calls his creative garden "Afrocentric." It's a jumble of plants growing in beds and containers. The fences

ABOVE Larry Davis sells vegetable starts twice a week at the Berkeley Farmers Market.

are decorated with vinyl posters of black musicians, and he's added pottery inspired by black culture. He composts, has a worm bin, and grows all kinds of vegetables and fruits from potatoes to tomatoes, peppers, strawberries, and more. His favorite foods are greens, and he likes to cook healthy versions of his mother's recipes.

People's Grocery is continuing its work in West Oakland, which it hopes will culminate in a new grocery store. Its most recent project at the hotel was to expand the area behind the garden with planter boxes and murals. The project added fruit trees and large portraits of black heroes such as Mother Wright, a local grand-mother who was a tireless advocate for the poor and hungry of West Oakland. Max and Larry have also been eyeing a vacant weed-filled lot across the street, which they envision transforming into a large vegetable garden. When it comes to bringing local produce to the masses, Max likes to quote Malcolm X: "By any means necessary."

Bringing Healthy Foods to Your Community

- *Have consistent weekly programs that attract diverse groups: People's Grocery hosts a weekly "Flava of the Garden" meal during the growing season for California Hotel tenants and neighbors. No one is turned away. It also sells vegetable starts at the farmers market two days a week.*

- *Schedule special events: People's Grocery employs a number of people to host food-related events and workshops; for instance, Billy Page of Divine Raw Foods has introduced raw vegan food, and Shalina Allen moderates and organizes Get Cooking!, a cooking club focused on healthy, affordable alternatives to fast food.*

- *Involve volunteers: People's Grocery calls its volunteer program "allyships." The staff works with new volunteers to make sure they are aware that they come from a position of privilege. The goal is to work from a position of solidarity with the community. Volunteers are required to go through anti-oppression training so they aren't stuck in the "colonial mind-set of a charity-based paradigm."*

- *Sponsor a CSA: People's Grocery offers a low-cost "grub box" program, through which people can order a box of organic produce that can be picked up weekly. They have also partnered with Highland Hospital to provide free weekly grub boxes and nutrition classes to fifteen families with children who either have a high body mass index or are at risk for childhood obesity.*

- *Offer classes: From time to time, People's Grocery also offers an "Edible Education" course on the growing movement to reform the American food system. The class covers the politics of food, nutrition, sustainable farming, and more.*

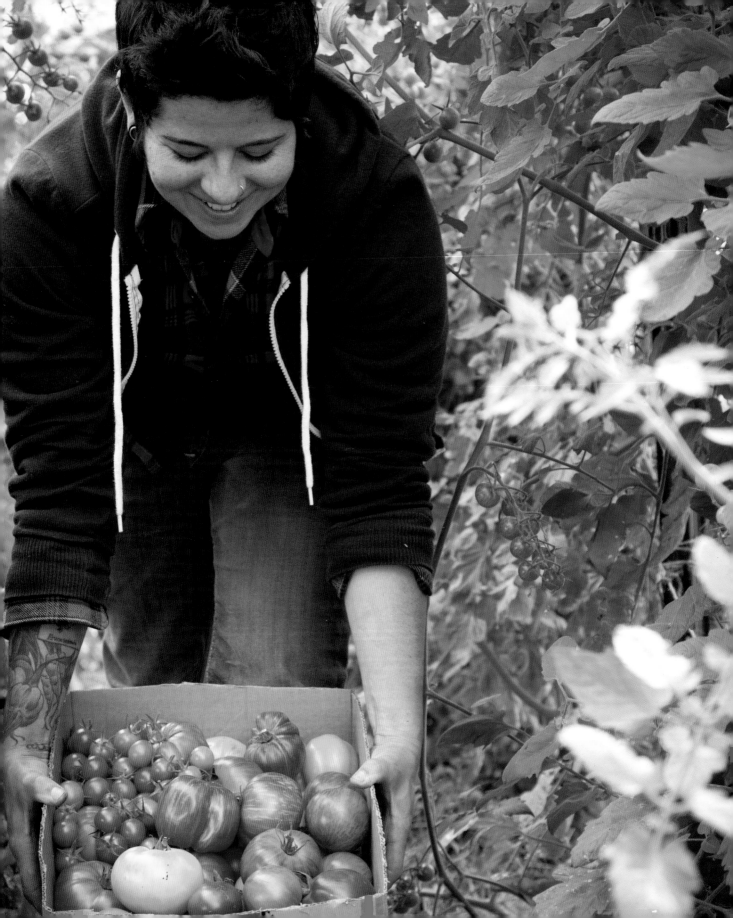

toward a community-supported restaurant

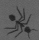

stacey givens
portland, oregon

STACEY GIVENS GOT INTO GROWING via the kitchen. Her background in Portland's restaurant scene had her cooking all over town, where she was influenced by the high quality of produce and the creative ways the chefs were using local food. At the city's short-lived Rocket Restaurant (whose space is now occupied by Noble Rot), she was introduced to the rooftop garden, where she saw varieties of food she never knew existed: lemon cucumber, all kinds of peppers, frisée, and lemon verbena. She got involved in the growing side and began planting at home. When Rocket closed in 2008, she decided to expand her growing into a bigger space.

In 2009 she found a 5,000-square-foot lot in the Cully neighborhood of Northeast Portland, and her business was born. The lot is big enough to provide local vegetables for eight restaurants, but small enough that it doesn't require a permit. "I like being a small operator," she says. With her connections to chefs around town, Stacey knows the kind of produce they like and calls her

Stacey Givens collects heirloom and cherry tomatoes from her Side Yard farm in Portland.

farm a "chef-to-chef" produce service. Her latest claims to fame are her micro crops: very tiny versions of vegetables such as radishes, carrots, amaranth, and ruby streak mustard greens. Chefs love them. She is also known for her heirloom tomatoes; specialty herbs such as shiso, salad burnet, lovage, and lemon verbena; edible flowers; and sorrel. She says most of her customers are "totally happy with what I give them," but she also takes requests.

Stacey depends on volunteers and bartering to help with the farm work, but she hasn't had any trouble involving people. She says neighbors even stop by to help, and they always get a free meal or some incredible produce.

She credits her parents with being her biggest influence. Her dad was the "hardest worker I've ever known," and her mom, "a fresh off-the-boat Greek immigrant," grew most of the family's fruit and vegetables and was an amazing cook for Stacey and her six brothers and sisters. Sometimes she'd walk home from school smelling the fresh bread her mother was baking. Stacey calls her mom a "gypsy forager." She introduced her daughter to finding wild food, often harvesting nuts and fruit from forgotten trees.

Thinking creatively, Stacey tries out new ideas all the time. She works with wineries and does food pairings, offers workshops, does catering, and still works at restaurants. She uses Facebook and a newsletter to connect with the community.

One of her most popular ventures is her weekly brunch at the Side Yard farm, where she has a small kitchen. She offers three menu choices, and everyone eats family style and pays on a sliding scale. During the summer almost all of the food comes from the farm, from the eggs and goat's milk to the vegetables and greens. In the winter she uses what she can from her garden, and she seats people in her greenhouse. She describes her cuisine as Americana, always seasonal and fresh. She also loves curing meats and making cheeses. One customer was overheard to say, "This is more than good, it's knockout incredible!"

Stacey has never lost sight of her ultimate goal: opening what she calls a community-supported restaurant (CSR), in which members own shares in the restaurant that can be exchanged for meals. In Hardwick, Vermont, for instance, Claire's Restaurant raised more than $100,000 through the community to open. Part of the funding came from selling coupons redeemable for $25 worth of meals on monthly visits throughout the year. In Portland, Maine, the Local Sprouts cafe has operated since 2008, selling seasonal memberships that include soups, entrées, salads, side dishes, and desserts that members can pick up once a week.

Stacey sees CSRs as the next step in local food, bringing neighbors together to eat without the hassle of cooking or paying for an expensive meal made by a celebrity chef. She feels that meals should be about people eating together and sharing, and envisions a family-style setting that would be comfortable, affordable, and adaptable to the needs of the community. People could purchase shares based on individual or family needs, and this would give her dependable funding with which to start the restaurant. Local food cooked for the local community: what a delicious idea.

Growing Micro Produce

Stacey advises never throwing away your thinnings. Plant your root crops as usual. When the vegetables are 2 to 3 inches tall, thin them, wash them thoroughly, and then use them in salads and as garnishes. She experiments with different root crops: radishes, turnips, and carrots. Radishes and turnips add a peppery, crunchy taste, while carrots are amazingly tender.

Micro greens are also easy to grow. Scatter seeds over loose, rich soil that gets a minimum of four hours of sunlight a day, approximately $1/8$ to $1/4$ inch apart. Water gently and don't let the soil dry out. Harvest the greens after they develop their first set of leaves, usually around 10 days to two weeks after planting. Cut the leaves just above soil level.

RESOURCES

The Side Yard (Stacey's website):
www.thesideyardpdx.com

OPPOSITE, CLOCKWISE FROM TOP LEFT Stacey serves potatoes during a recent winter brunch. The menu is written on a chalkboard. Plates are prepared, then served to guests in the greenhouse that doubles as a dining room at a December brunch.

FARM BENEDICT

HOUSE-MADE CRUMPET w/ JADANESE BRAISED PORK BELLY + DUNGENESS...
PURPLE TOP TURNIPS!

Summer HASH

SUMMER SQUASH + CORN. FAIRYTALE EGGPLANT. HEIRLOOM TOMATOES

PESTO, FRIED EGG.

BRIOCHE FRENH TOAST

ROASTED SUMMER LADY PEACHES. ANISE HYSSOP. FROMAGE BLANC.

MOST PRODUCE, EGGS & HONEY COME FROM
SIDE YARD FARM! $15-20

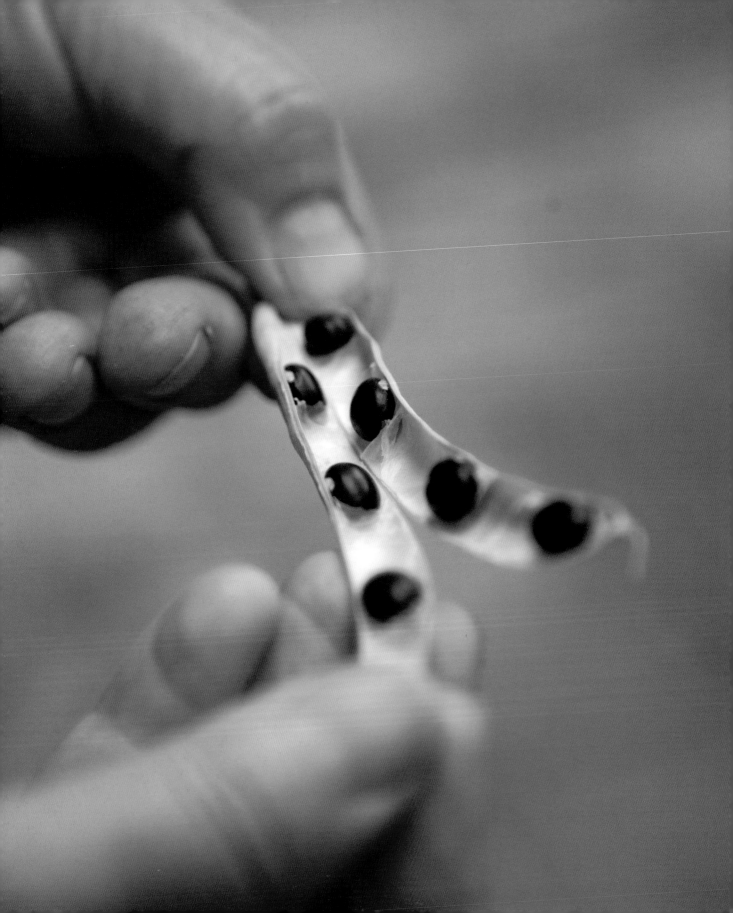

the dirt on seeds

birgitt evans
alameda, california

AS A MASTER GARDENER, Birgitt Evans has recorded over 3,500 hours of volunteer time helping fellow gardeners in Alameda County. Beginners have all kinds of questions and all kinds of problems. From yellowing leaves to ant infestations, Birgitt has heard it all. At the group's local outreach events, she's noticed that more and more people are interested in growing vegetables. She spends most of her volunteer time on education, helping answer questions with free brochures, including one on growing vegetables from seeds.

It surprises Birgitt how many gardeners, including fellow master gardeners, don't grow from seeds. "Seeds are life. Saving seeds and growing seeds are the basis of gardening." She grows most of her plants from seeds in her 1,000-square-foot backyard garden in Alameda. It's a jumble of edibles, from fruit trees to vegetables. "I think a lot of people are afraid to fail," she says. "I tell them it happens to everyone. Just try again."

Birgitt Evans collects seeds for planting as well as eating, such as these black turtle soup beans from her Alameda backyard.

In late winter she plans her garden by first deciding what she'd like to eat, and then adds varieties. For Birgitt, peppers are always fun. She plants many varieties, from sweet bells to hot chilies. She prefers heirlooms, both for their flavor and because she can save the seeds of the successful varieties and eventually have plants perfectly adapted to her climate. She does plant some hybrids, though, to prevent certain diseases such as verticillium wilt, a nasty fungus common in tomatoes and eggplants that can kill plants and then survive for long periods in the soil, infecting generations to come. Hybrids are plants that have genetically different parents, and that have been grown for selected traits. You can't save hybrid seeds, she cautions, because you never know what you'll end up with.

"Every garden has limitations," Birgitt likes to remind beginners. Her own yard is a little smaller and shadier than she would like, so she plants lots of greens, peas, and beans. Most vegetables and fruit trees need at least six to eight hours of sun a day, so she plants them in the sunniest spots.

Birgitt has never had big pest problems in her organic garden. "I've developed this philosophy that everything

has a place in the ecosystem." She tolerates some bugs because she knows the predators need something to eat. She remembers seeing aphids in her apple tree several years ago. Before long, she noticed that ladybugs and ladybug larvae had moved in and pretty much taken care of the problem. One exception is the nonnative snails that have no predators. Birgitt goes out with a flashlight at night and collects them in a bucket. The bucket goes to a neighbor's chickens.

Building the soil is another one of Birgitt's vital interests. "Everything starts with the soil," she says. Decomposition is the other half of life. "Most people take their yard trimmings, put them in a large green bin, and roll it out to the curb; and then, when they need to amend, they drive to the nursery and buy it back."

According to Birgitt, composting could not be easier. Start with two 3x3x3-foot piles composed of approximately half green (nitrogen-based) and half brown (carbon-based) yard trimmings. Keep the piles as moist as wrung-out sponges, cover with burlap to hold the moisture in, and turn occasionally to get oxygen into the material. She uses a compost thermometer to check the process; the optimum temperature is between 120 and 160 degrees F. She says there's no set time for compost. It could be done in three weeks if the mix is good and you turn it often, but if you dump your yard trimmings in a pile and forget about it, it could take a year. Either way, you'll get compost. As Birgitt writes in her blog, "Here's the thing: decay happens."

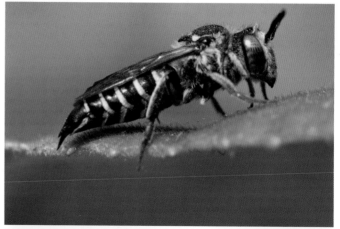

TOP Birgitt's yard attracts insects such as this native bee. ABOVE Birgitt's midsummer garden is a jumble of edibles. OPPOSITE, CLOCKWISE FROM LEFT Birgitt turns the steaming compost to add oxygen that will hasten decomposition. A late summer harvest of pumpkin, basil, peppers, zucchini, and Roma tomatoes. A pumpkin volunteer.

Birgitt starts her spring garden seeds in her basement in early February. She starts vegetables such as tomatoes, peppers, and eggplant inside, where it's warmer.

- For containers, use clean cell packs, make paper pots, or reuse egg cartons or yogurt cups. Sterilize your containers.
- Use damp, sterile soil. To make her own seed-starting mix, Birgitt mixes two parts peat moss and one part perlite or vermiculite.
- Fill your container with seed-starting mix, then plant the seeds according to the instructions on the packet and place them on trays.
- Water from the bottom, and be sure to keep the seeds moist so they will germinate.
- Keep your container in a warm, draft-free spot between 70 and 80 degrees F. Birgitt uses a waterproof seed-starting heat mat. Generally, the seeds don't need light to germinate, but as the seedling starts to sprout, it will need light.
- If you have a window that faces south and gets 6 to 8 hours of sunlight, place your cell packs there. Birgitt uses 4-foot shop lights on chains in the basement. She keeps the lights 1 inch above the cell packs and leaves them on for 14 to 18 hours a day.
- Keep the shop lights 1 inch above the seedlings, raising the lights as they grow. The seedlings should be stocky and healthy before transplanting. Acclimate the seedlings to the outdoors before transplanting, starting with two hours of sunlight and gradually increasing. In Birgitt's Alameda microclimate, tomatoes can be planted outside as early as late March, peppers and eggplants as early as mid-April.

ABOVE AND LEFT Birgitt starts her vegetable garden in February under shop lights in her basement. OPPOSITE Birgitt harvests in her backyard.

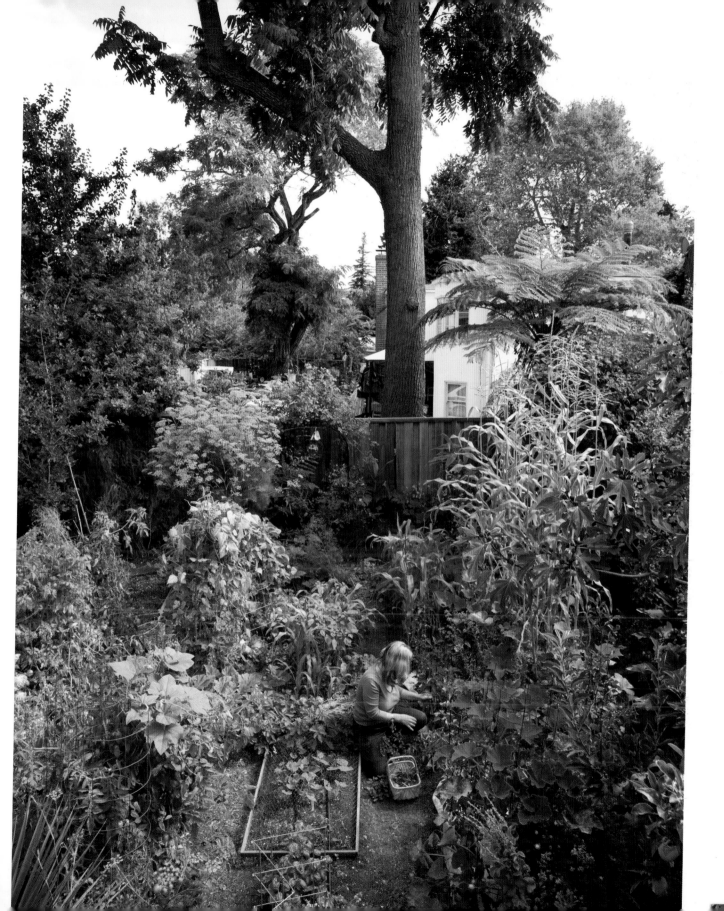

a family adventure in urban farming

melissa and tom clauson
seattle, washington

MELISSA AND TOM CLAUSON didn't plan to have an urban farm. They only wanted a vegetable garden. They bought their fixer home in 2007, and it came with a fixer yard. The 15,000-square-foot corner lot was covered with ornamental plants from the 1950s, and the backyard was full of blackberry brambles that took three truckloads to haul away. After all their work, they decided to only grow edibles—as Melissa emphasizes, "plants that give back." They planted fruit trees, blueberries, strawberries, and herbs, envisioning their three kids grazing on healthy snacks from the landscape.

The chickens came next. Until the 1940s it was common for American families to have chickens, Melissa learned. With their big lot, there was plenty of room to add a pen in the side yard. With the pen in place, they ordered four chicks, which arrived by mail in a small peeping box. Their little children were charmed. Melissa stresses the importance of adult supervision with the tiny chicks. She kept them in a plastic storage box with a heat lamp until they were old enough to go outside. Her small children would follow her around and help feed them and change the water.

The bees came after the chickens. Melissa had been reading about the plight of bees and was considering getting a hive when she gave *Jerry the Bee Guy* a call to find out more about his services. Among his offerings was a local swarm removal service that matched up swarms with people looking to start hives. Within 24 hours, Jerry had a swarm for her. "We aren't ready. We don't even have a hive," she told him. He reassured her that it would all work out, and the next thing they knew, they had bees.

Today they have two hives, one in the front yard and one in the back. "We're bee geeks now," says Melissa. The kids have learned all about bees. They decorate the hives and wear bee suits to watch their parents collect the honey. They sometimes get stung, but when that happens, Melissa and Tom tell them they have "bee power." They all know where to find the meat tenderizer to put on the sting.

Four-year-old Max Clauson with one of his family's Indian Runner ducks

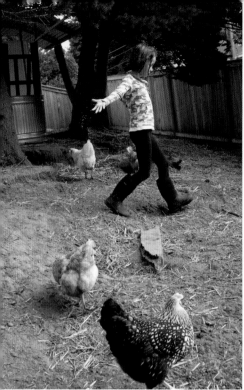
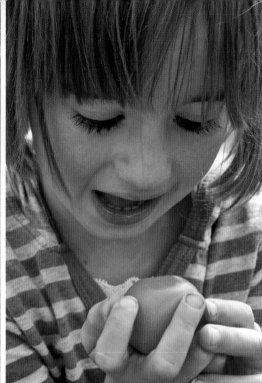
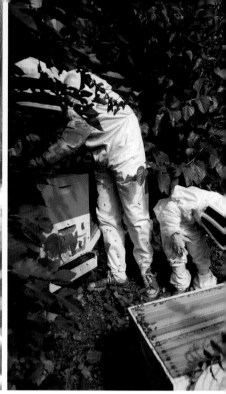

The goats are the latest addition to the farm. "It took a little work to get the goats," Melissa says, meaning that Tom had to be convinced. They had taken a class about goat keeping and another on cheese making, and Melissa had an aha moment when she realized she could make goat cheese at home in the kitchen. "We then went to see some local goat kids when Tom realized where it was all heading." They now have two goats that have turned their yard into a neighborhood destination. She estimates that 150 visitors came to see the goats in the first two months after they arrived.

Rain or shine, the goats have to be milked. Tom and Melissa share the duties, and they're training daughter Dylan Ann to pitch in too. They sometimes reward each other by taking over for one another as a special treat. They use the milk for yogurt, chèvre, cheesecake, and more. They recently got a creamer from Ukraine, which they hope to use to make butter. Hard cheese is another thing they want to try making.

Melissa loves having her urban farm as much for herself as for her kids. She was never allowed to have pets as a child. Her mother teases her, saying, "This is what happens when you don't let your kids have pets." The couple enjoys teaching their children the value of nature and life, and seeing them take on more chores as they get older. Max and Gracie share the egg-collecting job and sell half a dozen eggs a week, putting the proceeds into a rainy-day fund for something fun in the future. Dylan Ann once took a chicken to school for show-and-tell, where she taught the class how to catch the bird. The urban farm is the family's entertainment and adventure, and the kids have no idea that their lifestyle is unusual.

Having the right attitude is important, because things don't always go right. They've had both disasters and successes with plants. "Artichokes are hard, and we've never had much luck with corn," Melissa says.

ABOVE, LEFT TO RIGHT Dylan Ann Clauson, eight, runs through the chicken and goat pen in her family's Seattle backyard. Gracie Clauson, six, prepares to eat a freshly picked tomato. Tom and Max check one of the two beehives they keep in the yard. OPPOSITE Tom teaches Max how to milk a goat.

Involving Your Kids in Your Urban Farm

These tips are from Ann Naffziger and Paul Canavese, a Bay Area urban-farming family.

- *When deciding what to grow, start with what your family likes to eat. Plant a variety, so you'll have a better chance of success, and plant things that are expensive to buy in stores, so you'll save money.*

- *Even if your kids say they hate a certain vegetable, don't assume you shouldn't grow it. Kids will be more interested in trying foods if they've participated in growing them. Encourage them by telling them how much better the homegrown version will taste.*

- *Don't force kids to do chores at an early age. Ann and Paul have found that their kids are naturally interested in what they are doing and usually imitate what they do. The kids won't think of it as work if they aren't pushed into it.*

- *Have the patience to allow them to try things. Ann says it's tempting to do everything herself because it's so much faster, but kids like to try things. Let them.*

- *Share the knowledge. Having an urban farm is a great way for kids to learn about science, botany, nutrition, conservation, and more. You'll be surprised by what they pick up. Ann has heard her four-year-old daughter, Madeleine, explain to a friend that every white flower on the strawberry plant will turn into fruit.*

- *Eat according to the season: it helps kids learn what plants grow during which parts of the year. Madeleine already knows that tomatoes and melons don't grow in Northern California in January. On the other hand, she knows from looking in her backyard that tangerines are in season.*

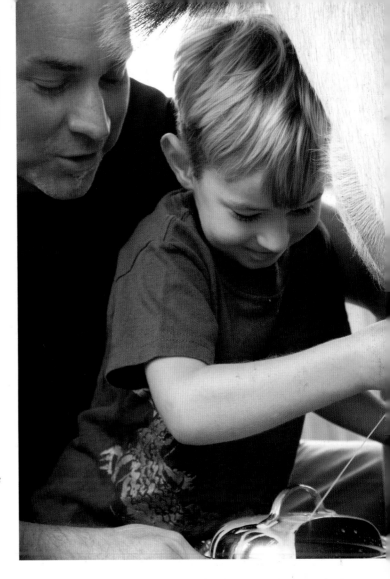

Tomatoes have always done well for them, though. They love having chickens, but ducks didn't work out; they were unfriendly and messy, always getting the drinking water dirty.

But Melissa doesn't see problems; it's a way of living, she says. Milking the goat is a moment to be enjoyed, to feel grateful for the fresh milk. The neighbors have all been supportive, and the Clausons like to share their bounty, which includes jam, eggs, and honey. To know where your food comes from and to enjoy its high quality makes the work worthwhile, Tom and Melissa believe. "Gracie loves soft-boiled eggs, and watching her eat that bright yolk makes me think it's all good," says Melissa.

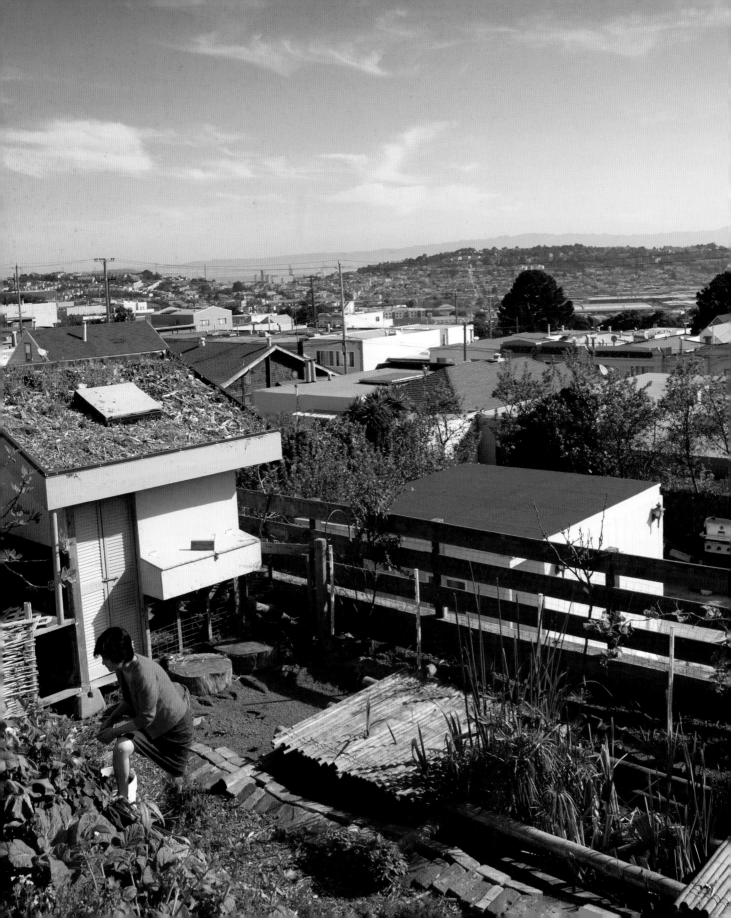

bringing fruit trees back to the city

tara hui
san francisco, california

PERCHED ON A HILL in San Francisco's Visitacion Valley, Tara Hui's house has beautiful views that stretch from the South Bay to across the Bay Bridge to Oakland. But when you take a closer look, the resourceful garden commands as much attention. Not an inch is wasted in her 900-square-foot backyard; a chicken coop anchors the back corner, and a narrow chicken pen runs the length of one side of the yard, next to a pond. Along the perimeter of two sides grow fruit trees, including two figs, a cherry, a nectarine, an apple, and an Asian pear. The rest of the terraced yard is used to grow vegetables. She collects rainwater in barrels on her deck, uses greywater for her fruit trees, and has solar panels on her metal roof.

She didn't learn to farm from her parents; they were world travelers, moving her from Beijing and Hong Kong to Melbourne and New York. She was influenced by her Chinese grandmother, though, with whom she lived for

Tara Hui in her Visitacion Valley backyard in San Francisco

two years in a small village in the Fujian province of China. The elder woman grew vegetables and kept chickens, rabbits, and, once, a pig. But it was more her attitude that has stayed with Tara: "She was resourceful, wise, and positive." She created abundance with whatever she was given.

Tara has worked to create that same abundance in her own yard and with a group called Guerrilla Grafters, which she helped form. The group is working to convert San Francisco's ornamental street trees into fruit-producing trees: apples, plums, cherries, and pears. Back before World War II, fruit trees were commonly grown all over the city, even in Golden Gate Park. After the war, as people became more affluent, the fruit trees disappeared. With the economy unstable, Tara thinks it's a good time to bring them back.

She helped start Guerrilla Grafters two years ago out of sheer frustration. She has lived in her low-income neighborhood in San Francisco for eleven years, and during the entire time it has been difficult to get access to fresh food. There were no grocery stores; if you wanted fresh produce, you had to drive out of the area. Tara

The best time to graft a fruit tree is in the early spring, when buds are present but before the tree has leafed out. The cool, moist air of spring will help a graft succeed.

The stem to be grafted is called the scion. It should be ¼ to ½ inch in diameter, have dormant buds, and be no longer than 4 to 5 inches. The tree to which the scion will be grafted is called the stock, or rootstock. It should be the same diameter as the scion.

For successful grafts to take place, the rootstock and the scion must be from the same genus. The genus is the first Latin name of the tree. Tara's group matches fruiting pears to ornamental pears, and fruiting cherries to ornamental cherries, but nectarines, pluots, and plumcots can all be grafted to ornamental plums.

The cambium is the layer of cells between the bark and the wood that will carry water and nutrients up the growing scion. Tara uses a method of grafting called wedge grafting, which makes good cambial contact and heals quickly. She keeps a number of scions on hand in the refrigerator.

To create a wedge graft, make a clean, straight cut on the stock and split it down the center, or make a V shape if possible. Shave the scion into a V shape and fit the pieces together, matching the cambial layers exactly.

Keep the cambial layers moist for a few weeks, until the graft heals. Tara recommends wrapping the splices with electrical tape; it's cheap and comes in colors, so you can color-code your grafts. It's a good idea to treat the scion with grafting wax to keep it moist; otherwise, try to keep the graft in the shade. Be sure to label the graft so you can remember what it is.

BELOW, LEFT TO RIGHT First, Tara finds a stem the same diameter as the scion. She then cuts the end of the scion into a V shape. Next she makes a clean straight cut down the center of the stock stem. If possible, she shaves the cut into a wedge shape. Then she carefully fits the two stems together, matching the cambrial layers exactly.

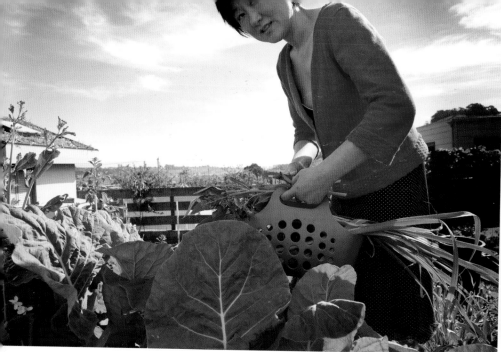

observed the two things the neighborhood does have are sunshine and space. Why not grow fruit trees and make the harvest available to everyone?

When Tara sought to get some fruit trees planted, though, she met with resistance on all fronts. Friends of the Urban Forest, a local group that has helped home-owners put in sidewalk trees all over San Francisco, expressed concern that fallen fruit might attract rodents or stain the sidewalk. This didn't make sense to Tara because some of the ornamental trees the group advo-cates, such as strawberry trees, have inedible fruit that can stain the sidewalk. She went to neighborhood meet-ings and contacted other city agencies, trying to find someone willing to advocate for fruit trees. Everyone was concerned about the mess of unharvested fruit. But even when property owners offered to take responsibility for the fallen fruit, all of the agencies remained opposed to planting fruit trees.

Guerrilla Grafters started with a few dozen volun-teers, but has grown to an email list of over 150. They have no leaders, relying instead on the self-motivation of volunteers who discover the group via the internet or Facebook. They graft in early spring, looking for orna-mental plum, cherry, and pear street trees to match with fruiting scions from the same family or genus. The scions for grafting come from the California Rare Fruit Growers association. After finding suitable trees, the group finds caretakers and then begins grafting. With a little luck, a grafted scion will start producing fruit within a couple of years. The trees are always in public places, easily acces-sible so that anyone can enjoy the fruit.

For Tara, it's an idea whose time has come. Fruit trees are not a nuisance; rather, they bring quality of life to a city. "It's about creating abundance," she says, an idea she learned from her forward-thinking grandmother.

ABOVE, LEFT TO RIGHT Tara harvests greens from her backyard garden. She works with another "guerrilla grafter" to make an ornamental plum tree productive on a city street.

RESOURCES

Guerrilla Grafters: **www.guerrillagrafters.org**
Excellent grafting video:
www.youtube.com/watch?v=Jy1Ca8RotRI

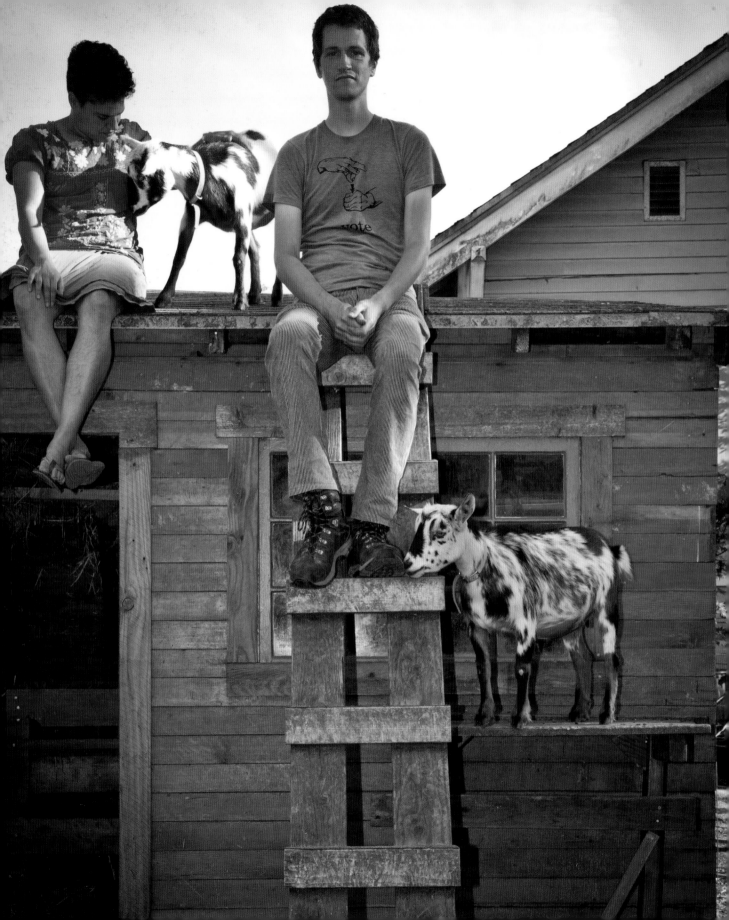

from a weed-filled lot to an urban farm

kenya spiegel and seth brown
portland, oregon

WHO WOULD GIVE UP A HOUSE they own and move into a rental simply to get a bigger lot? Kenya Spiegel and Seth Brown decided that the opportunity was worth the challenge. They had outgrown their tiny 40x80-foot Portland lot. There was no more planting space, and it was difficult to teach their urban farming workshops when the class could fit only on the sidewalk.

Kenya says growing on a small lot teaches you to be creative with the space. The goat enclosure at their old home is a good example. The barn featured a goat ladder that gave the animals extra rooftop space. The ladder took advantage of their natural climbing instinct and increased the square footage of their pen. The old barn also creatively used recycled material; the siding was made of old wood flooring that a neighbor was throwing away. Because of its interlocking pieces and finish, it

Kenya Spiegel and Seth Brown—and a couple of Nigerian Dwarf goats—sit on the roof of the goat barn they built in Portland.

worked surprisingly well to keep the weather out. Kenya estimates they spent about $30 on the entire project.

Their new property is almost double the old one. Located in Northeast Portland, it's about a third of an acre. When they got it, it was neglected and overgrown with ivy and laurel trees, but Kenya and Seth could see the potential: a food forest, an annual vegetable garden, and space for their three goats and four ducks. "Our goal is to turn the property into a regenerating system."

They're relying on several tried-and-true techniques to revitalize the property. The first job was to cut down overgrown laurel trees and get rid of the ivy and weeds. One of their favorite methods of killing weeds is sheet mulching, which layers brown (carbon-based) and green (nitrogen-based) plant matter on top of the weeds and allows natural decomposition to do the rest. There's no digging. They prefer it because it doesn't disrupt the microorganisms in the soil.

To do your own sheet mulching, make the first layer a weed barrier. Kenya gets burlap bags from local coffee roasters because the burlap decomposes quickly. You can also use brown corrugated cardboard or three layers

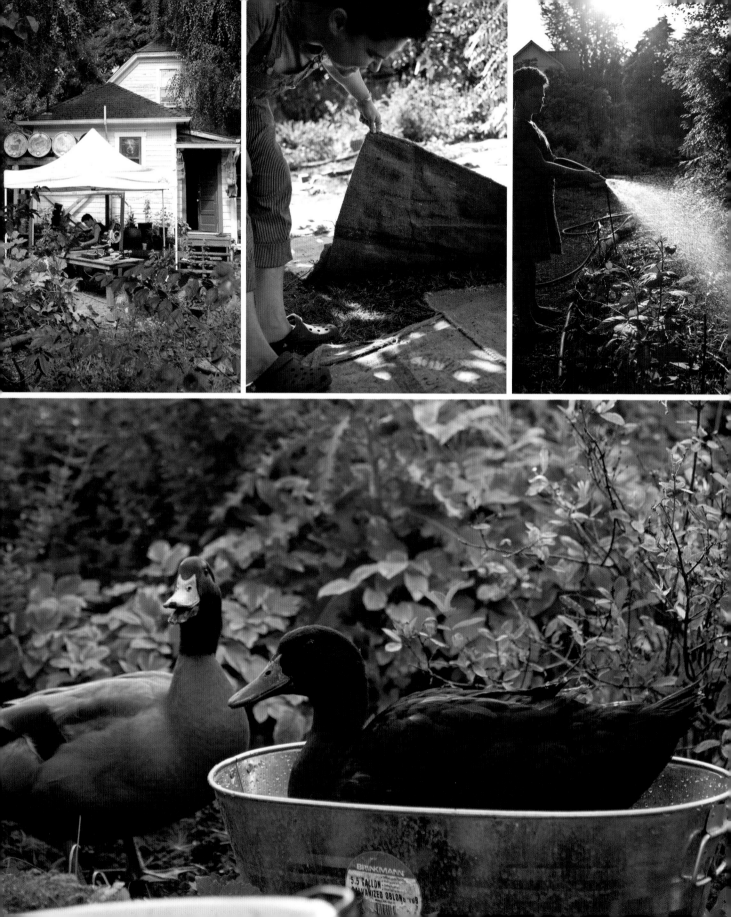

of newspaper. Wet it down to help start the process and to attract earthworms. After that, simply add alternate layers of green and brown plant matter. Green layers are nitrogen-based: grass clippings, vegetable scraps, coffee grounds, and weeds that haven't gone to seed. Brown layers are carbon-based: dead leaves, pine needles, shredded newspapers, and peat. The brown layer should be twice as thick as the green. Ideally you should keep layering till you have a 2-foot-deep bed. Fall is the ideal time to sheet-mulch because you can take advantage of the falling leaves and seasonal rain, although any time of year will work.

The ABC method of crop rotation is another technique that Kenya and Seth like. It works in a larger area and enlists goats to help. Kenya says to follow the rotation backward. Start by growing a cover crop (C), preferably over the winter. In the spring, turn the space into a barnyard (B). Let the goats graze the cover crop and fertilize the soil. Finally, use the same area to grow your annual vegetable garden (A). Farmers have used this system throughout the ages to naturally build the soil.

Kenya says the large yard is shaping up fast. There's been no shortage of interest and help, and their neighbors are happy to see the transformation. She and Seth are committed to their project, and for now they like having their farm in the city, where they can still enjoy the benefits of urban living. But she also says the project could "snowball," so a farm in the country could be in the future.

OPPOSITE, CLOCKWISE FROM TOP LEFT Kenya cuts wood to build a fence for her new backyard. She uses burlap bags as the first layer in sheet mulching. Kenya waters in the evening. Two of the couple's four ducks. BELOW Kenya and Seth use straw bale gardening in a part of the yard where the soil is contaminated.

Straw Bale Gardening

Sometimes planting is impossible due to soil contamination. In these cases, straw or hay bales can be used as an inexpensive container in which to grow vegetables and build compost at the same time. Bales cost around $5 each. If possible, use old bales; they will compost even faster.

The first step is to arrange the bales to get the best sun exposure, then water them and wait a week or two to allow some decomposition to occur. As this happens, the temperature inside the bale increases, which can damage seedlings. Adding nitrogen-rich fertilizers can help speed the heating process. When the temperature in the bale remains constant at a depth of 3 to 4 inches, it is ready to plant. Seedlings can be planted by making pockets in the bale and adding growing medium, or by spreading a layer of growing medium on the top of the bale. It's important to use a rich growing mixture, such as compost mixed with blood meal, and then to water thoroughly.

Vegetables planted in the bale will need more water than usual, but weeds will be minimal and insect control will be much easier. At the end of the season, the bales can be integrated into the soil.

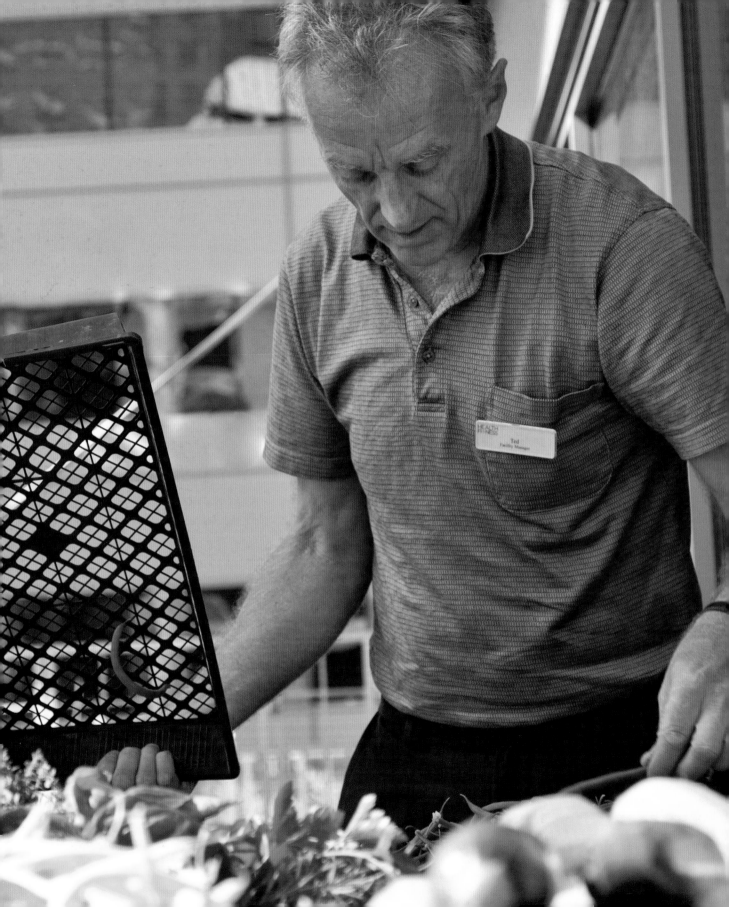

a rooftop farm for a community kitchen

ted cathcart
vancouver, british columbia

WHO WOULD EXPECT TO SEE a rooftop farm among the skyscrapers of downtown Vancouver? Ted Cathcart saw the potential in an underused ornamental roof garden when he first started his job as facilities manager at the downtown YWCA in Vancouver, British Columbia, in 2006. The nonprofit was spending $4,000 a year for maintenance of a basic lawn and bushes, and Ted wondered if it might be better to grow vegetables instead. The Y's community kitchen provided a free lunch to women and children five days a week, but it was serving a lot of canned food; they weren't getting high-quality fresh produce.

Ted gathered volunteers and began an experiment on a small part of the garden. Their first job was to amend the shallow, sandy soil, which had less than 3 percent organic matter. Not knowing what would grow in the amended soil, they tried a little of everything—tomatoes, zucchini, carrots, beets, peppers, and beans—and had

amazing success. "We had ten volunteers, and we harvested 330 pounds of produce in only 500 square feet." After the success of the first year, they moved to take over the entire 2,000-square-foot garden.

Ted says growing on the roof has had unpredictable advantages and disadvantages. "The only thing I did learn was to ignore the experts and just try things and see what works." For example, the garden is surrounded by tall buildings that block the sunlight. But the glass windows create a heat sink that makes it possible to grow high-quality, expensive fruits such as strawberries, raspberries, blackberries, kiwis, and Asian pears. The heat also helps keep the soil warm, so plants grow faster and produce more. "We start planting earlier in the season, and we're able to get several crop rotations." Another advantage of the isolated rooftop garden is that some pests, such as snails, slugs, and aphids, are easier to control. "If worse comes to worst and the pests get out of control, you can always tear out the plants and start fresh," he says.

The unexpected problems have included crows that ate all the bean seedlings and rats that got in the compost.

Ted Cathcart sorts produce at the YWCA rooftop garden in downtown Vancouver.

They had to figure out plants that the crows wouldn't eat and learn that even on a roof, it wasn't safe to compost food scraps. Ted has struggled with the shallow soil, but he has also been surprised by how well some plants have done despite the lack of depth. And he's learned that the soil needs plenty of amendments, given its shallowness and the high number of crop rotations.

The garden operates from the beginning of March to the end of November and is maintained entirely by volunteers, including Ted, who works extra hours at his job as a facilities manager to make up for the weekday time he spends gardening. Almost all the work—harvesting the food, delivering it to the community kitchen, and replanting—is done on Tuesdays and Thursdays from 11:30 AM to 1:30 PM. Because the volunteers are able to use the irrigation system from the old garden, watering is not a big problem. A lot of the work consists of careful planning, because as soon as food is harvested, new plants need to be ready to go in.

Ted has compiled a lot of statistics since starting the project. He's seen the harvest go from 330 pounds in the first year to 1,700 pounds in 2011. He likes to keep track of the garden's productivity and is interested in figuring out its true worth, but he says much of its value can't be tallied on a spreadsheet.

The high-quality organic produce that's consumed right where it's grown is just the beginning. There's also the education the volunteers receive in how to grow food, and the fact that they are able to learn right in the city. There's community building, as like-minded people organize to do something good for their neighbors. And in an unexpected development, all the attention and good feeling has helped increase donations to the YWCA. Ted says the primary benefit for him is relaxation. "As soon as I walk up to the garden, all my cares disappear." Although he plans to retire from his full-time job at the YWCA next year, he says he'll continue working with the program as a volunteer.

Donating Produce to Food Banks

Backyard growers often have more vegetables than they know what to do with. Most local food banks accept produce donations; find them by googling "food bank" on the Internet. Be sure to package your donation in a sturdy box or double paper bag to prevent bruising, and donate only hardy foods that have a three- to five-day shelf life. If possible, donate items that don't require refrigeration, since refrigerators fill up fast.

In California, the Department of Food and Agriculture restricts donations to the county in which the food was produced. It doesn't allow fruit or vegetables with insect damage, including the small holes caused by caterpillars.

Paul Ash of the San Francisco Food Bank says about 65 percent of the food distributed is fresh produce. But donating food isn't the only way to help; food banks also need volunteers to repackage and distribute the donations. Paul says the gratitude of the recipients is "palpable"; the donations make a powerful difference in their lives.

RESOURCES

YWCA Metro Vancouver: **www.ywcavan.org**

OPPOSITE, CLOCKWISE FROM TOP Ted harvests greenhouse tomatoes. He delivers freshly harvested produce to the YWCA community kitchen located just a few miles from the rooftop garden. A portion of a mid-August harvest from the garden. Volunteers harvest bush beans amid the skyscrapers.

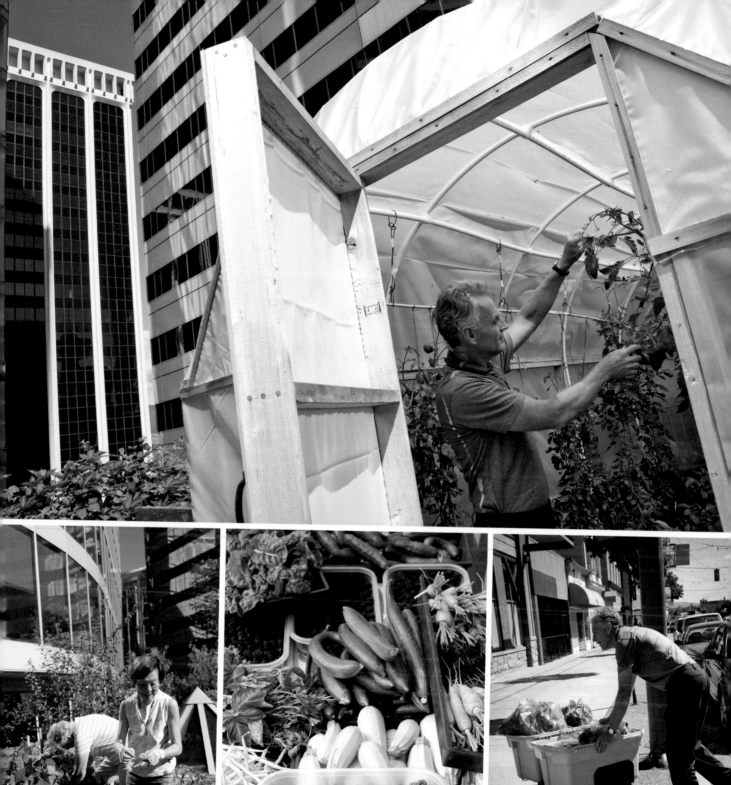
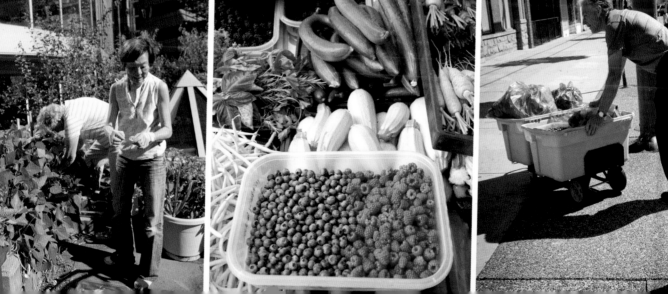

city foraging

rebecca lerner
portland, oregon

MANY CITY DWELLERS DON'T have yards, or even if they do, they may not have the time or inclination to nurture a vegetable from seed to harvest. That's not a problem for Rebecca Lerner. She sees urban foraging as a way to experience edible plants without having to grow or buy them. It's more spontaneous than planting a vegetable garden. "It's just the harvest," she says, "but it's a great way to connect to wild plants."

"Foraging has changed the way I look at the world; it's brought about a sense of discovery that is more than just practical," she says. Finding a ponderosa pine tree in the neighborhood whose needles make a soothing tea gives her a different perspective on her environment. "It reconnects me with a lost world that is much more magical than this one." When Rebecca says "magical," she's not talking about fairies and gnomes. She sees a world of wonder all around her that makes her feel like she's living inside *Willy Wonka and the Chocolate Factory*. "The world really is edible."

Rebecca Lerner forages near her home in Portland. She sees foraging as a spontaneous way to experience edible plants without having to grow or buy them.

Rebecca has thought about foraging a lot. She first became interested in wild foods when she took a survival class in Ithaca, New York. Back then she was concerned about the politics of food, the accessibility and possible scarcity of it. If everything fell apart, what could she find as a resource? Would life be possible without a grocery store?

Since then she's learned a lot about wild edibles. "Besides having herbalist Emily Porter as an influential teacher, I'm almost entirely self-taught." She now leads plant walks in Portland, and recommends Michael Moore's *Medicinal Plants of the Pacific West* for herbal medicine and Sam Thayer's *Forager's Harvest* and *Nature's Garden* books. She has read a stack of books on harvesting wild plants, and no longer worries too much about eating poisonous ones—though she cautions that it *is* important to do your homework first. Very few plants can actually kill you; the worst thing that generally happens is an upset stomach. But danger lurks. Take, for example, poison hemlock, which looks a lot like wild carrot. She also advises foraging for mushrooms only with an experienced guide.

A few years ago, Rebecca put herself to the ultimate

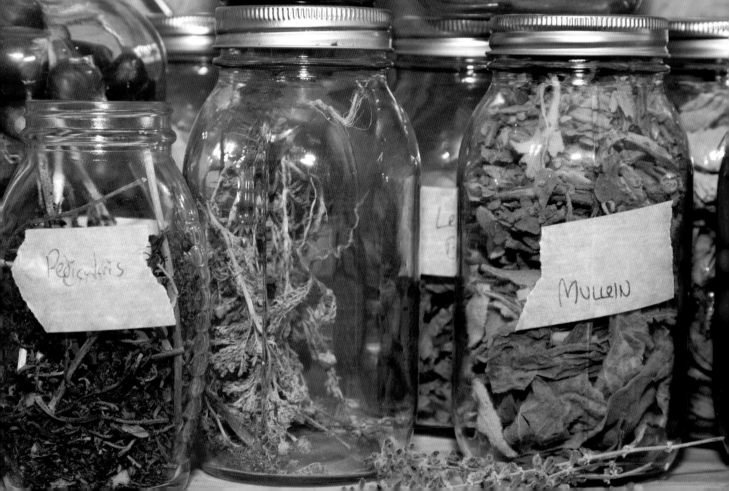

urban foraging test: living for five days off harvested wild plants and weeds that she gathered in Portland. Her menu included stinging nettle broth, roots of burdock, and wild carrot, as well as the raw greens of chickweed, miner's lettuce, and dandelion. She learned a lot in the process, such as the importance of knowing where to find plants and how to store them. Another lesson was the amount of time it took to harvest enough food to sustain her. "Foraging was fun, but surprisingly tedious," she says. The importance of community also became apparent; sharing knowledge and tasks made the work much more efficient. She later attempted the foraging survival test again, this time for seven days. With the knowledge she gained the first time around, she succeeded with ease on the second try. She is currently writing a book on her adventures.

Cities are surprisingly good places to forage, according to Rebecca. "There's more biodiversity found in cities than in some highly managed forests or parks." Cities offer edible weeds, native plants, exotics, garden crops, and feral crops. Much as many cultures of people make up cities, plants from all over the world come together in urban environments.

One of the main challenges of urban foraging is that there is simply not enough food to be found to sustain a mass population of foragers, although Rebecca thinks that could be changed. Many urban areas are off-limits to foragers because they are private property. To find foraging space, she suggests talking to neighbors. She has even posted on Craigslist seeking private yards whose owners would allow foraging. She likes the idea of a foraging park, too. "It could just be a lot, open to anyone."

OPPOSITE, CLOCKWISE FROM TOP LEFT Chickweed (*Stellaria media*), a salad green; little western bittercress (*Cardamine oligosperma*), a spicy salad green; and raspberry leaf (*Rubus sp.*), used to make a herbal tea. Rebecca stores dried foraged herbs in jars. ABOVE AND RIGHT Rebecca can identify a ponderosa pine by smell. Yarrow leaves (*Achillea millefolium*) can be used to make herbal tea.

RESOURCES

First Ways (Rebecca's blog): **http://firstways.com**
Wild Food Adventures:
www.wildfoodadventures.com
Identifying and Harvesting Edible and Medicinal Plants, **by Steve Brill**
The Forager's Harvest **and** *Nature's Garden,* **both by Samuel Thayer**
From Earth to Herbalist, **by Gregory L. Tilford**
Medicinal Plants of the Pacific West, **by Michael Moore**

Foraging has become trendy lately, but the media often makes foraged food sound like a delicacy that is expensive or off-limits to the average person. This can be the case, Rebecca acknowledges—for instance, when professional foragers harvest plants from public parks and then sell them for private profit. Another problem is sustainability. Small-scale harvesting is one thing, but larger operations can disrupt ecosystems. Goldenseal and wild ginseng, for example, have been so overharvested that they are close to extinction in their native North American habitat. Like many other foragers, Rebecca advocates harvesting only a certain percentage of native plants. (Of course, aggressively harvesting invasive species for eating is useful!)

Foraging has changed the direction of Rebecca's life. She finds plants fascinating. "I'll often become intensely curious about a particular plant in my neighborhood, figure out how to identify it, and then research its historical uses." She shares her enthusiasm, knowledge, and ideas on her blog, by teaching workshops, and in her published writings.

OPPOSITE Rebecca picks needles from a ponderosa pine to make a soothing tea. ABOVE Occasionally, she smokes a mixture of foraged herbs for their calming effect.

Foraging in the City

Here are a few tips from Rebecca:

- *Be careful where you choose to forage food. Nuts and fruits are fine to gather by streets, but avoid gathering greens near curbsides or areas frequented by pets.*
- *Stay away from plants grown by railroad tracks; they are often sprayed with herbicides. Be aware that many city parks are not pristine, and herbicides are often used there too.*
- *Pay attention to the health of the plants you are harvesting. Don't pick wilted, dried, or sick plants.*
- *Don't overharvest, unless you are harvesting an invasive species.*
- *Learn about plants from a reputable source, and don't eat anything you don't know how to identify.*
- *Talk to your neighbors or other property owners to find safe, accessible foraging places.*

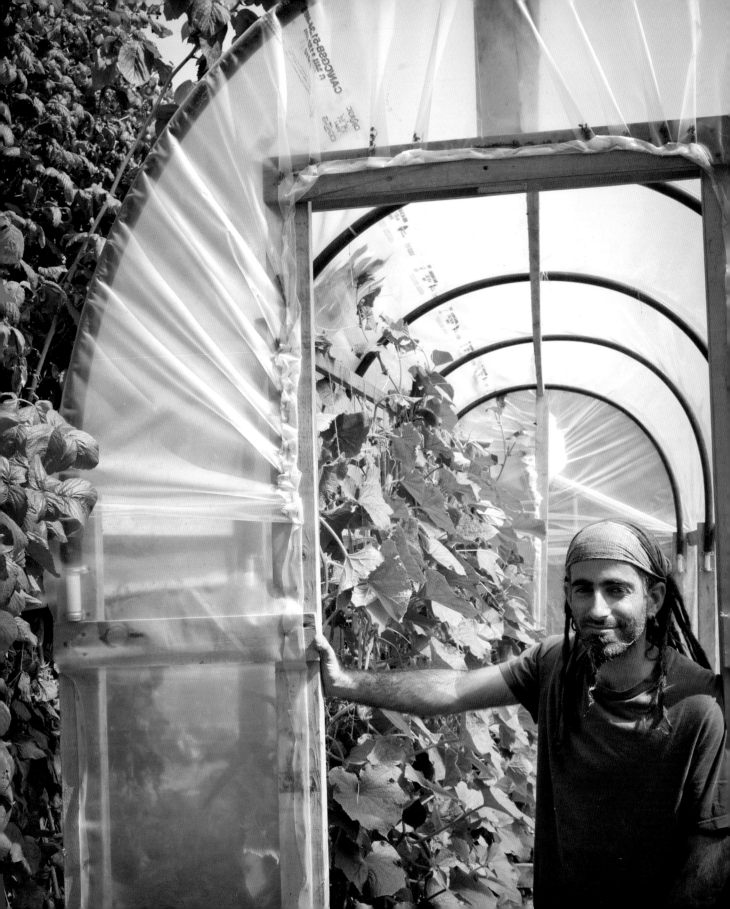

a neighborhood csa

gray oron
vancouver, british columbia

"IT'S EMPOWERING TO GROW FOOD. When my pantry is full, I feel rich and relaxed."

Gray Oron's yard proves his point. It's a testament to his productivity as well as to his creativity. Practically every inch is planted, from the curbs to the pots lining his front steps to the balconies on the second level. There's a greenhouse with a composter incorporated into its design that works as a natural heater. Throughout the yard are hoop houses—affordable greenhouses that extend the growing season and protect crops from the cold. They give seedlings an early start and protect them from pests. In the backyard, a 12-foot-tall tepee covered with scarlet runner beans hides a bathtub for relaxing outdoor soaks.

A natural activist, Gray grows things partly for the sheer love of it and partly because he believes fresh local food is a right. Growing up in Israel was an early influence on him: "It's a tiny country where pretty much everything is local and fresh. I could grab an orange right off the tree.

Gray Oron's Vancouver backyard farm features a greenhouse and several hoop houses.

It made me realize how much I loved food." Later, while he was in college studying computer science, he read a book by Dan Jason, an outspoken Canadian opponent of industrial agriculture, which got him interested in growing his own food. He soon filled his backyard with edibles.

He started growing food commercially using a community-supported agriculture (CSA) model to provide food for seven families from his own backyard. CSAs were created to foster growing and eating locally; they allow anyone in the community to buy a share in a local farm and, in return, receive a weekly box of produce throughout the entire growing season. Ilana Labow joined him, and after a season of fun and success they created Fresh Roots, a neighborhood CSA, in 2010. What makes Gray and Ilana's CSA a bit unusual is that part of their growing space is in the backyards of local homeowners, who allow them to grow vegetables there in exchange for fresh produce. Fresh Roots now has nearly thirty members and seven local backyards to grow in, and has teamed up with a local school to create more growing space. It also has a half-acre plot in nearby Richmond.

Lately, Gray's mission to nurture future farmers has expanded. "We want to sow the seeds of a sustainable

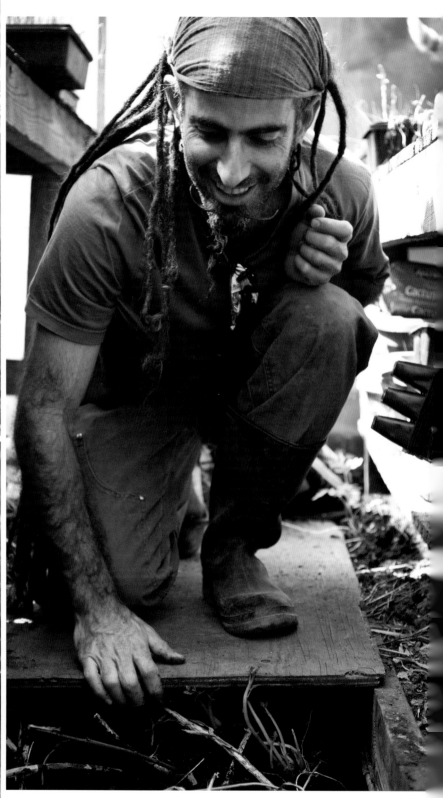

OPPOSITE, CLOCKWISE FROM TOP LEFT Gray harvests hothouse beans; he keeps a holster of coffee with him while working. The greenhouse features a composter built into the floor that acts as a natural heater for the growing plants. His cat is often found napping in the warm greenhouse. ABOVE Gray delivers produce using a 7-foot-long bike trailer that he welded together.

urban farm system." To that end, last year Fresh Roots took on five interns from the University of British Columbia, who got college credit for their work and had to write a paper on the experience. Another partnership involves even younger students: Fresh Roots sold a share of its harvest from its farm-to-cafeteria program to Queen Alexandra Elementary School for the cafeteria's salad bar, and located its first model urban farm on the school's property. The farm provides the school with an outdoor hands-on classroom where kids can get their hands dirty. At another school in the district, a vacant

greenhouse is now used to start seedlings and is included in class projects. Recent plans include two more $1/4$-acre gardens at two additional high schools. Fresh Roots won a major credit union's Good Money Impact Venture Challenge in 2012, and it has become a nonprofit organization so it can put more of its energy into education.

Even though he has a business to run, Gray strives to have the smallest carbon footprint possible. He makes Fresh Roots deliveries with a 7-foot-long bike trailer that he welded together himself with help from the Bike Kitchen, a local bike co-op.

During the growing season, Gray admits to working long hours nearly seven days a week. But he says it's empowering and energizing. Having his gardens in a high-traffic area gets them lots of attention. "We get the thumbs-up from older neighbors, who are surprised to see young people working so hard. But I want a better food system, grown in, by, and for the neighborhood. Fresh local food should be accessible to people living in the inner city. It's a right."

OPPOSITE A hoop house in Gray's garden

RESOURCES

Fresh Roots:
http://freshrootsurbancsa.wordpress.com
Salt Spring Seeds (Dan Jason's website):
www.saltspringseeds.com

Making a Hoop House

Gray is a big believer in hoop houses. They're cheap and easy to make, and the supplies can be purchased from local hardware and plumbing stores. This one, designed to fit on a 4x8-foot raised-bed frame, is a little different from the hoop houses he builds. He plans to include his trade secrets in his own forthcoming book.

SUPPLIES

4x8-foot raised-bed frame
10 $3/4$-inch pipe straps
$1/2$-inch screws
6 ten-foot lengths of $3/4$-inch PVC pipe
1 roll of 3 ml plastic

2 boards, 2 inches x 2 inches x 8 feet
twine
staple gun with $1/4$-inch staples
spring clamps

DIRECTIONS

1. *Start by screwing the pipe straps to the interior edge of each 8-foot side of the 4x8-foot frame. Continue screwing each strap 24 inches apart along each side of the 8-foot frame.*
2. *Fit each PVC pipe into a strap, then fit its adjacent strap, bending the pipe into a semicircle to fit.*
3. *Cut the last PVC pipe to 8 feet and tie it to the top of the hoop house with twine to stabilize the five lengths.*
4. *Staple one end of the plastic to a 2x2x8-foot board; then wrap the plastic over the hoops, staple it to the other 2x2x8-foot board, and trim. The board will help weigh down the plastic, which can be rolled up when the hoop house is no longer needed.*
5. *Use the spring clamps to close the ends.*
6. *When the cold season is over, the hoop house is easy to disassemble and store.*

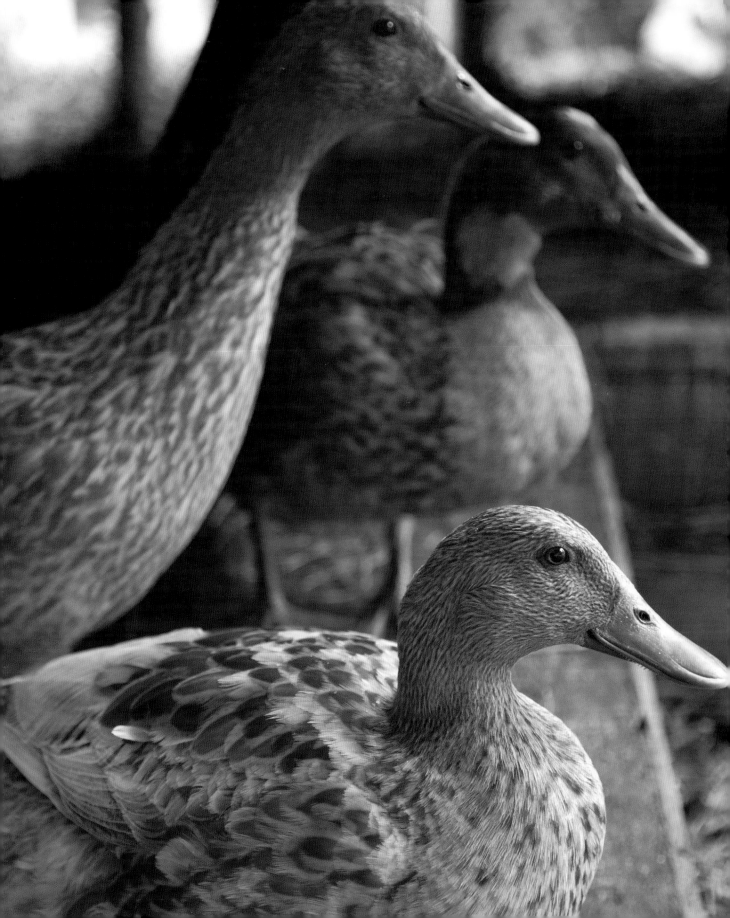

duck keeping 101

bj hedahl
seattle, washington

"DUCKS ARE THE ULTIMATE rainy Seattle poultry," says BJ Hedahl, who teaches duck keeping at Seattle Tilth, a nonprofit that promotes organic gardening, conservation, and locally grown food. She also raises ducks in her North Seattle garden, and is surprised that more people don't. "So many people wonder why I have ducks. But the fact that the cold, wet Northwest winters are not a problem is just one advantage." Her long list of benefits has convinced many nonbelievers.

Eggs are one of the biggest advantages of duck keeping. Duck hens tend to lay more than chickens and the eggs are usually larger and the shells thicker. The larger yolks "stand up" when you break them and have a slightly higher fat content. Bakers love using duck eggs; adding them to a recipe makes a batter thicker and smoother than do chicken eggs. Ducks are more casual about laying eggs than chickens; BJ sometimes finds clutches of eggs behind plants around the yard. Once she found an egg in the wading pool. Duck hens rarely go broody, and

they lay for two or three years instead of one to two years, as chickens do. BJ has found a market for her extra duck eggs; she started with just a sign at the end of her driveway, and now she has a loyal following.

Ducks also need less housing than chickens. A simple, low, predator-proof coop works fine. Ducks' webbed feet don't require perches, but nesting boxes should be low enough for them to reach. Ramps provide good access. Because their quacking can bother people, BJ put their coop in the back corner of her yard, away from the neighbors. Flying has been bred out of most domestic ducks, so a 3-foot-tall fence is high enough to keep them from wandering off, although it's important to protect them from predators. BJ has used treats to train her birds to go into the coop at night when she slaps her leg.

Another big difference between chickens and ducks is that ducks lack the pecking order that chickens often brutally enforce. "Once I had a pair of ducks who couldn't get along," BJ says. "They spent a few hours pressing their chests against each other, but now they are friends. Neither is dominant." Ducks and chickens both love to eat bugs, but unlike chickens, ducks will eat snails and slugs too, and they'll do it without scratching up the yard.

Highly prolific layers, the Khaki Campbell ducks BJ Hedahl keeps in her Seattle backyard average around 300 eggs a year.

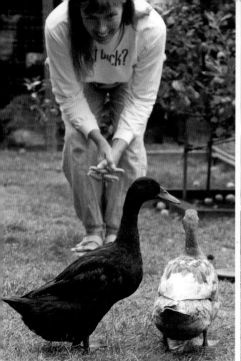 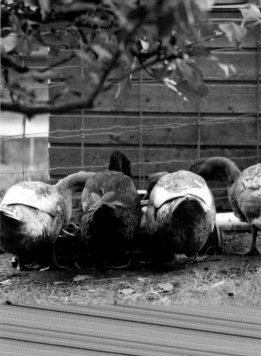 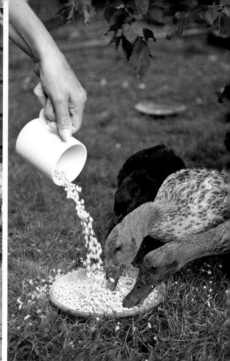

The Two Best Ducks for Egg Production

Indian Runners: BJ's favorite breed, these unusual ducks stand upright like penguins and love to run. They are originally from the West Indies and have become popular for their high egg production—150 to 200 eggs annually. This breed does not fly and rarely makes nests or incubates eggs, tending to drop eggs wherever they may be. They are good foragers and don't require a pool of water, preferring to hunt slugs, snails, and even flies. They weigh between 3 and 5 pounds and are from 20 to 30 inches tall. BJ likes their "perky outlook."

Khaki Campbells: These ducks are highly prolific layers, averaging 300 eggs a year. The breed was developed in the late 1800s when an Indian Runner was bred with a Rouen and then crossed with mallards. The result was a very hardy, prolific layer. This brownish duck weighs 4 to 4$\frac{1}{2}$ pounds and is at home on land as well as in water.

The most common complaint about ducks is their messiness. They love to splash around in the mud and dirty up their drinking water. BJ says their drinking water needs to be kept close to their food and changed frequently. Although domesticated ducks don't require water to swim in, she provides a wading pool for hers that she changes every couple of weeks, using the water for her vegetable garden. Ducks do best when they have a container large enough to allow them to at least dip their heads and necks in the water.

Can't decide between ducks and chickens? Both need to be protected from predators at night, and they eat similar food, although ducks require a niacin supplement. They get along well together, so if you're not sure which to raise, you can always get both.

RESOURCES

Seattle Tilth: **seattletilth.org**

ABOVE, LEFT TO RIGHT BJ with her ducks. The ducks line up to eat. They eat a pellet mix supplemented by insects, snails, and vegetables. OPPOSITE BJ occasionally finds hidden clutches of eggs in the yard.

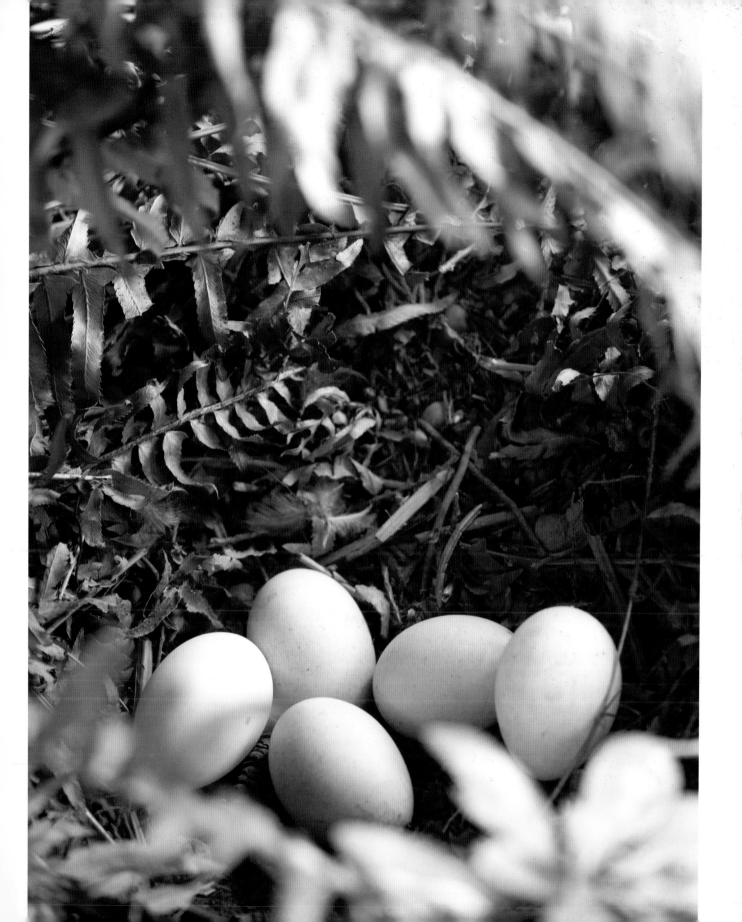

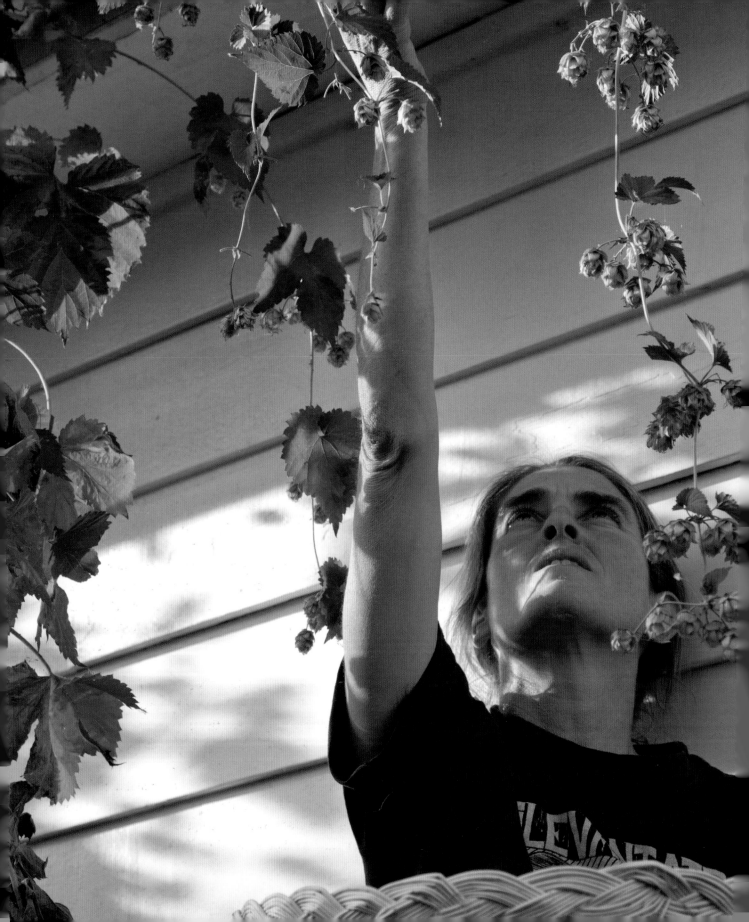

medicinal herbs for folk remedies

rachel freifelder
portland, oregon

RACHEL FREIFELDER IS a self-described "plant-geek." She has a master's degree in biology and can give you the Latin name of any plant in her yard. She and partner Rob have lived for four years in the Cully neighborhood of Portland, where they grow almost all their vegetables on their 9,000-square-foot lot. The yard used to be all grass and ornamentals, but she has transformed it into a sprawling experiment of edibles and herbs. She has ducks in the backyard along with seven beds where she grows staples such as kale, garlic, parsnips, beets, carrots, and winter squash, as well as experimental varieties like mashua, scorzonera, and sea kale. The front yard is semiwild with fruit trees and herbs.

Rachel began growing medicinal herbs 15 years ago as a way to help support herself. She loved farming but didn't want to get into large-scale agriculture that required acreage and mechanization. Growing herbs by hand and making tinctures and oils, she thought,

would add enough value to her product to make the work worthwhile. But she encountered so many restrictions on selling bottled products that she gave up the idea of commercial growing, and now grows medicinals only for her own use. She likes having the "old wives' tale" remedies that she says are a way to reclaim your health care.

Growing herbs and medicinals is easy, Rachel says, because many are like wild plants. Most don't require much care and do fine in poor soil without a lot of water. Like many high-quality grapes grown for wines, many medicinal herbs have higher concentrations of their active ingredients when they are grown under harsh conditions.

Calendula is a good beginner's plant. It has marigold-like yellow flowers that bloom throughout the season. The petals are edible, and the flowers can be dried and made into oils that are good for skin irritations such as burns, scrapes, and infections.

Chamomile is a low, spreading annual that flowers in the summer months. Its flowers can be picked and dried to make a well-known calming tea. It also can be made into a tincture that helps relieve pain.

Rachel Freifelder picks hops from a vine to make a relaxing tea in her Cully neighborhood yard in Portland.

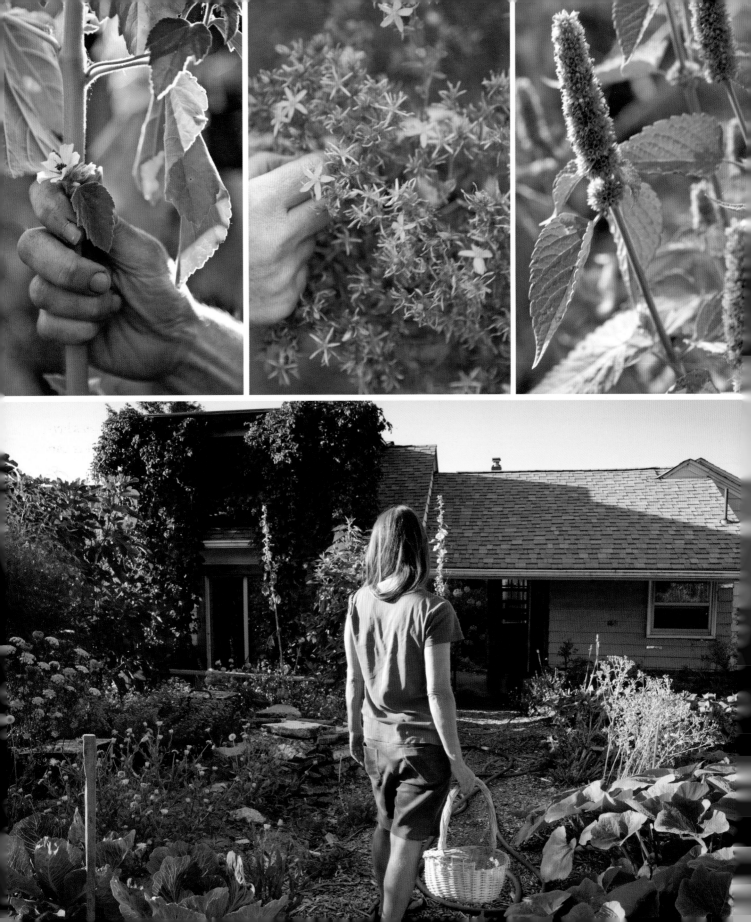

Making Tinctures, Salves, and Oils

Some herbs require a solvent stronger than water to release their chemical compounds. Using oil, beeswax, or alcohol to make salves and tinctures from herbs is an effective way to preserve the herbs and release their active ingredients. Tinctures are made with alcohol, mixed with water, and taken internally. They have a long shelf life and can be added to hot or cold water to make instant tea or compresses. Oils and salves are used topically.

Making an herbal tincture: Harvest the herb when it is at its peak. Wash, if necessary, and let dry; then tear or chop it into 1-inch pieces. Pack the herb into a small jar and then pour 80- or 100-proof vodka or Everclear alcohol over it. Cover the herb completely and let it steep for at least a couple of weeks, then filter through cheesecloth into a new jar.

Making an herbal oil: Harvest the herb, wash it, and let it dry for several days in the sun. Tear or chop it into 1-inch pieces and pack it into a small jar. Use your favorite oil and cover. Leave the jar in a sunny place for two to three weeks, check for mold, and scrape off any that accumulates. After six weeks, strain the oil through cheesecloth into a new jar.

Making a salve: Melt $\frac{1}{2}$ to 1 tablespoon beeswax in a cooking utensil over the stove, then add some herbal oil. Pour it immediately into a small container and let it set. You may need to re-melt the salve to adjust the beeswax/oil parts to the desired consistency.

OPPOSITE, CLOCKWISE FROM TOP LEFT Marshmallow plant roots can be used for a medicinal tea. Calendula has edible flowers that can also be dried and made into oils good for skin irritations. Anise hyssop leaves and flowers can be used for a relaxing tea. Rachel harvests in her backyard. RIGHT Rachel stores dried calendula, dandelion root, and chamomile in jars.

Yarrow is a native herb that does well in sunny, dry areas. The flowers can be dried and made into tea or into tinctures that are good for colds.

Marshmallow is a large plant with soft, velvety leaves and late summer flowers that can be grown for ornamental or medicinal uses. Rachel dries the root for tea and uses it for soothing the mouth, throat, and stomach.

St. John's wort is so easy to grow that it's considered a pest. It thrives in poor soils and is drought and cold tolerant. The flowers can be dried and made into a tea that is a well-known mild antidepressant. Rachel makes tinctures from the flowers and uses them to treat physical trauma.

Dandelions grow freely in Rachel's yard, but that doesn't bother her. She digs up the roots and dries them, then grinds them up for a coffee-like drink. The leaves are good for salads.

Anise hyssop, an herb from the mint family, has lavender flowers that bees love. The leaves and flowers can be used for a relaxing tea.

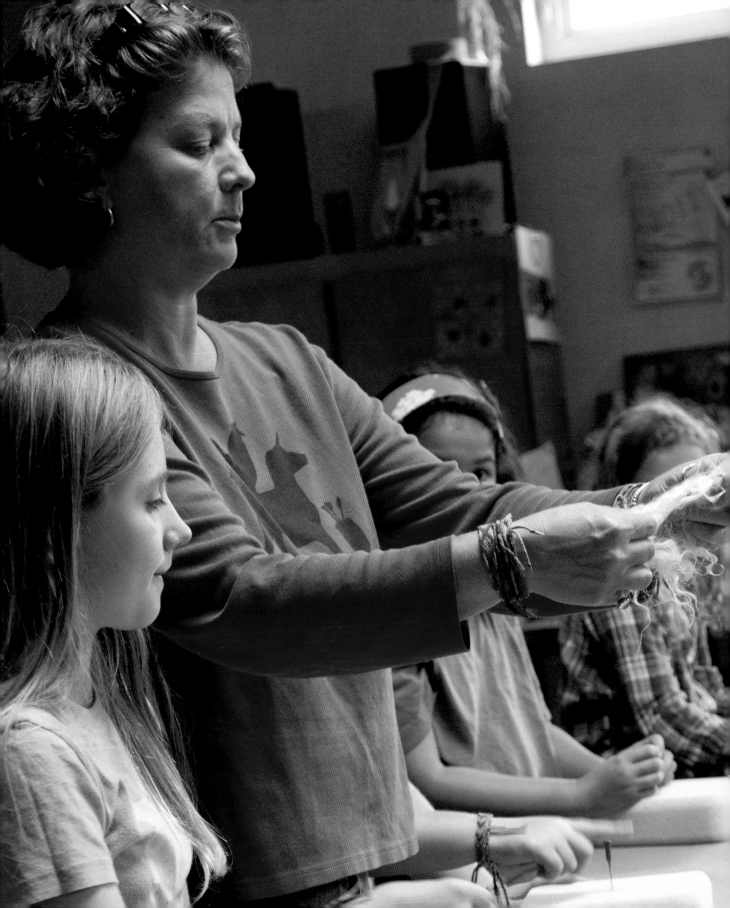

city art farm

joan engelmeyer and steve irish
seattle, washington

"WE GROW ART," SAYS Joan Engelmeyer, talking about her City Art Farm program for kids. The art classes that she teaches from her South Seattle home studio are an organic way of combining her art career with her backyard farm. Her students naturally gravitate toward the animals and garden, where they are easily inspired. Hanging out on a farm, the kids get to make things and discover where the materials and foods come from.

An artist with twenty-five years of experience, Joan shows her work nationally and in a variety of mediums: paint, ceramics, printmaking, and sculpture. She likes teaching children because they come to any project with an open mind, and she gets a lot of inspiration from them too. A natural teacher, Joan first started teaching kids privately fifteen years ago, and taught in an after-school program called Powerful Schools. She began teaching at her own studio after building a small classroom attached to the back, and now offers 10-week after-school classes, weeklong summer workshops, and art parties.

Joan Engelmeyer teaches a class on felting using wool from her Pygora goats in her City Art Farm studio in South Seattle.

The art projects for the kids take advantage of whatever material is abundant on Joan's urban farm, where she has been growing vegetables and raising chickens since she moved in over fifteen years ago. For instance, during her summer garden classes, students make vegetable prints, blackberry jam, lavender eye pillows, and bamboo bee houses. An entire wall in the studio is filled with nothing but supplies—her "magic wall"—with everything on hand for any new idea.

One of her recent popular after-school classes incorporates goats into the curriculum. After keeping the animals became legal in Seattle in 2009, she developed some serious "goat envy." She wanted to add goats to her backyard farm but didn't want the commitment of milking them every day. A dedicated knitter, she became interested in fiber goats that produce beautiful Angora wool. She ended up getting two Pygoras—pygmy Angora goats, which have wool that grows 4 to 6 inches long.

She includes the goats in her classes by teaching needle felting, using carded wool—wool cut from the goats that is then rolled and matted together to make objects. The kids learn an interesting age-old craft, but also get to meet the animals that made their wool. Joan

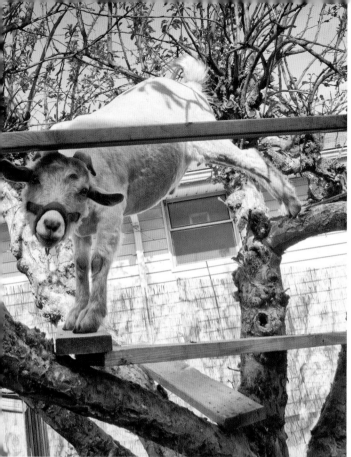

Harvesting Wool from Pygora Goats

Pygora goats were developed in Oregon by Katherine Jorgensen in the 1980s. They're a cross between Angora and pygmy goats and require the same care as other goats. They are raised for their fiber but can also be milked. They produce about a quart of milk a day.

There are three fleece types:

Angora (type A): A long, curly, lustrous fiber that grows to 6 inches or more. The fiber is fine and like mohair. This fleece must be shorn.

Blend (type B): A pygmy undercoat blend of Angora and cashmere that grows to 3 to 6 inches and is crimped. The most common fleece of Pygoras, it may be shorn, combed, or plucked.

Cashmere (type C): A fine, nonlustrous fiber that grows to a length of 1 to 3 inches. The fleece may be shorn or combed.

Joan's goats are Class B Pygoras that she shears twice a year with professional dog shears. "The shearing isn't difficult," she says, but separating the yarn-quality fiber from the more coarse fleece takes time. She gets 5 to 8 balls of yarn per goat, and uses the coarse fiber for felting.

After shearing, she washes the fleece in hot water with Dawn dishwashing liquid—which is used specifically because it breaks down oils with no agitation—being careful to not let the fleece felt up. She washes each small batch two or three times, then rinses it and lets it dry, which can take days. She admits that it's a time-consuming process, but says it's therapeutic. Once the process is finished, the wool is ready to card and dye. One of her next projects is starting a natural-dye herb garden so she can teach natural dying.

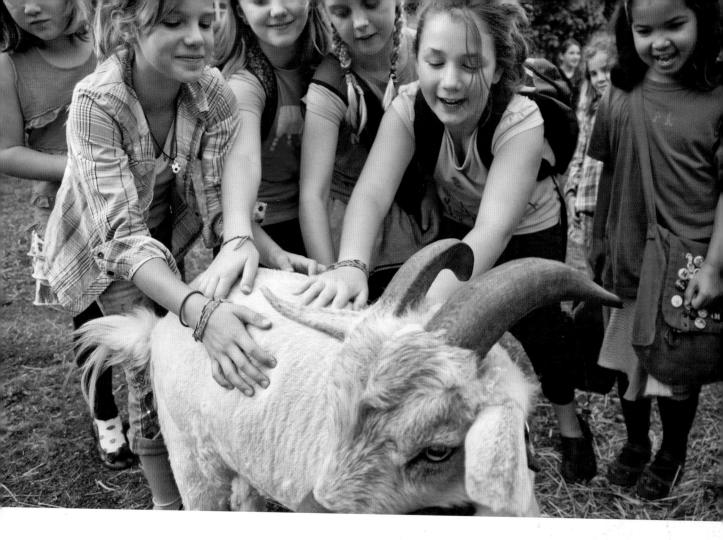

says it's important for the kids to see such connections. "They have more respect for the material when they've met the animal."

In her Art du Jour class, the kids do a different project every week. The creativity of using recycled materials or something grown on the farm always comes into play. Bottle caps are turned into tiles. Colored chicken eggs are used for mosaics. And students learn about science by putting interesting things they find in the yard under the microscope and drawing them.

OPPOSITE, ABOVE AND LEFT Joan and Steve built simple platforms so their goats could climb a tree in their backyard. Joan made this felted version of a goat to show her students. ABOVE Students enjoy meeting the recently shorn source of the felt.

In her Masters Painting class, the kids learn the techniques of famous artists while practicing resourcefulness and sustainability. In the class on Jackson Pollock, they make a huge painting together using only recycled paints. They spread a large canvas out in the yard, choose the colors they want to use, then take turns splattering paint all over. It's a popular class! And the kids learn teamwork and cooperation; at the end of class, Joan cuts up the painting and each student gets to take home a piece.

Joan's husband, Steve Irish, is an artist as well, but he works with plaster, doing jobs that have included making the Wave Wall for the Seattle Aquarium and restoring homes for the Seattle Historical Society. He also built the cordwood chicken coop in their backyard, inspired by an

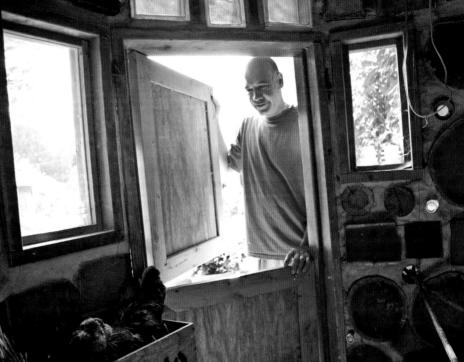

old complex of buildings he came across on the Washington coast.

Cordwood masonry consists of laying whole or split wood widthwise on a bed of mortar. It's an old-world process, a humble architecture with unclear origins. Steve liked the resourcefulness of it, and using mortar, a material similar to plaster, appealed to him. He also wanted a more secure coop for their chickens, since raccoons had been wreaking havoc in the yard.

Some advantages of cordwood include its low cost, its energy-efficient thick walls, and the fact that it's easy to work with. The principal disadvantage is the hard work of mixing many pounds of mortar. With his plastering skills, Steve thought building the coop would be an easy job, but it took two weeks of dawn-to-dusk labor and two tons of mortar.

Like many cordwood buildings, the coop is circular. Steve began with a cinder-block foundation and set the door frame with two-by-fours. He then worked in a spiral, setting in windows as he progressed to the roof. The rafters are mortared into the sides and the entire building is made from recycled material, mainly from an old cedar tree that was to be burned as firewood.

Steve and Joan have made their urban farm an extension of their love of art. They work differently but are similar in their resourcefulness and intuitive eye. Joan sums up the philosophy of City Art Farm this way: "To see how art can be found in every minute, every idea, every action, from garden to studio."

RESOURCES

City Art Farm: **www.cityartfarm.com**
Cordwood construction: **www.daycreek.com/dc /html/dc_cordwood_masonry.htm**
Cordwood masonry: **www.cordwoodmasonry.com**

OPPOSITE, CLOCKWISE FROM TOP Joan says these two hens are friends, and you can always find them together; here, they roost in their cordwood coop. Steve checks the nest box through the Dutch door. The cordwood coop features a green roof. RIGHT Steve designed the coop with a chicken door controlled by a rope and pulley so it can be open and closed from the outside.

defending the right to raise animals for food

esperanza pallana
oakland, california

ESPERANZA PALLANA WAS A NOVICE when she got into urban farming eight years ago. She had just gotten married and decided to tackle her husband's neglected yard. Their home, located near the busy Lake Merritt shopping area in Oakland, has about 1,600 square feet of growing space. She wanted to plant broccoli, but had no idea how to do it. "I was horrified by my lack of knowledge," she remembers. Her grandparents were first-generation Mexican immigrants who had farms with chickens, goats, and rabbits and lived in the Central Valley of California. Esperanza wanted a deeper connection with her culture and food.

Starting with vegetables and fruit trees, she then moved on to raising animals. She got chickens, turkeys, and meat rabbits. She was interested in raising her own healthy and humane sources of food and discovering how it connected to her cultural heritage. But even though she grew up in a family that raised and processed its own animals for meat, her decision to do it herself came with a

lot of angst. She wanted to be at peace with having meat as part of her diet, which for her meant not eating an animal that had lived a short, brutal life on a factory farm. Raising her own meat-producing animals became a way of connecting to her food source, knowing the animal had been well cared for, honoring its life, and sharing food with others. A turkey she raised and slaughtered became a part of a spring ritual of *mole*. "Sharing it with family and friends is a way to celebrate the animal and keep my cultural knowledge alive."

Recently in Oakland there has been controversy over the right of urban farmers to slaughter their animals for their own consumption. Esperanza has always maintained that she and other homesteaders are "practicing a basic human right." In her blog, she writes, "I have the right to affordable unadulterated food, including meat that is raised organically and humanely." An Oakland-based group called Neighbors Opposed to Backyard Slaughter has organized to oppose livestock keeping on urban farms. Its website frowns on eating animals in general, with specific opposition to raising and slaughtering animals for food.

Esperanza Pallana carries a turkey she slaughtered in her Oakland backyard.

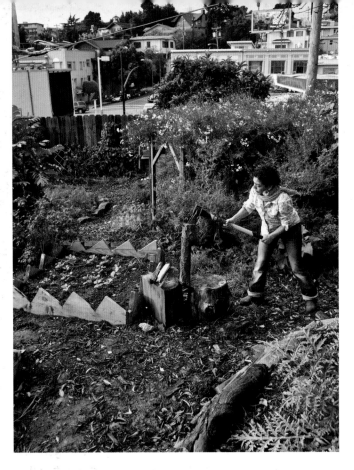

The controversy has attracted a great deal of media attention, both pro and con, in local newspapers and beyond. An *Atlantic* magazine article by history professor James McWilliams cast a critical eye on home slaughter, citing a few disturbing anecdotes of "immense suffering" caused by animals being "inexpertly slaughtered." The article angered many Bay Area locavores; James Norton of the food website Chow wrote that it failed to mention that most urban farmers are "driven by principles of animal welfare," and its opposition amounted to "a small pseudo-statistical pile of psychobabble."

"There's a moral case to be made for vegetarianism," Christopher Mims wrote for a *Grist* article on the topic, "but if the goal is to reduce the quantity of suffering in the universe, it makes more sense to start with the treatment of animals in factory farms."

Esperanza writes, "It is fully permissible in the city of Oakland to raise animals for food." The city is working to streamline its policy on urban agriculture and animal keeping in general, including defining urban agriculture, improving the permitting process, creating operating standards, and expanding nuisance laws as they pertain to animals. These changes will reduce the burden on city staff and facilitate high standards of care for all animals in Oakland, not just livestock. It should be noted that almost all of the Oakland Animal Services' cases involve cats and dogs.

Esperanza first joined the discussion as an advocate for urban farmers, but now manages the Oakland Food Policy Council. She also cofounded the East Bay Urban Agriculture Alliance. She says the city's policy needs to be updated to ensure safe practices for all animals, and the community needs to be involved. At an Oakland community forum last year, over 300 supporters came out to support urban agriculture. While the vast majority supported the proposed changes, a vocal minority spoke out against eating meat. The debate got agitated at times, but Esperanza stayed calm and kept the discussion on topic.

Preparing for a Public Debate

It's important to be able to defend what you believe in. In addition to gathering supporters who agree with you, you'll need to communicate to others convincingly. It is a skill that can be learned.

Do your homework: Know facts and figures, and bring notes to defend your views. Be prepared for the opposing side's arguments.

Stick to the points: Stay on topic. When the debate goes off subject, it's important to bring everyone back to the discussion topic.

Stay calm and reasonable: Don't raise your voice or be drawn into an emotional battle. Once you're upset, you're not reasonable.

Bring visuals: Illustrating your point can be a more effective tool than using words.

The ordinance will soon be introduced to the planning commission and make its way to the city council. Esperanza believes there is strong support for retaining Oakland residents' right to raise animals for meat. As she writes in her blog, "Animal-integrated agriculture is as old as dirt. The practice of raising your own animals for food in the city has been done for centuries, and will continue to be done, legal or not. However, legalizing it would allow for the open creation of an infrastructure to ensure access to excellent resources for learning and care."

OPPOSITE Esperanza chops wood in her backyard. CLOCKWISE FROM TOP LEFT Esperanza holds one of her American heritage rabbits. She cleans a freshly butchered turkey. Esperanza prepares a spiral bed for growing carrots. Her large vine-covered chicken coop.

RESOURCES

Pluck and Feather (Esperanza's website): http://pluckandfeather.com
For objective articles on home slaughter, **Esperanza** recommends *Mother Jones,* Chow.com, and the *Journal of Agriculture, Food Systems, and Community Development* as good places to start.

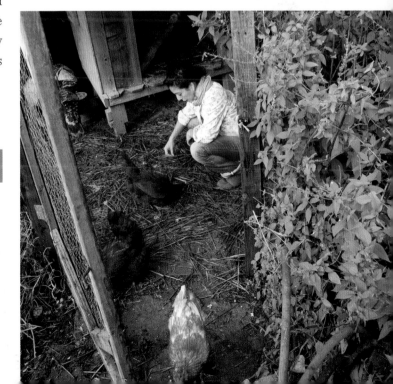

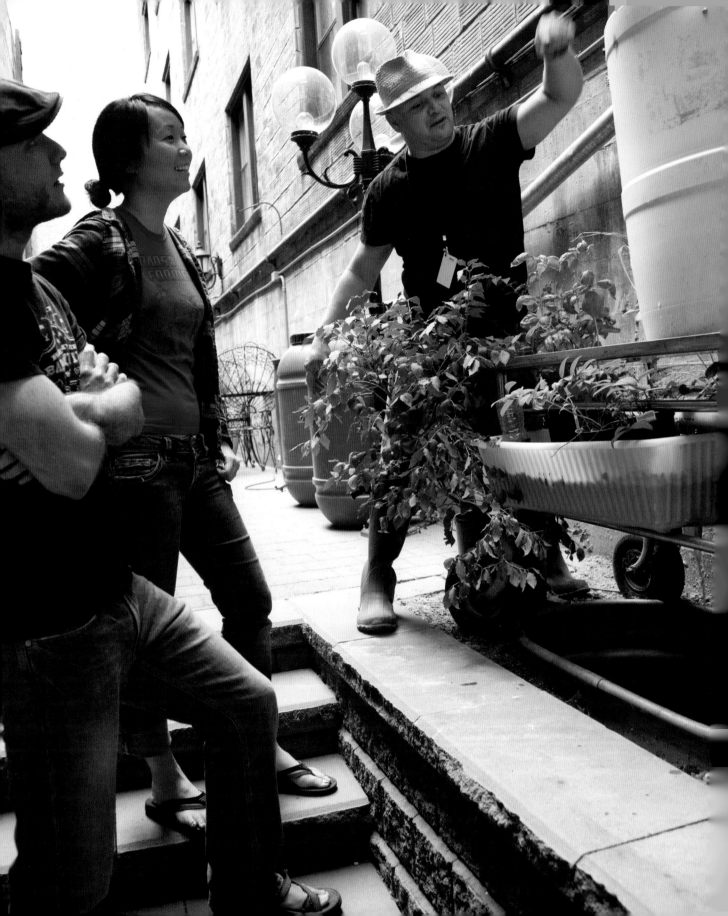

inspiring travelers at a downtown hostel

lee kindell
city hostel, seattle

A BACKPACKERS' HOSTEL IN a gritty downtown neighborhood is not really a place where you would expect to find a demonstration farm. But Lee Kindell is not your average hotelier. He bought the building on Second Avenue in the Belltown neighborhood of Seattle in 2009 with the help of investors. In its original incarnation as the Lorraine Hotel, built in 1929, it offered glamorous accommodations in the center of Seattle's early film district, where movie stars and film reps stayed while promoting their films. After falling on hard times in the 1980s, the building became a low-income rooming house that was eventually vacated in 2007.

Even though "it was a derelict building that nobody wanted," Lee says, "I had a big vision for this place. I wanted to inspire the kids who come through here." He started his renovation by using as much recycled material as he could: recycled-soda-bottle tile, tables made from doors, and reused granite counters. He installed low-

Lee Kindell tells visitors at City Hostel, in downtown Seattle, about the aquaponics system he set up using recycled and repurposed materials.

flow toilets and compact fluorescent lights, along the way cleaning and restoring the building to its lost glory.

He wanted art to inspire the young visitors, so he had forty-seven local artists paint the rooms in the hostel. The result is an experience that's way hipper than your average museum. Each room is unique to the artist's vision, and many include a heavy dose of street-inspired art. From stenciled buddhas to giant drippy spray-painted faces, the art in every room makes a statement. In the first-floor gallery, the artists sell their work commission-free. In the basement, local filmmakers are encouraged to share their work.

Lee has always felt like a "mad scientist" who enjoys "mixing art and science and following the creativity." His interest in sustainability inspired him to explore urban agriculture. It began with chickens in the back alley, their coop built using old table legs, reused cabinets, recycled plant pallets, and windows. Lee put the pieces together using salvaged wood, oriented the window to face south, and raised one end for ventilation. The nesting boxes are made from 5-gallon buckets, and the living green roof grows lettuce and herbs. The coop and adjoining run

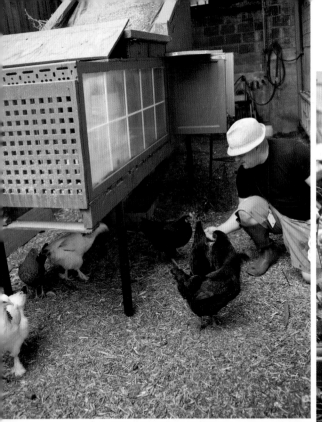

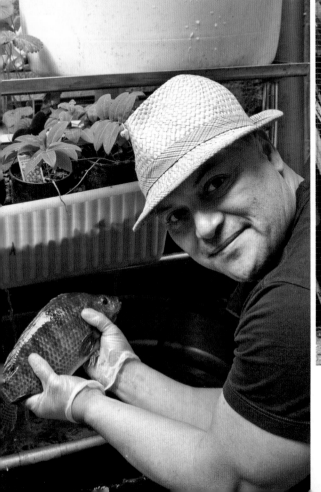

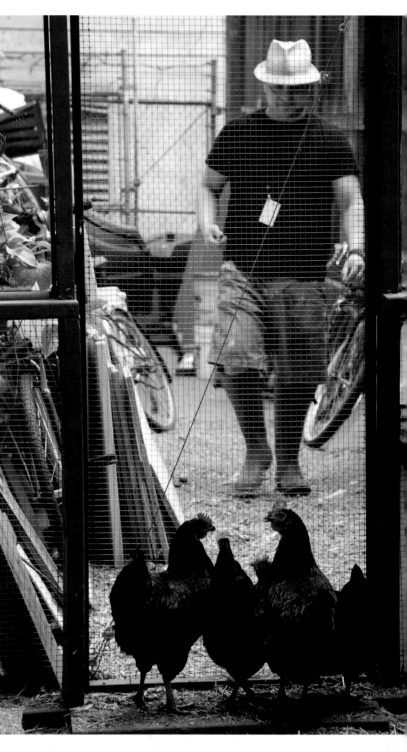

stretch along the side of the building and give the chickens 30 feet of space. Lee started with four Australorp chickens, known for their friendliness. He's since gotten four more hens and says the sixty eggs he collects weekly are for the staff and young guests who stay there.

Not having a lot of space or money has not deterred Lee. He wants to educate the next generation and show them it doesn't have to be expensive to be an urban farmer. On his downtown roof with a view of the Space Needle, he's now experimenting with growing dwarf fruit trees and keeping bees. To keep the costs down and the weight on the roof to a minimum, he plants in 5-gallon buckets, placing one inside another to create a wicking system that waters the plants. He cuts a hole in the top bucket and places a small plastic pot with vertical slits that fits exactly into the hole. It's filled with dirt and then placed in the second bucket, which contains 2 inches of water that wicks up to the plant, making watering less of a chore. His rooftop beehives are brand-new, but he's optimistic about harvesting honey soon. Lee also grows vegetables in pots right on the street, just to show that it can be done.

Lee's aquaponics demonstration system is another idea he believes in. He sees it as a great hope for the

OPPOSITE, CLOCKWISE FROM TOP LEFT Lee with the coop that he made entirely from recycled materials. His Australorp chickens wait expectantly for treats. A tilapia fish from his aquaponics system. BELOW Lee keeps a beehive on the roof of the hostel.

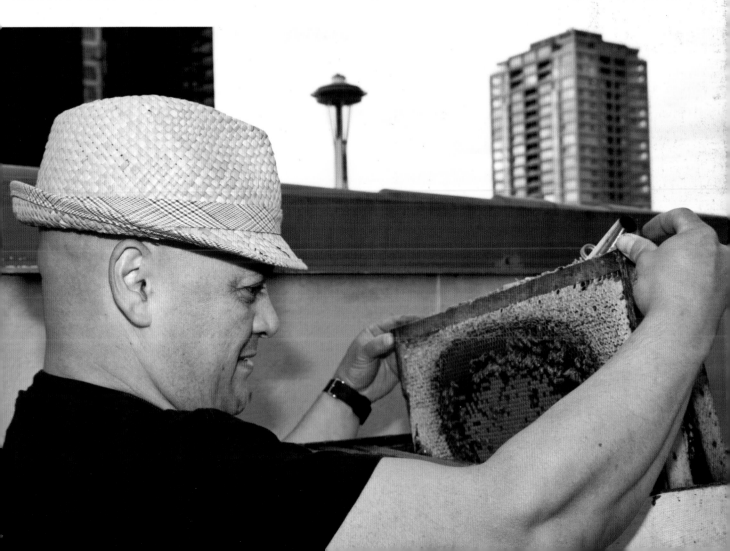

future of agriculture. It's a closed system that conserves resources, growing plants from the waste of fish and harvesting both fish and plants. He learned how to set up his aquaponics system from what he calls the "internet university," where he always goes first to find out how to do things. He again used mostly recycled materials: The fish are kept in a livestock trough at the bottom. Above it, a stainless steel medical cart holds the plants on one shelf and the filtering system in plastic barrels on the second shelf. The water is pumped in a closed loop from the fish to the filtering system to the plants and then back to the fish. He hopes to expand to eventually raise as many as fifty tilapia and tie the project to a vertical garden.

Lee says "the kids have been blown away" by his urban farm projects, and he hopes to continue doing more and on a larger scale. With 40,000 visitors a year staying at his immaculate hostel, his projects have the potential of reaching a lot of people. And he must be doing something right: City Hostel is rated as one of the top hostels in the country. Just by staying there, travelers might be motivated to put down roots with their own urban farm.

RESOURCES

City Hostel Seattle: **www.hostelseattle.com**

ABOVE A visitor heads into the historic hostel. OPPOSITE, LEFT TO RIGHT A finished self-wicking planter bucket. The plastic pot at the bottom of the top bucket is cut vertically to allow water to wick up to the plant's roots. The system works with rectangular buckets too.

Making a Self-Wicking Planter Bucket

Lee's self-wicking rooftop planter buckets are made from two 5-gallon buckets.

SUPPLIES

heavy-duty utility knife with extra blades

2 five-gallon buckets that fit inside each other,
 plus one lid

drill with 1-inch bit and ¼-inch masonry bit

1 small plastic pot or 1 drain gate (costs about $5)

1 mesh bag (the packaging that fruit comes in)

permanent marker

1 two-foot-long plastic pipe, 1 inch in diameter

hacksaw

rounded file

potting soil

DIRECTIONS

1. Using the utility knife, cut a hole for the small plastic pot (or drain gate) in the bottom of the top bucket that will wick the water. Trace the large end of the pot on the bottom of one bucket. Use the drill to make a hole and then the utility knife to carve it to the right size. Be careful; some types of plastic shatter. The plastic pot should fit snugly inside the hole you make.

2. Cut vertical slices or drill holes out of the plastic pot so water can flow through. If you are using the drain gate, skip this step. Line the plastic pot or drain gate with mesh. Use the drill to put some additional ¼-inch holes in the bottom of the bucket.

3. Mark the hole for the 2-foot-long pipe in the lid and on the bottom of the top bucket. The hole should be about ½ inch from the edge. Drill the holes.

4. Cut an angled segment out of the plastic pipe using your hacksaw. This is so water can flow out of the pipe.

5. Mark the hole for the plant. Drill and/or cut, depending on the size of the plant.

6. Use the rounded file to soften any sharply cut edges, then assemble. Put the plastic pot or drain gate in the bottom bucket. Put that bucket into the other, then put the pipe through the bottom hole.

7. Now you're ready to plant. Fill the top bucket with potting soil, and be sure the small plastic pot or drain gate is filled with soil. Pot your plant and carefully fit it through the hole you made in the lid. Water through the pipe on the side.

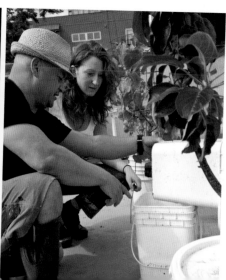

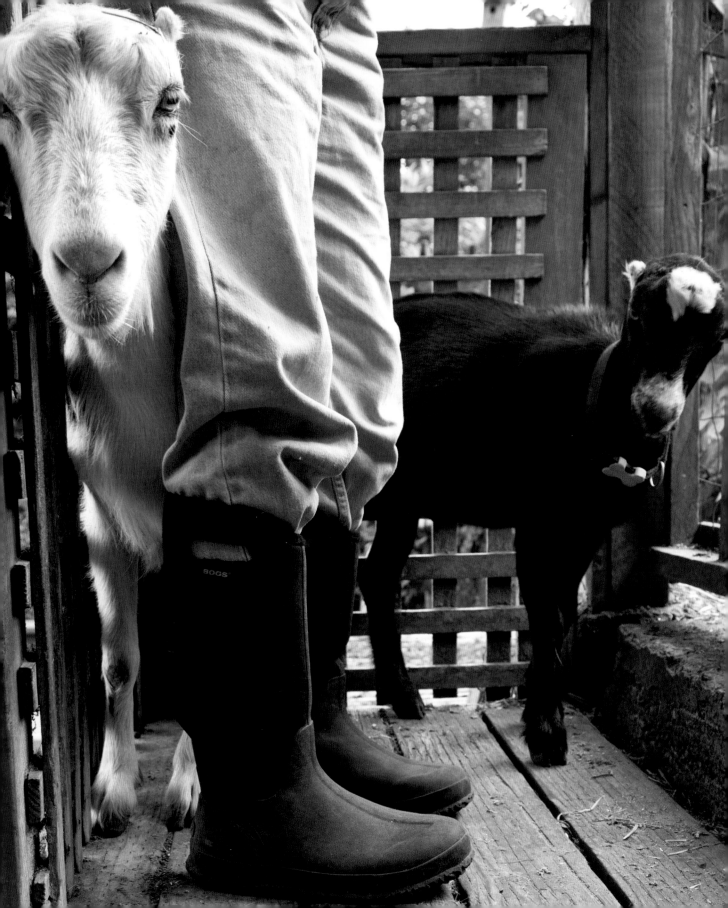

legalizing backyard goats

jennie grant
seattle, washington

JENNIE GRANT DOESN'T REGRET breaking the law. She figures someone had to keep goats illegally to challenge the Seattle law. Her story started in her backyard, a property that sloped down a hill and had a tangle of blackberries at the bottom. Her fixer-upper house had a beautiful view of Lake Washington, but a neglected area at the bottom of the yard wasn't sunny enough for growing. At that time she had already been growing vegetables in the upper garden and was interested in expanding her urban farm. She ended up making the space into a large chicken pen. Chickens are said to be the "gateway" animal, she laughs.

After settling in with the chickens, she tasted fresh goat's milk for the first time and was surprised at how good it was. It was like cow's milk, only richer, sweeter, and easier to digest. She also learned that goats and chickens get along well together. Her interest in keeping goats was piqued and she talked to her husband about it, but he kept saying no. Jennie found lots of reasons why

Jennie Grant keeps her two goats in a goat pen in her Seattle backyard.

they were a good idea and kept trying. In the end, she wore him down. She remembers it well. "He put his head in his hands and said, 'Just stop asking me.'" Jennie then checked with her immediate neighbors, who didn't mind, and she got her first two goats.

In 2007 one of her neighbors' kids came down with Q fever, a bacterial infection associated with farm animals. It was eventually discovered that her goats had nothing to do with the child's sickness, but it was too late; they had been reported to the health department. She then found out that in Seattle, no farm animals were allowed within city limits.

Jennie had no choice but to try to get the ordinance changed, and she was lucky to find her local city council member eager to help. Richard Conlin was a big proponent of local food. His assistant even had chickens. They helped Jennie get an extension allowing her to keep her goats until the city could have a hearing on the matter.

She organized friends and made a petition to change the law to allow goats. They went to local farmers markets and the Seattle Tilth Harvest Fair with her goat Snowflake as the ambassador. They eventually gathered 1,000 signatures. After a reporter asked her

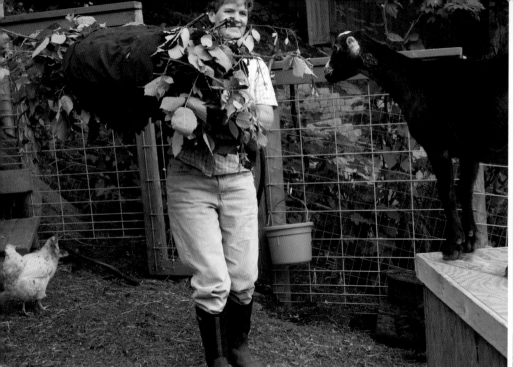

Foraging Healthy Weeds for Goats

Goats are browsers and are designed to like eating brush, trees, and bark more than grass. Milk-producing goats put a lot of energy into producing milk and need a protein-rich diet. Jennie has done research on which weeds are good sources of nutrition to supplement the expensive alfalfa of their regular diet.

Blackberry bushes: Blackberry leaves contain 16 to 21 percent protein and are high in calcium as well. Because of their invasiveness, they're free and easy to find. Jennie feeds her goats blackberry brambles every day in the summer and two to three times a week in the winter, when they're a little harder to find.

Nipplewort: Nipplewort is a common weed of the Northwest with 20 percent protein.

Kudzu: Common and invasive in the South, kudzu has 27 percent protein.

Goats also will eat ivy, rose clippings, and fruit tree leaves. Keep them away from poisonous laurel and rhododendrons.

how many members she had in her organization, she formed the Goat Justice League. She made cards for it that said "I'm pro-goat and I vote" so she could tally the number of card-carrying members, which eventually grew to over 100.

In the end, about 50 people showed up at the city council meeting to support goats. "It was a big goat lovefest," Jennie says, except for one opponent with a rambling dissent. The council voted unanimously to reclassify goats as small animals and to make it legal to have up to three small animals. Goats cannot weigh more than 100 pounds, males must be neutered, and they must be disbudded (have their horns removed).

Since then Jennie has become the go-to person for locals who become interested in keeping goats. She started a website for the Goat Justice League that includes all kinds of goat-keeping tips, from basic info to her favorite books and local goat veterinarians. She also teaches a class, City Goats 101, at Seattle Tilth, and has

ABOVE, LEFT TO RIGHT Jennie brings protein-rich blackberry branches to her goats every day during the summer months. Her yard overlooks Lake Washington.

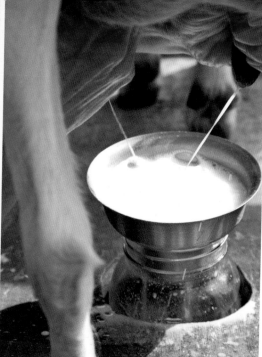

written a book. She gets emails from all over the country asking for help legalizing goat keeping. She recommends first finding a city council member who is sympathetic to the cause and soliciting help. It's also important to keep the goats tidy to make a good impression. Don't argue that they're pets, she says; use the "nuisance argument." In other words, argue that you should be allowed to own goats as long as they don't bother anyone.

Jennie loves keeping goats, despite the fact that they are "hardly practical." "It's much better as a pleasurable hobby," she says. She likes the fact that they are affectionate like dogs, but you get milk from them. She recommends mini Oberhaslis and LaManchas for the city because they are the quietest. "One loud goat could make a bad name for the entire caprine species." She says you have to have a minimum of two goats; they are herd animals, after all. It's also important to make sure your goats get along with each other before you commit

to them. Her goat Snowflake was never happy with other goats—until Jennie kept Snowflake's daughter.

Jennie says the work of keeping goats is unrelenting, and it's important to realize it before getting started. "When you get your goats," she says, "find someone in the neighborhood who would like to get goat's milk occasionally. Enlist that person to be your backup milker. You'll definitely need someone to fill in once in a while."

Jennie's husband, Don, eventually came around to liking goats. He realized that Jennie's interest in them wasn't just a whim, and he's seen how much they've done for her. The kids are entertaining and cute. Besides, they're even legal now.

ABOVE, LEFT TO RIGHT Jennie gets some help cleaning the chicken coop. She filters the goats' milk during the milking process. Jennie goes through the paperwork she collected to get goats legalized in the city.

RESOURCES

Goat Justice League: **http://goatjusticeleague.org**
Seattle Tilth: **seattletilth.org**
City Goats: The Goat Justice League's Guide to Backyard Goat Keeping, **by Jennie Grant**

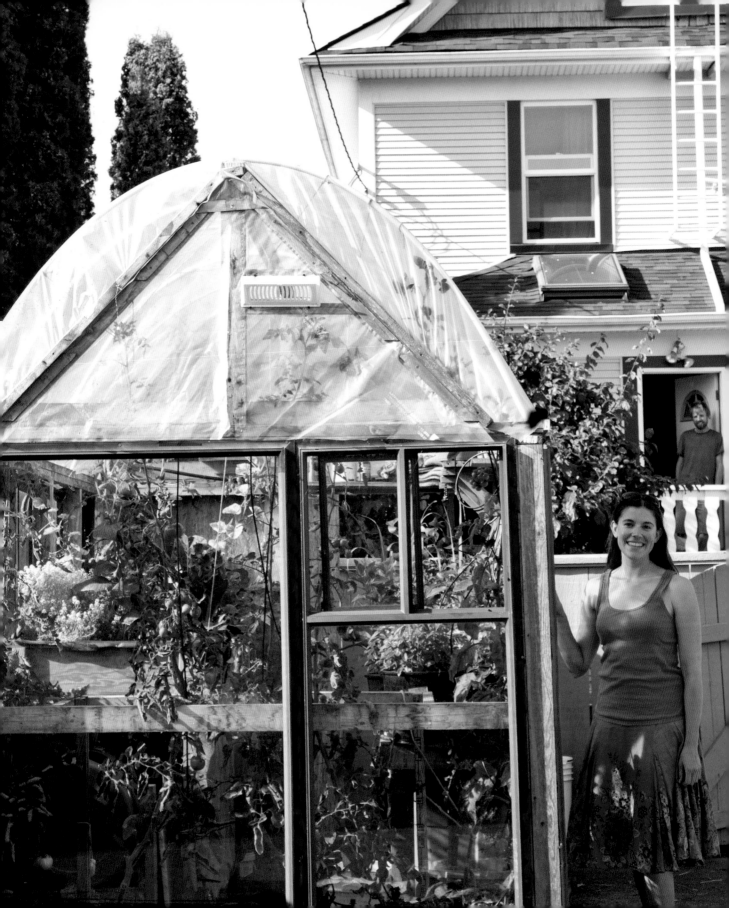

backyard aquaponics

jodi peters
vancouver, british columbia

JODI PETERS FIRST FOUND OUT about aquaponics when she researched it as part of her permaculture internship at Linnaea Farm in British Columbia in 2009. It's a sustainable system that combines raising fish and plants for food in a closed loop. The plants are grown in water using the nitrogen from the fish waste as fertilizer. The plants absorb the waste and the clean water is pumped continuously back to the fish. Wetlands use this same filtering system.

Jodi sees it as a perfect technology for cities. "We have to find a way to grow food without destroying the planet. With aquaponics," she says, "we have the potential to raise more food per square foot than with any other system." Aquaponics systems can be built where traditional gardens are impossible, like in a parking lot or a basement. Conventional agriculture uses up to six times more water than aquaponics, which naturally conserves water. The environmental impact is minimal, since the waste is recycled back into growing plants. Jodi finds it's also a great way to teach kids about ecosystems.

Jodi Peters set up a backyard aquaponics system with Jeff Radke in Vancouver.

When she returned to Vancouver after her internship, she began to work with the Environmental Youth Alliance on a project for a nearby high school. "They were a fantastic group of kids who were really interested in food security." With Jodi's help and a free online do-it-yourself guide, they built an experimental system called Barrel-Ponics in a greenhouse. Designed by Travis Hughey of South Carolina, Barrel-Ponics is a simple, easy-to-build introduction to aquaponics involving three food-grade plastic barrels connected with PVC pipes and powered by pumps. Jodi was a little dubious at first because the students had discouraging problems like leaky pipes and clogs. She says making it through the first year is crucial, because that's when the learning curve is really steep. The students did make it, and they ended up winning their school a $1,500 prize in an annual province-wide environmental action contest. The system is still up and running today.

Jodi and her husband, Jeff Radke, then set up their own system in an empty parking space behind their rental house in central Vancouver. Jeff designed the system using some principles from Barrel-Ponics, but also introduced some new ideas. Jodi explains the two

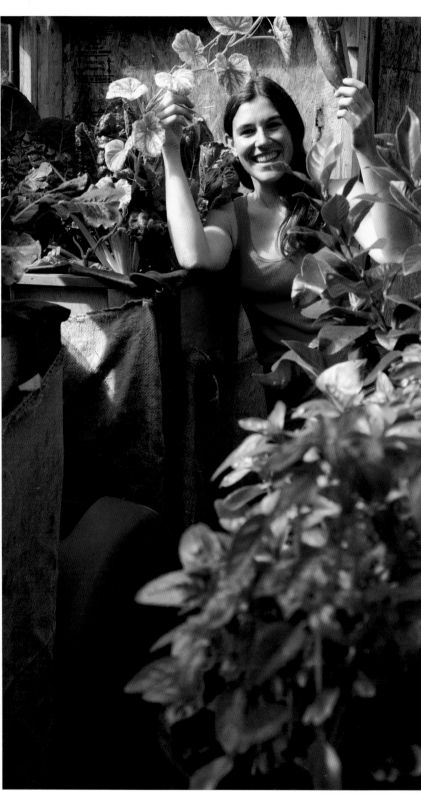

Getting Started in Aquaponics

- *Take time to choose the best location: You will need access to electricity and a spot that will not be damaged if you have a leak. If possible, set up your system in a greenhouse so it will be protected from the weather in winter. Using a water heater for the fish in the winter will also warm the surrounding air for your plants.*
- *Use the Internet: Read blogs, forums, and websites to learn all you can about aquaponics. Jodi recommends reading about DIYers' experiences; they will be the most valuable, she says.*
- *Make friends with local retailers: The staff of your local high-quality aquarium, irrigation, or hydroponics store will be very valuable in bringing hydroponics and aquaponics together.*
- *Start small, but do start: Don't be afraid to learn from your mistakes.*

main differences: "Our home system uses a continuous trickle (Barrel-Ponics uses flood and drain), and our system has wood-framed grow beds with pond liner, instead of barrels."

Jodi and Jeff also decided to raise tilapia instead of the nonedible koi that the students had raised. Tilapia are fast-growing, easy to raise, and tasty in a variety of recipes. Importing them from the nearest supplier in the United States would have cost over $400, though, so they

ended up obtaining some from a nearby university aquaponics project.

The system, she says, required a lot of tinkering. They had their share of disasters, including clogged pipes and stolen electrical cords. In aquaponics, the fish and plants are so intimately connected that if there are problems with the fish for even a day, the plants can suffer. Also, the ratio of plants to fish needs to be exact.

"There were problems we couldn't solve by reading the manuals," Jodi says, but she was able to find help on aquaponics forums and blogs. For example, the plants need certain trace minerals. At one point she noticed that her plants looked healthy but weren't growing. She found that they were iron deficient and learned that the problem could be solved by throwing a nail into the biofilter. As the nail rusts, it adds a small amount of iron to the water; the plant gets the trace mineral it needs, enabling it to grow normally.

OPPOSITE, CLOCKWISE FROM TOP LEFT Water that has been enriched with fish waste is recycled and used to grow vegetables. Jodi shows off the first cucumber of the season grown with her aquaponics system. Chard was the "superstar" of her system; it grew continuously for nine months without bolting. ABOVE The homemade clarifier unit is responsible for solids removal, one of the most important functions in the aquaponics system.

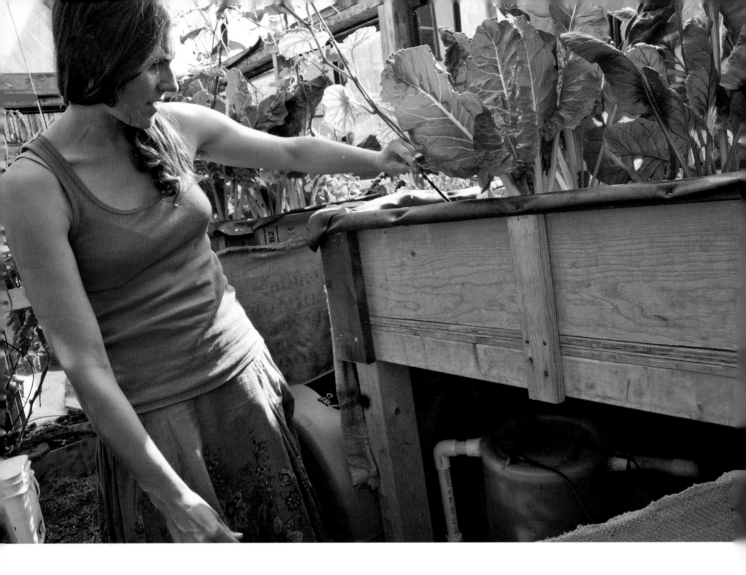

The couple had other, more serious problems as well. Their landlord tried to evict them for using their parking space for aquaponics. They overturned the eviction but were forced to dismantle the project and ended up moving. In their new home, they set up a smaller system to raise tilapia and vegetables. It's wise to consult with the landlord, and perhaps with your city government to find out whether there are any relevant ordinances, before embarking on an aquaponics project.

Commercial aquaponics often concentrates on growing basil and lettuce for fast profit, but Jodi and Jeff have experimented with many different plants, including tomatoes, cucumbers, and cilantro. "The superstar," she says, "is Swiss chard." Her chard grew continuously for nine months without bolting. Curious about why that happened, she found that Swiss chard bolts only when there is a drastic change in the root temperature; it's not affected so much by the air temperature. Since the tilapia required consistently warm water (around 78 degrees F), the chard never bolted.

Next, Jodi says, she would like to find a fish food that is more sustainable. Some fish food is made with genetically modified soybean meal, while other fish foods are harvested unsustainably from wild fish. She'd like to find fish food that is neither. She'd also like to use solar power for the pumps.

Aquaponics is a lot of work and it's not for everyone, Jodi says, but her dedication was reaffirmed when she first tasted the fish. "They were so delicious!" She also feels there is huge interest in aquaponics now, and the time is right for it to really take off. "When I first started studying it, 95 percent of the people I talked with had never heard of it, but now there is a critical mass and it's even being taught at universities."

OPPOSITE Jodi checks to make sure the micro-irrigation tubing that distributes water throughout the growing bed is not clogged. ABOVE Jodi has raised a dozen tilapia in her aquaponics system.

RESOURCES

Faith and Sustainable Technologies (Travis Hughey's free downloadable brochure on Barrel-Ponics): www.fastonline.org/content/view/15/29

Backyard Bounty page on aquaponics: www .backyardbountycollective.com/aquaponics.html

Linnaea Farm: www.linnaeafarm.org

The Urban Farming Guys (Jodi's favorite inspirational site about serious food production, which has a great aquaponics video): http:// theurbanfarmingguys.com/aquaponics-how-to

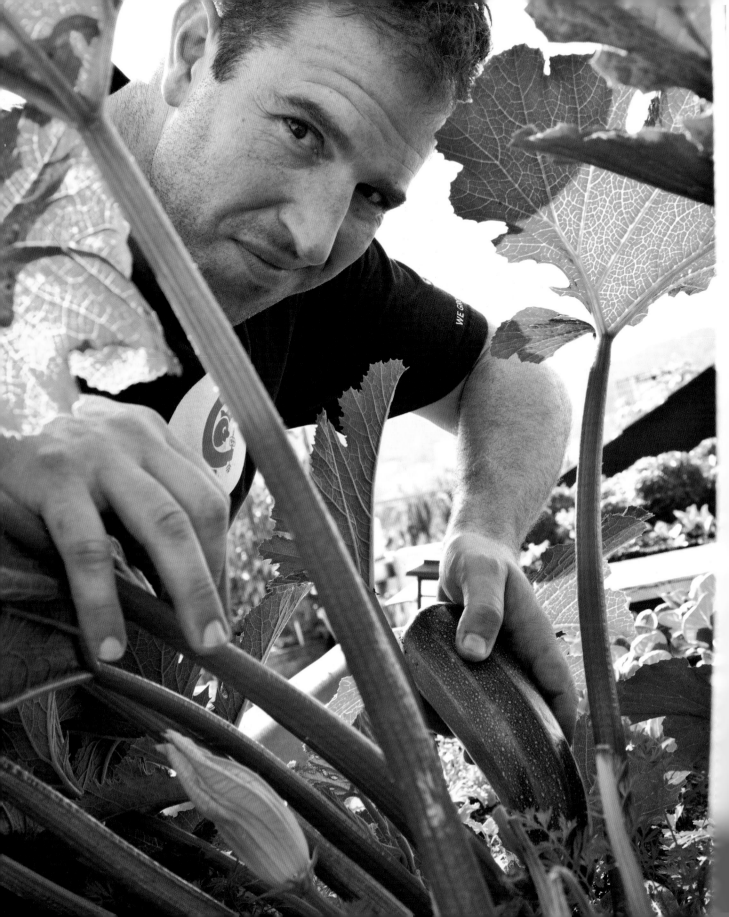

a restaurant's rooftop garden

noble rot
portland, oregon

CHEF LEATHER STORRS REMEMBERS the internship he had at Chez Panisse at the beginning of his career. He "was greeted by a stack of boxes, taller than me, containing lettuces. My job for the next six hours was to clean these little heads in a big sink of water." He hated it. "I stood over that sink cursing Alice Waters." He now understands the effect it had. It "installed a profound understanding of quality" that has stayed with him. "There is no substitute for fresh vegetables, carefully tended and harvested at their peak."

In 2008 he had the opportunity to grow his own produce when he moved his restaurant, Noble Rot, to the Rocket Building in Portland. Noble Rot, which he opened in 2002 with wife Courtney and partner Kimberly Bernosky, was already known for its nightly changing wine flights and local food. Moving to a LEED-certified green building that came with a 3,000-square-foot rooftop garden was an opportunity he couldn't pass up. It was a chance to innovate by experimenting with the actual growing and by producing food on-site.

Leather works with gardener Marc Boucher-Colbert in the garden. Everything is grown in containers, and fortunately, the building was already engineered to handle the weight of the garden. When they were first getting started, they experimented with different containers. They tried plastic round kiddie pools, but didn't like using the brittle, unrecyclable plastic that cracked easily. They ended up making all the beds out of different lengths of Douglas fir, 3 feet wide and 4 to 6 inches deep, a good comfortable working width and depth. The beds are lined lengthwise with a pond liner, and the ends are covered with landscape fabric that allows drainage. For soil, they use lightweight potting soil mixed with perlite.

Leather works with Marc to figure out not only what plants will grow in the shallow soil but also which ones will make great dishes. He's found that greens, peppers, and herbs do especially well, but they also grow eggplants, carrots, turnips, edible flowers, tomatoes, and more. The restaurant always features whatever is being

Chef Leather Storrs harvests a zucchini from the rooftop vegetable garden above his Portland restaurant, Noble Rot.

harvested from the garden. "We work the supply side," Leather says. When they had a bumper crop of peppers last year, he roasted them, pickled them, stuffed them, and made piperade.

Marc takes into account many variables when they plant. Fast-growing plants are important, but they are also interested in unusual varieties. They like to grow things they can't get at the farmers market. Last year they grew an unusual small-leaf basil, for instance, that they used in dishes and garnishes.

The rooftop garden is also useful for growing plants that don't store well, such as mustard greens and arugula, since the harvest-to-table distance is short. These greens tend to wilt and turn yellow quickly after you buy them, so having them accessible for easy harvest is ideal. Harvesting a plant or herb at a different stage than what is available at the market is something they experiment with too. They found that the green seeds of a cilantro plant are a lot like capers and make an interesting addition to recipes.

Another consideration for rooftop gardens is the accessibility of water. Noble Rot is lucky to have access to a natural aquifer under the building for its water use. Roof gardens get full sun and intense wind and require watering often. They installed a drip irrigation system for their plants, and they also water by hand. Marc says nutrients from the shallow soil are depleted quickly. He generally adds a balanced fertilizer with every planting, something that contains bonemeal and chicken manure.

The Noble Rot garden's biggest production months are from June to October, when the restaurant gets close to half of its produce from the garden. During the winter, when very little is going on, Marc and Leather plan the spring garden. Marc loves to pore over seed catalogs; his favorites are Johnny's Selected Seeds and GrowOrganic. He starts many of the plants at home under grow lights or in a greenhouse as early as January, and keeps the seedlings coming so the next crop is always waiting in the wings.

Marc says working with Leather creates a great synergy because he's so passionate about food. "The garden is the soul of Noble Rot," Leather says. "It's all about the dirt-to-plate connection. It's something we've lost that I want to bring back."

BELOW, LEFT TO RIGHT The rooftop garden produces endive, butter lettuce, and a tiny-leaved variety of basil.

 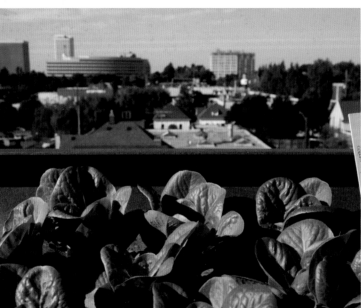

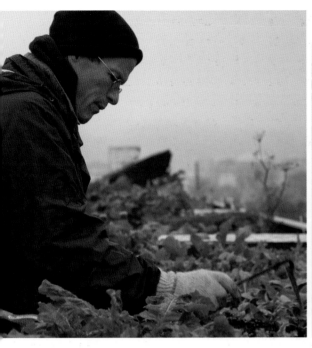
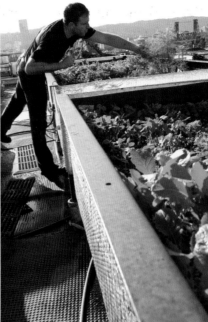
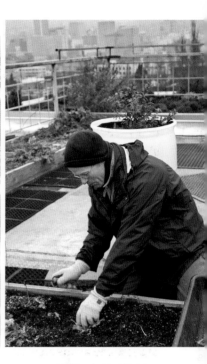

Planning Your Rooftop Garden

Make sure your roof can handle the weight. Figure out the square footage of the planting area and the weight of a fully saturated square foot of soil, then check with a structural engineer. Remember that the edges are the strongest part of a roof.

To reduce the weight, use lightweight containers and a potting soil mixed with either perlite or pumice. Marc recommends amending the soil with fertilizer with every planting.

Make sure water is accessible. A drip irrigation system, or at least a hose bib, is useful. If your roof can handle the weight, a rain barrel collection could be ideal.

Here are some plants to try growing:

- *Greens are a fast-growing option, but must be well watered. Arugula is one of the fastest-growing greens; it's ready to harvest 21 days from germination. Many lettuces are ready to harvest in about 40 days.*
- *Herbs are ideal, especially Mediterranean varieties that are more drought resistant, such as oregano,*

rosemary, lavender, and thyme. They are also a good investment, since the sprigs can be pricey at the farmers market or grocery stores.

- *Carrots will do well if you have at least 6 inches of growing depth. Peppers will grow well if you get enough heat. Turnips and radishes will grow well in less soil, since their roots start at the soil line.*

ABOVE, LEFT TO RIGHT Marc Boucher-Colbert weeds the winter greens in Noble Rot's rooftop garden. Leather harvests vegetables in August. Marc prepares a bed for planting.

RESOURCES

Noble Rot: www.noblerotpdx.com
Johnny's Selected Seeds: www.johnnyseeds.com/
GrowOrganic: www.groworganic.com

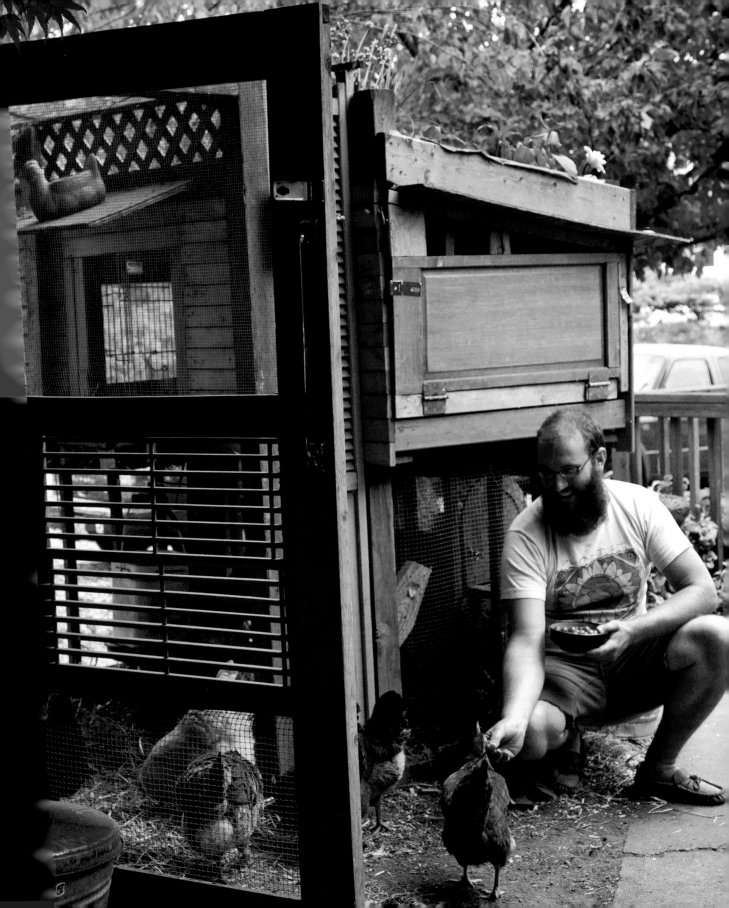

a chicken coop co-op

jake harris and emma klein
seattle, washington

THE FIRST THING YOU NOTICE when you arrive at Jake Harris and Emma Klein's place in central Seattle is, as Jake describes it, "the front-yard chicken palace." Right next to the sidewalk, this 6x24-foot enclosure is built almost entirely from recycled material and found objects, down to the screws reused from an old wheelchair ramp. A creative, free-form structure, it has been the subject of local media attention over the years. The coop incorporates a tree that provides roosting possibilities and a fence that runs along the property line. Its nesting enclosure has a green roof planted with herbs and a window that looks out on the street. At night the chickens roost in front of their sidewalk window, providing a chicken TV show for anyone walking by.

Jake and Emma's decision to put their chicken coop in the front yard was no accident. A real community builder, the coop attracts neighbors who like to stop by and visit the hens. "People meet at the coop. They learn the names of the chickens. They bring the kids." Jake's

Jake Harris lets the chickens try some cherry tomatoes at the door of his Central Seattle "front-yard chicken palace."

gotten so much interest that he regularly teaches a Joy of Chickens class for folks who want to get a flock of their own. He calls the chickens "farm ambassadors: they really connect people to food in a way that vegetables can't."

Another advantage of the setup is that the coop is also a co-op. It was Emma's idea to start a chicken co-op and to call the venture a "coop-op." By having eight chickens, the legal limit in Seattle, the group gets the maximum benefit with the least amount of work. They rotate the chores of cleaning and buying supplies every month and divide the eggs weekly according to shares. Emma and Jake feed the chickens and collect the eggs, since those chores are easiest for them to do, but all of the other tasks are shared. The arrangement is handy when someone goes on vacation, since there's always someone to fill in.

Jake and Emma also grow vegetables in their front and back yards. They are creative with the beds: in the parking strip is a large butterfly-shaped raised bed made from found cinder blocks and stones. They enriched the soil using a method called "lasagna gardening." It involves assembling layers of carbon and nitrogen, grass clippings, dead leaves, and chicken compost to naturally build the soil. In the backyard they grow grapes and have

several fruit trees. Under the fruit trees the two have had success with wine cap mushrooms, which Jake says grow easily in damp Northwest conditions.

Community building through a front-yard chicken coop is just one of Jake and Emma's passions. Emma sells organic produce at the farmers market, and Jake's edible-landscaping business, Stone Soup Gardens, builds raised garden beds and chicken coops for clients. In 2009 Jake and Emma became involved in a campaign to reduce plastic bags in Seattle by instituting a five-cent surcharge for them at stores. "Plastic bags are the ultimate symbol of throwaway products," says Jake. But while he's serious about the issues, he likes to keep things fun and engaging. The two make "Bagmonster" costumes out of hundreds of plastic bags and wear them at fairs and parades, where their eye-catching outfits raise awareness and get media attention. Although the 2009 campaign was unsuccessful, the initiative was reintroduced and passed three years later. Plastic bags are now banned in most Seattle stores. The Seattle Bagmonster continues to educate children at local schools about waste issues.

Running a Chicken Co-Op

Emma loves the chicken "coop-op," as she calls it. Here's the system she set up.

- *To start the coop-op, Emma organized a group of neighbors to invest in the birds. Each chicken equaled a share of ownership. It works best if members live within walking distance of the chicken coop.*
- *Eggs are tracked daily, divided up at the end of the week by shares, and placed in an easily accessible central location for members to pick up.*
- *The hosts (those on whose property the coop resides) are responsible for daily feedings, egg collection, and care. Each month, one member is responsible for the other chores: cleaning the coop twice a month and purchasing food and hay. All expenses are tracked, and members pay dues quarterly, based on shares.*
- *Most importantly, several times a year members get together for potlucks to enjoy one another and their flourishing flock.*

RESOURCES

Stone Soup Gardens (Jake's website): stonesoupgardens.com

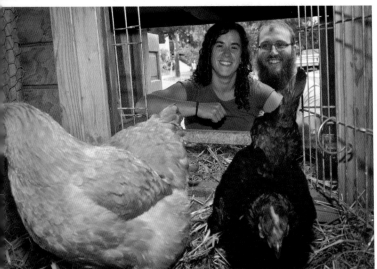

LEFT, FROM TOP Emma Klein and Jake check their hens. They grow greens in their winter sidewalk garden. OPPOSITE, CLOCKWISE FROM TOP LEFT Jake designed the coop to be easy to clean with one quick sweep. The coop's door handle is made from an old towel rack. Co-op member Emily German and baby Eloise come by to collect eggs. The chickens roost nightly in the coop's window.

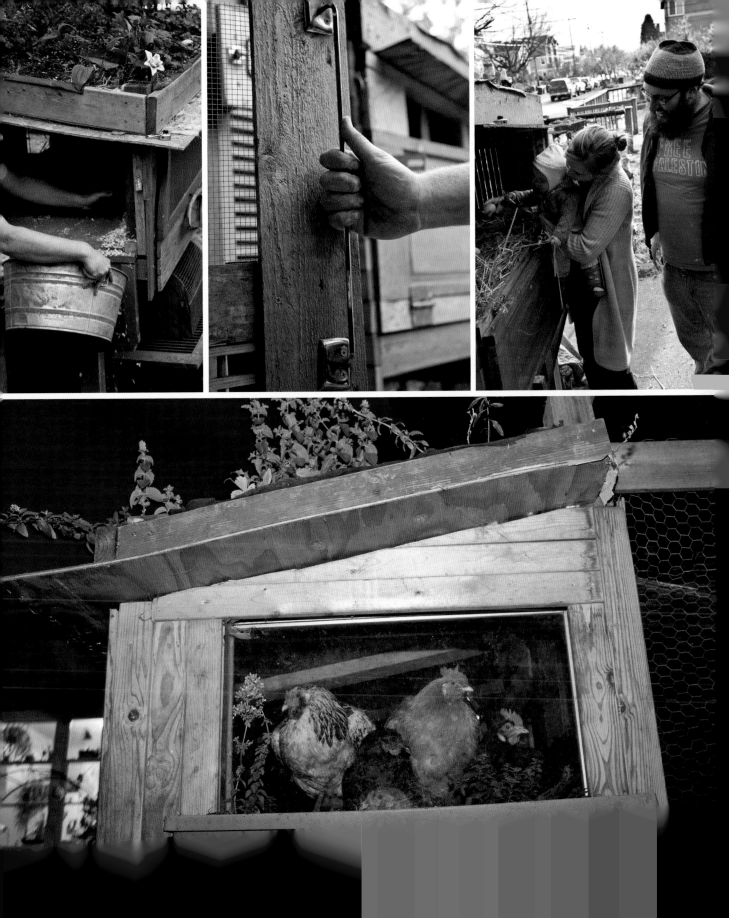

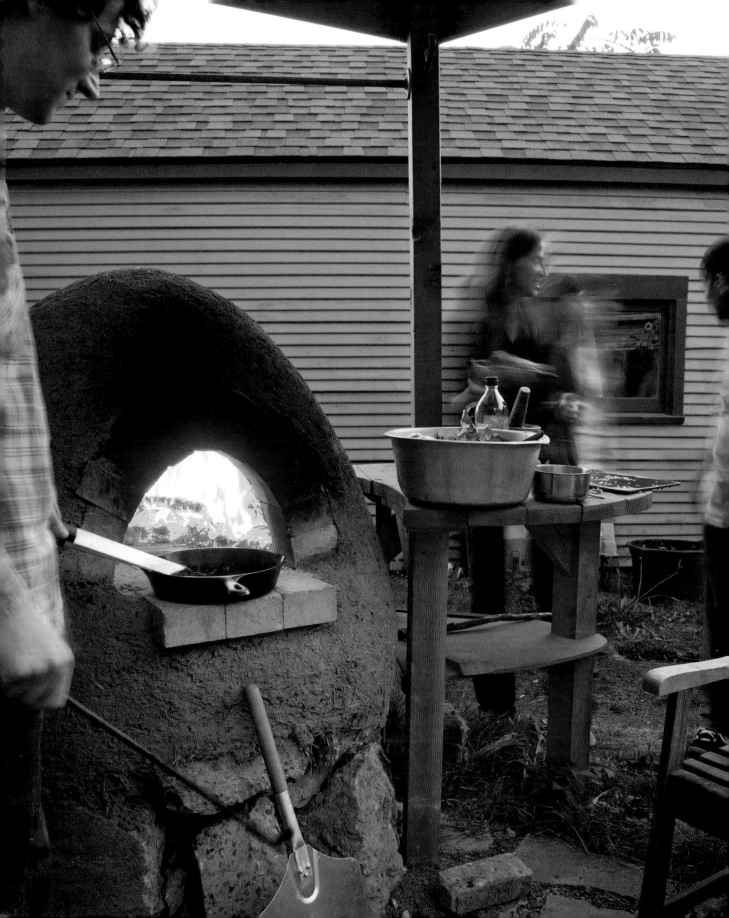

a cob oven
for backyard cooking

stephen osserman
portland, oregon

THERE'S NOTHING LIKE SERVING wood-fired pizzas topped with tomatoes and vegetables you grew yourself. Stephen Osserman says his outdoor cob oven is a great way to cook for friends. "The oven gets to over 700 degrees, perfect for cooking breads and pizzas. Once I made forty-five pizzas in two hours for a big backyard party." He says the oven gets so hot that his pizzas cook in two to three minutes. The thick walls absorb the heat and conduct it directly, giving bread and pizza that crispy, puffy texture that everyone loves. "People have often told me it's nothing like the typical pizzeria fare they usually have."

Cob is the name given to building material that uses clay, sand, straw, water, and earth. It's been around since ancient times and is used to make all kinds of structures, but with its thick fireproof walls it's ideal for ovens. It's popular now as a way to build sustainably and locally.

It's also an inexpensive way to build, and cob ovens cook without using fossil fuels.

Stephen gives all the credit for his cob oven to Kiko Denzer, author of the well-known book *Build Your Own Earth Oven*, which has sold over 50,000 copies. "If you can make mud pies, you can build a cob oven," Kiko says. In 2008 he led a workshop at Stephen's house where ten people came and learned the process. They started by making a circular foundation of broken concrete chunks, which lifts the oven off the ground to an easy-to-work counter height. Next a layer of insulating clay and sawdust was added and then fire bricks were leveled in sand, forming the base of the oven. Before building the dome, an arched doorway of bricks was formed, mortared with sand and clay. The dome was made of mud, clay, soil, sand, and wood chips. The chips burned up, forming a pumice-like surface. A dense layer of mud and plaster formed the outer surface.

Stephen uses his oven every month or two, but it's especially popular for large gatherings during harvest season. He loves growing more food than he can eat and inviting friends over for a feast to share his backyard

Stephen Osserman loves cooking for friends in his backyard cob oven in Portland.

bounty. He usually starts a wood fire in the back of the oven about an hour or two before the feast, depending on how much cooking he's planning on doing. When the ashes start to incinerate and the walls have turned from black to a terra-cotta color, he knows the temperature has reached close to 700 degrees F. His favorite foods to cook in the cob oven are breads and pizzas, but he has also grilled fish and cooked quiches, stews, and many other dishes. At the end of the evening he often puts a big pot of beans in the oven to cook overnight. As the oven slowly cools down it acts like a slow cooker, giving the beans a delicious smoky flavor when done.

He's lived in his Northeast Portland home for several years, slowly transforming the yard by planting more and more edibles. Fruit trees, raspberries, blueberries, tomatoes, peppers, greens, favas, squash, and more populate several large backyard beds. Recently he even had success with corn in the front yard. He also is a member of Portland's Urban Farm Collective, a group that works to transform vacant lots in North and Northeast Portland into public vegetable gardens. The group involves neighborhood kids and gardeners and uses a barter system in which members can exchange work time, land, or their own extra vegetables for produce. It makes sense to Stephen, who says gardeners tend to have more than they need. He often takes extra produce to the collective's Monday night exchange.

Building with Cob

Here are a few tips from Kiko Denzer's website:
- *Start small. Build a muffin-size oven to start with; it will build your confidence.*
- *Involve friends, neighbors, and family. It's more fun to build with other people.*
- *If possible, find a location for the oven where it can be shared and used for group gatherings. Cooking and eating together are great ways to build community.*

RESOURCES

Build Your Own Earth Oven, by Kiko Denzer
Urban Farm Collective:
www.urbanfarmcollective.com
For other natural-building plans and ideas, visit
www.greeniacs.com, www.heatkit.com
(brick oven page), and **www.small-scale.net /yearofmud.**

OPPOSITE, CLOCKWISE FROM TOP LEFT Stephen harvests vegetables for a summer gathering. A pizza cooks quickly in the cob oven. Stephen grows tomatoes, tomatillos, squash, greens, and much more in his backyard. He and a housemate pick berries. ABOVE Stephen blows ashes out of the cob oven.

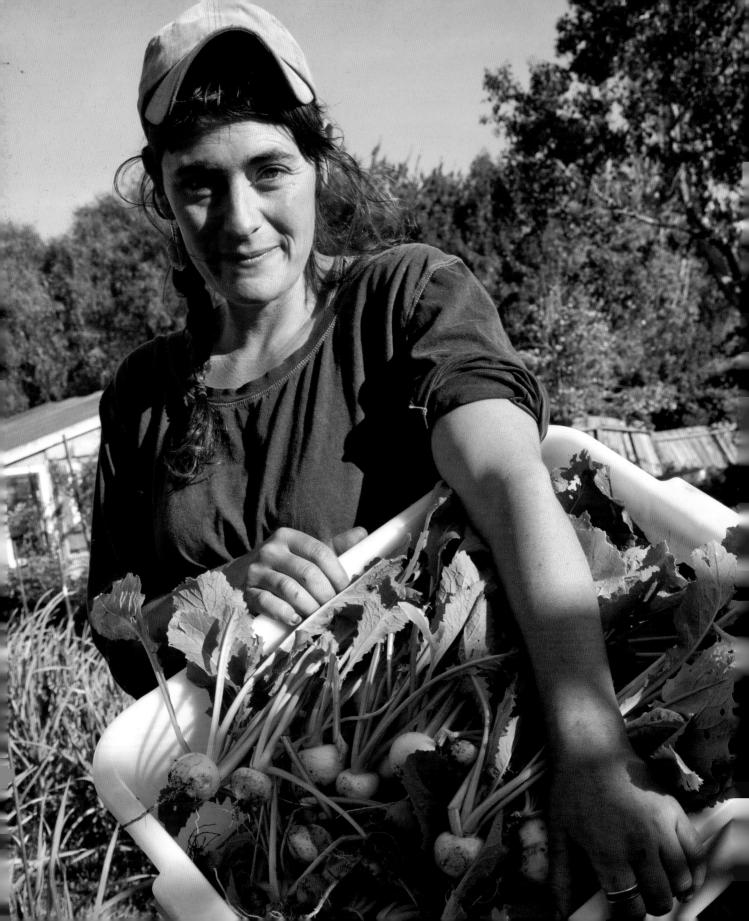

fighting for a farm

little city gardens
san francisco, california

IS IT POSSIBLE TO MAKE a living as an urban farmer in San Francisco? Caitlyn Galloway and Brooke Budner embarked on an experiment to find out. Their odyssey began simply, as two friends who enjoyed gardening together. They didn't realize that they would become the first legally operating small commercial farm within San Francisco city limits, and that they would have to change a zoning law and become farming advocates just to make it possible.

Their journey began in 2007, when Brooke discovered a hidden weed-filled lot while looking down from her rooftop in the Mission District of San Francisco. She contacted the property owner, who agreed to allow her to garden the lot. Caitlyn, who also lived in the neighborhood, met Brooke through a mutual friend and began helping her. Having discovered their shared interest in growing food, they began a part-time business selling their vegetables and herbs to a restaurant, some caterers, and a handful of neighbors. Particularly well received

Brooke Budner holds freshly harvested turnips from Little City Gardens.

was their spicy salad mix, which contained a few dozen different greens.

After a while the demand was greater than the amount of food they could produce, so they decided to take it to the next level. "We weren't naive, and we knew it wouldn't be easy," Brooke remembers, "but we wanted to try to turn the backyard project into a business." They found their current location with the help of Google Earth. It's a long, thin lot nearly an acre in size that runs behind a block of houses in the Outer Mission neighborhood. The property used to be Cayuga Creek. It offered rich soil, a high water table, and full sun.

The owners were hesitant, yet open and curious about the project. They ended up letting the two use the property for the price of liability insurance and the promise to beautify the space. The caveat was that they had to tell everyone in the surrounding neighborhood that it was a temporary arrangement that could end anytime. The owners were trying to sell the property and didn't want the neighbors to demonize them if a new buyer wanted to develop the land. Caitlyn and Brooke said the caveat was a "heartbreaking" reminder of their temporary situation. It's also indicative of the biggest

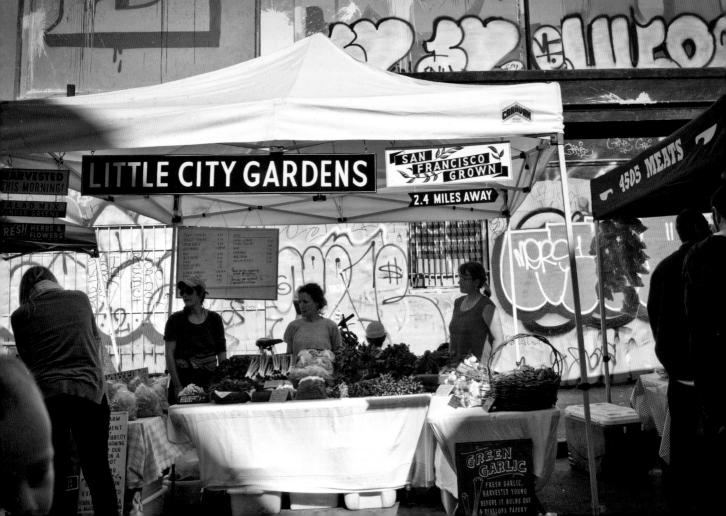

obstacle to urban agriculture—high property values that often make long-term arrangements difficult.

After their initial success in finding the lot, Brooke and Caitlyn immediately faced a potential deal-breaker. It turned out they needed a conditional use permit to grow food commercially within city limits. Getting the permit would cost over $2,000 and involve architectural drawings, public hearings, and more headaches.

Since they couldn't afford the permitting process, they decided to fight the requirement. They reached out to friends and customers on their blog, asking them to send letters to the mayor. After all, San Francisco was known for its progressive food politics; in 2009, the mayor had issued an executive directive on healthy and sustainable food that, among other things, encouraged conversion of unused city-owned lots, median strips, and rooftops to food production.

It took almost a year, but the city agreed to change the zoning law to make it easier for small farmers—those with less than an acre of land—to sell their produce. The mayor presided at Little City Gardens' celebration of the signing of the new ordinance. They were the first commercial farm to apply for the new change-of-use permit, which cost a much more reasonable $300—although even that was a "hairy process" that took hours of time, Caitlyn recalls.

OPPOSITE, CLOCKWISE FROM TOP LEFT Root vegetables offered for sale. The sign tells people just how local Little City Gardens' produce is. Caitlyn Galloway helps a customer. Brooke and Caitlyn sell their produce at the Mission Community Farmers Market.

Marketing Outlets for Urban Farmers

In experimenting with different marketing outlets, Caitlyn and Brooke learned the benefits and challenges of each.

Restaurant sales: The two have nothing but good things to say about their restaurant connections, Bar Tartine and Mission Pie. Both chefs are "creative and flexible." Their restaurant orders were also the largest orders they received, which helped make the relationship efficient and financially successful.

CSA (community-supported agriculture): Having a strong CSA is the heart of Little City Gardens' business plan, and it's "one of the more socially fulfilling components of our business." Many of their subscribers are immediate neighbors, and all were big supporters of the endeavor. Because Little City is such a small farm, their box is not as diverse as the larger CSA boxes; they focus on their salad mix and include cooking greens, root crops, herbs, and, from time to time, flowers or

farm-inspired artwork. They get customers to prepay and pick up the boxes at either the neighborhood farmers market or the farm. They offer a sliding scale for low-income families.

Farm stand: They hoped to sell surplus produce at a farm stand during the once-a-week CSA pickup, but the farm's tucked-away location wasn't ideal for drop-in customers. The future location of the farm stand will probably determine its success.

Caterers: Caitlyn and Brooke found that caterers are the "best market for herbs, baby root vegetables, and edible flowers" and that these items bring the highest prices. They also found that the efficiency of working with caterers is highly variable. Some need lots of communication and special pickup times, while others place big orders and are easy to coordinate with. The two would like to work with more caterers, but they may establish a minimum order and set pickup times.

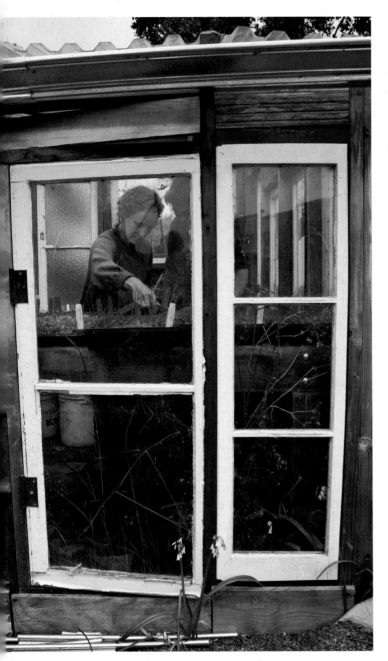

The two approached their new business seriously. They formed a partnership and wrote a business plan. They created spreadsheets and cost analyses to figure out pricing. They studied markets and developed strategies for selling their produce. To get the initial funding to buy equipment, they enlisted a filmmaker friend who made a short video about the project and posted it on Kickstarter, an online funding platform that helps connect creative projects with donors. They met their initial goal of $15,000 in only two weeks and eventually raised $20,000. The two invested the money in necessities such as an irrigation system, two toolsheds, a greenhouse, a washstand, and countless other start-up items.

Although they have yet to turn a profit, their year-end assessment was mostly positive. They were proud to have covered all their operating costs, put aside some money for the next year's materials, and paid themselves a small salary. They learned about the benefits of urban farming, which included community engagement, the opportunity for others to learn, and close proximity to markets. They also learned about some of the challenges: the high value of city property, which makes it difficult for farms to exist without the generosity of landlords; the high price of urban water; and the need to persuade people to pay more for high-quality organic food.

RESOURCES

Little City Gardens: www.littlecitygardens.com

ABOVE Caitlyn and Brooke check seedlings in their greenhouse. OPPOSITE, CLOCKWISE FROM TOP LEFT A view inside the greenhouse. Caitlyn harvests baby lettuce for their spicy salad mix. Caitlyn and Brooke pose with a fresh harvest.

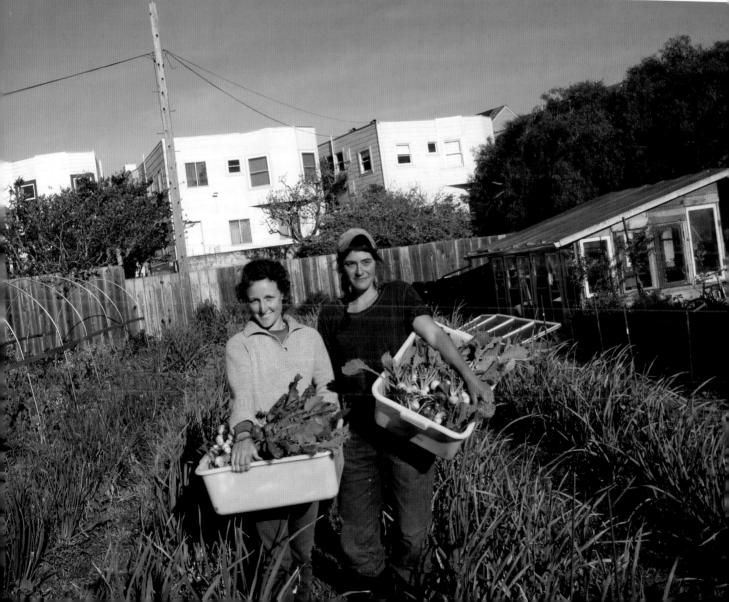

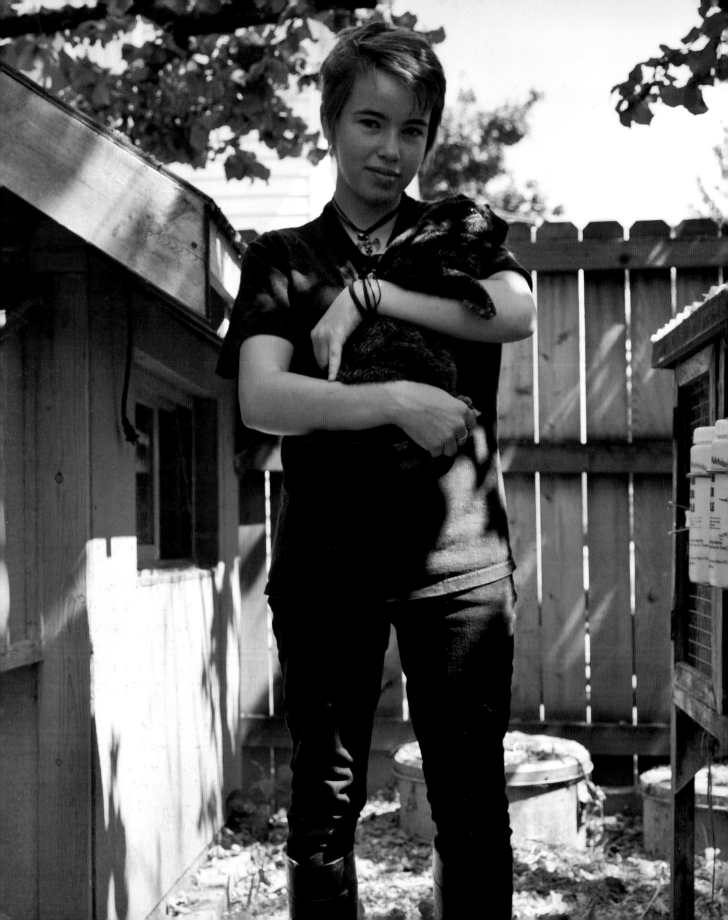

backyard believers

rebecca hazard and lori vail
seattle, washington

"FOOD IS ACTIVISM," Lori Vail says. "Every bite you put in your mouth is a political choice. Our political action is making food for our family." She and her partner, Rebecca Hazard, live their politics on their South Seattle urban farm, where they keep a large vegetable garden, chickens, milk goats, and meat rabbits.

Six years ago they and their children came close to moving to a seven-acre property outside the city. The plan fell through, but it was just about the time that goats became legal to own in Seattle. The couple realized they could give their kids a rural upbringing without having to give up their urban conveniences if they created an urban farm. Rebecca, who bought the house twenty years ago, says the yard used to be a typical lot with grass and ornamentals. The dirt was hard clay without any organic matter. She has worked hard to build the soil, and has composting bins all over the yard. She's not terribly scientific about composting; the "let it rot technique" always works, she says.

Kellen Vail, 16, holds a Silver Fox buck. Her family raises the endangered heritage breed of rabbits for meat on their South Seattle urban farm.

Both Lori and Rebecca can trace their roots back to hardscrabble agricultural pasts. Lori's family comes from Texas and Louisiana, and she remembers her maternal grandmother describing farms by the condition of the soil; a "black land" place meant one where you could thrive. Rebecca's grandmother, who died recently at the age of 101, used to barter milk, butter, cheese, and meat to help her large family during the Depression. "Everything had to be used. Nothing was wasted."

Lori and Rebecca are passing those values to their kids, who help with the chores. Kellen, 16, is the one who is most interested in the farm. She gets up at 5:30 AM to feed the animals and collect the eggs. She's always loved animals and feels a great sense of responsibility and devotion toward them. In fact, she's thinking about veterinary school.

Lori and Rebecca's large corner lot helps organize all the activity in the yard. One corner houses the goats and chickens, with a small barn-coop on one side. A large section next to it has raised beds. Five rabbit hutches line the side yard. There's also a very useful outdoor stainless steel sink and counter. But the yard is not all farm; there's a large deck off the kitchen, and the family likes

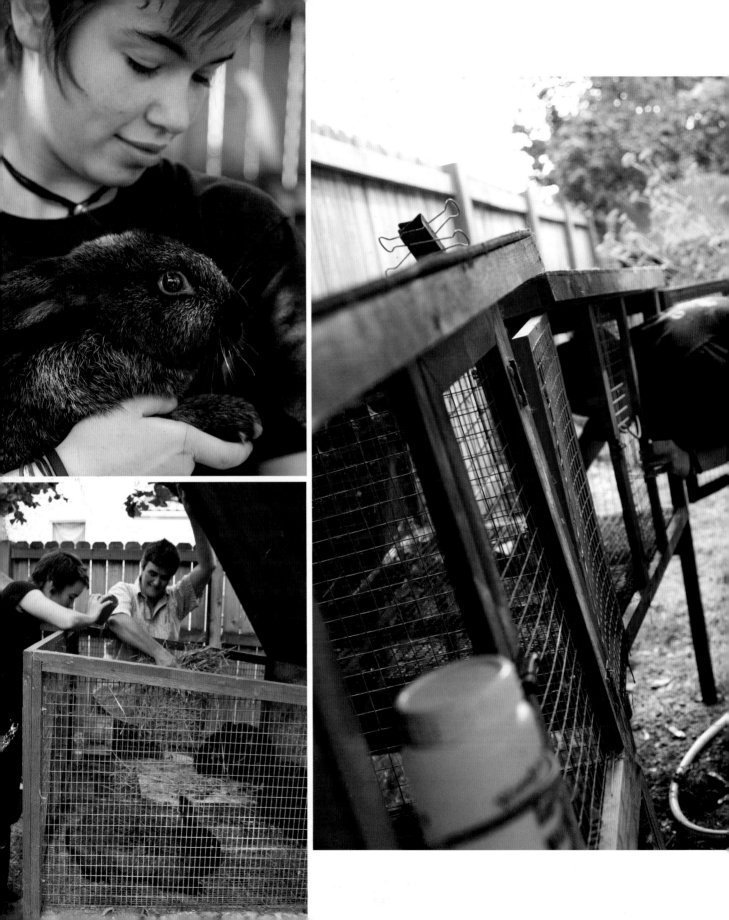

to eat dinner outside in the summer. The entire yard is surrounded by a 6-foot-tall fence, a needed security precaution in their neighborhood.

Rebecca started with chickens back in 2004 and then got goats. The couple has had raised vegetable beds

for five years. They have an entire bed dedicated to tomatoes, another one just for arugula, and another for herbs.

Rebecca was a vegetarian for twenty years, but started to eat meat again after discovering that she was anemic and had high cholesterol. The problem was that she did not want to eat factory animals. At first the couple bought bison meat from a friend who had a bison ranch. Then Rebecca became interested in raising meat rabbits after finding out that they are very efficient meat producers. They are ready to eat in sixteen weeks, they're quiet, and they don't take up much space. The meat is tender

OPPOSITE, CLOCKWISE FROM TOP LEFT Kellen holds a rabbit. She gives the hutches a good scrubbing every couple of months. Rebecca Hazard and Kellen feed the rabbits. ABOVE Lori Vail makes a French rabbit stew.

and lean. The manure doesn't even have to be composted. They raise a critically endangered heritage rabbit breed called Silver Fox. They have one buck and two does that produce about four litters a year. Each litter has five to ten kits. Rebecca makes sure to handle all the kits so they are used to people.

When it comes time to slaughter an animal, she sets it on the grass, between her knees, letting it calmly graze. She always waits for the animal to be peaceful; then, using a pellet gun, she quickly shoots the animal in the head. "It's very important that there's no suffering," says Rebecca. Lori and Rebecca put the highest value on the fact that their animals are well cared for and happy.

It's a lot of hard work having an urban farm. Lori says fall is the busiest season. She works as a writing teacher and comes home to cooking, canning, and making cheese. Dealing with the tomatoes alone is a big job; she cans them, dries them, makes chutney and marmalade, and even fries the green ones. But the food is all organically grown, fresh, safe, and delicious. Lori says it's how they make the world a better place.

RESOURCES

Mission Farrier School:
www.missionfarrierschool.com

ABOVE Lori, Kellen, and Rebecca hang out in their kitchen.

A Rural Job in the City: Becoming a Farrier

A farrier shoes horses and specializes in equine hoof care. Back when Rebecca was fourteen years old, she learned about farrier science at a lecture. She remembers being really interested and going up to the lecturer after the talk. He told her, "Girls don't shoe horses. Don't waste your time and don't waste mine." She was crushed and gave up on the idea, but mentioned the story thirty years later to Lori, who was horrified.

They discovered that one of the best farrier schools in the country, Mission Farrier School, was located only an hour from their home. Rebecca enrolled in its eight-week course and learned the natural balance method of shoeing horses, a way of working with each horse individually, adjusting the shoe to the horse rather than the other way around. The work requires old-world technology such as a forge and anvil, files, and other blacksmith tools.

Rebecca loves having a rural job that lets her work outdoors with animals. Being centrally located in Seattle enables her to serve clients within a 45-minute radius of the city. She also gets work trimming goat hooves at other urban farms in the city.

"Women make excellent farriers," a Mission Farrier School representative says. "About 40 percent of the students enrolled here are women."

BOTTOM, LEFT TO RIGHT Some tools of the farrier: the pull-offs, the horseshoe, the rounding hammer, and the anvil. Rebecca "boxes the heel" of a horseshoe with a rasp. Using a rounding hammer and the turning cam of the anvil, she turns the branch of a shoe.

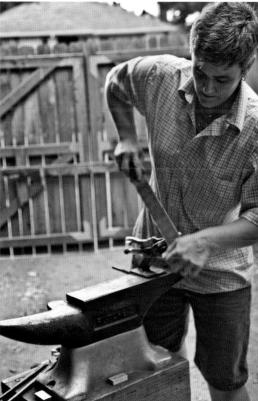
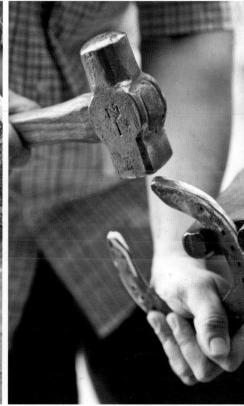

giving up the grocery store

rachel hoff and tom ferguson
vallejo, california

IMAGINE NEVER GOING to the grocery store. What started as a year-long challenge to eat locally is still going strong for Rachel Hoff and Tom Ferguson of Vallejo, California. "We don't set foot in a grocery store," Tom says, pausing for effect, "at all." In October 2010, inspired by a documentary called *No Impact Man*, Tom and Rachel decided to challenge themselves to stop buying from grocery stores, big-box stores, convenience stores, and restaurants. For a year, they would eat as much as they could from their own backyard and supplement what they couldn't grow by bartering or buying from farmers markets and local producers.

The couple, who live about 30 miles north of San Francisco, had bought their tiny house with a large lot a couple of years earlier with the intention of growing lots of food and raising chickens. They were already growing vegetables, and they had canned tomatoes, pickles, jams, and peppers on reserve. The chickens had been joined by goats, rabbits, and turkeys. Rachel, a

landscape design consultant by training, had designed the yard with long rows of beds in the center, 15 fruit trees along the back and side, and the goats and chickens in the far back. Tom, who works in the electrical supply business, had made the goat barn, chicken coop, and other structures from recycled materials; the turkey coop was made from pallets.

Rachel and Tom knew their experiment would require adjustments at first. Rachel found a local buying club that supplied organic staples such as rice, flour, oil, and sugar directly from the growers, for instance, but they still had no local source for milk at the outset. The goats hadn't been bred yet, and it would take months after that for them to produce milk. As time went on, however, things got easier. "We learned that you don't have to produce your own food to give up the grocery store, you just have to get out there and meet the people that produce your food," Rachel wrote on the couple's website. This knowledge took some pressure off the two during the winter, when there was not a lot of food from the garden, and then later when heavy rains and unseasonable coolness ruined their fruit crops and put everything behind schedule.

Rachel Hoff and Tom Ferguson's urban farm in Vallejo is just over a quarter acre.

Rachel got used to doing a lot of cooking. She made everything from scratch, and found that she enjoyed it. "It's more of a priority for us to make a good meal from scratch and eat it together instead of watching TV," she said in an interview during that year. She also found that some foods she used to buy were actually easy to make at home, and much tastier. Mayonnaise can be made quickly with an immersion blender, for instance, and making sausage can be as easy as combining ground meat and spices.

By late spring, the garden really began to produce. In June they harvested 47 pounds of food. It became so easy to get all their food from the garden that they decided to give themselves an extra challenge: for the last three months of the year, they would eat only food they had grown, stored, or bartered for.

Those last three months became the hardest part of the experiment. "We were stuck for weeks eating nothing but green beans, cucumbers, and zucchini," Rachel remembers. The charm of cooking had worn off, although Rachel had gotten much faster at it. She couldn't find any good recipes and made endless salads. They were also eating much less meat and dairy, but lots of omelets and frittatas.

At the end of the year, Rachel tallied the numbers. They had harvested 1,232 pounds of produce, 2,322 eggs, 251 pounds of meat, 60 gallons of milk, and 59 pounds of honey. The big winners in produce were strawberries, tomatoes, cucumbers, onions, and squash (all around 50 pounds each). In the meat department, the rabbits were the clear winners, with close to 90 pounds. Compared to the year before, when the couple had harvested only

OPPOSITE, CLOCKWISE FROM TOP LEFT Tom holds a midsummer harvest. Rachel picks spring carrots. The refrigerator and freezer are full of produce from the backyard. Tom and Rachel in the squash patch. ABOVE Strawberries were one of Rachel and Tom's biggest successes last year.

RESOURCES

Another Year Without Groceries (Rachel's blog): http://ayearwithoutgroceries.blogspot.com
Dog Island Farm (Rachel and Tom's website): www.dogislandfarm.com

Here are some tips from Rachel's blog:

- *Start small: Rachel suggests transitioning gradually. Start by replacing store-bought products with home-made ones. Mayonnaise is a tasty replacement that's easy and fast to make. Another idea is eliminating processed food from your grocery cart or giving up fast food.*
- *Shop at the farmers market or join a CSA: It's a great way to eat seasonal local food and support your local farmers. Rachel and Tom shop weekly at the farmers market.*
- *Find a meat CSA: If you have room in your freezer, you can buy larger quantities and save money. If not, go in with family or friends. Rachel and Tom bought a whole hog, organically grown, for $2 a pound.*
- *Find cookbooks you like, or be willing to experiment: Don't worry if you fail sometimes. Rachel's first breads ended up like bricks, but she was able to perfect her methods over time.*
- *Have the right tools: A pressure canner is a worthy investment. A food mill is great for removing tomato skins and seeds while making sauce. A mandoline is perfect for slicing.*

6 pounds of meat and no milk or honey, the farm had really taken off. Even with unexpected vet bills for the goats, the benefits were clear.

Rachel and Tom learned a lot from their experiment. They are healthier and happier, have saved money, are eating high-quality, organic foods, and have learned that they work well together. They know it's important to have food stored for emergencies, and they've developed a bartering system with friends. They've also met many people, and they enjoy sharing what they've learned on their blogs and in consultations.

Even though the last three months were hard, and living off their farm alone was too extreme, they stayed with their original plan of not buying anything from grocery stores for twenty-two months. In a blog post titled "Soy Sauce and Apricots Did Me In," Rachel describes how she hit her breaking point when she needed soy sauce for a recipe. But since then, they've modified their plan only slightly: they now buy only things they can't make or grow at home (such as wheat, sugarcane, or soy sauce). They buy from local farmers whenever possible, and never from giant supermarkets or big-box stores.

ABOVE Tom and Rachel in the garden OPPOSITE, CLOCKWISE FROM TOP LEFT Under the heat lamp, Tom and Rachel play with day-old kids. Rachel and her 13-year-old stepson, Paul, hold the day-old kids. Tom built the turkey coop out of pallets.

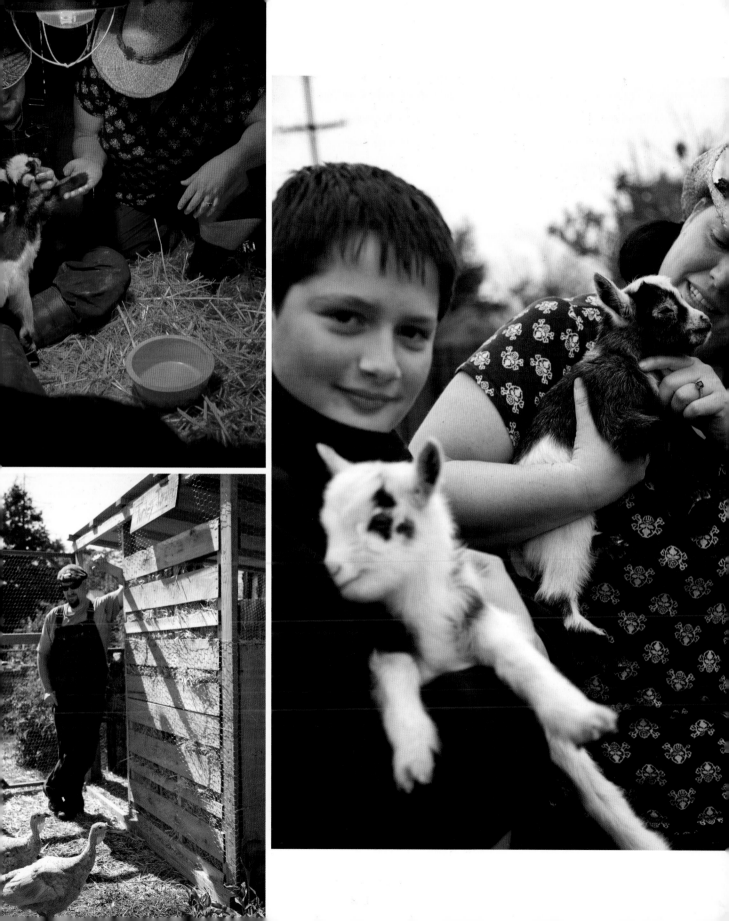

a cooperative adventure in goat keeping

going goaty
portland, oregon

HAVING BEEN IN A CO-OP for twenty years, Diane Meisenhelter is a true believer in community power. Back in 1991, she was involved with a cohousing study group. "We wanted to start a cooperative urban block," she says. About a dozen people were involved: three singles, three couples, and two single moms. They were similar in politics and interests, and they wanted to create a shared community. They would ride their bikes around town, talking to people and looking at houses.

They eventually found what they were looking for on Going Street in the Sabin neighborhood of Northeast Portland: a group of five vacant, affordable houses with varied layouts and large lots, all on one block. One was purchased together as a common house, and the other duplexes and single-family homes were purchased by individual members. With the exception of the common house, the group members kept their finances separate, but were committed to sharing resources and help-

ing each other. When they moved in, they literally took down the fences and their co-op, OnGoing Community, was born.

"It's like having a chosen family, a home base of strength that launches you out in the world," Diane says. Other advantages of the co-op include being able to support each other, get together socially, help each other with projects, and "not have ten lawnmowers." The worst conflict they ever had, she says, was over a tree that one member wanted to cut down.

One reason it works is because the group has been allowed to evolve organically. It's now composed of twenty to twenty-five people of diverse ages, from school-age kids to a member in her seventies. The different age groups give the community balance and keep the elders young. The cooperative environment is good for raising children too, as it provides many positive role models. Diane remembers trying to persuade her daughter to regularly ride her bike. The younger members of the co-op all rode bikes and challenged her daughter to do the same. "She listened to them and now is a bike commuter."

A mini LaMancha munches alfalfa at the Going Goaty co-op in Portland.

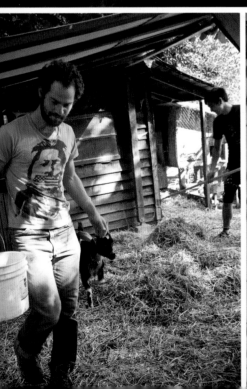

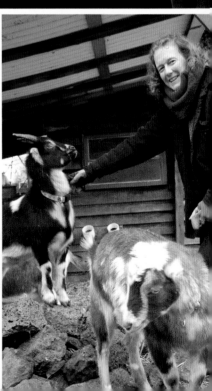

Several years ago, a co-op member next door to Diane brought up the idea of keeping goats. The co-op was already growing vegetables and had a shed and chickens, so it wasn't such a stretch. They converted an old playhouse to a goat barn and bought two mini LaMancha does, which they raised together and then had bred. One member had experience with goats and taught the others how to milk them.

Today the goats have become a co-op within the co-op. Going Goaty is organized by shares, and anyone from the larger co-op can join. There are six full shares and two half shares. New members pay $100 a share to join. A different person is responsible for milking each day, and the chores are divvied up. Emily Gowen, the treasurer, keeps track of expenses, which are split by share, and members make decisions by consensus at the co-op's monthly meetings. Members sometimes walk the goats in the neighborhood—a great way to build community, as people always stop to pet the animals and ask questions.

David Kurushima got involved in the co-op mainly because he likes animals; he used to take care of a goat herd on the coast of Oregon. He's been a member of Going Goaty since the beginning and is impressed by how smoothly it runs. "Most of us are in our twenties, and [having the co-op] allows us to go out of town when we need to."

Occasionally members must make tough decisions on their own. At one point, Kurushima had to deal with a goat that had been attacked by a dog. He took the goat to a 24-hour vet, where it received stitches and antibiotics. It was a decision that couldn't wait, but the group later agreed to split the costs.

OPPOSITE, CLOCKWISE FROM TOP Emily Gowen keeps track of milk production in a notebook at the Going Goaty co-op. Diane Meisenhelter is an original member of the co-op. Besides having monthly potluck meetings, the co-op uses a board to keep track of chores and money. Joel Shupack (left) and David Kurushima clean the goat pen.

Joel Shupack, one of the newer members, says the goats were a big factor in his decision to move into the co-op. He had worked at Goats with the Wind, a goat dairy in Israel, which was a beautiful, thoughtful operation: the animals were well cared for, the structures were artfully built, and everyone worked and shared meals together. He wanted to have that kind of experience again.

Diane says there are lots of benefits to the goat co-op. She likes having relationships with her food. "They are functional pets and keep you connected to the cycle of life. We all have artificial timelines, but when a goat is ready to be born, there is nothing more pressing. Besides," she says, "baby goats make me laugh."

Successful Co-Op Communication Skills

Co-ops are a great way to share the responsibility of goat keeping. But they depend as much on good communication between the members as on good goat care. Going Goaty co-op has monthly potluck meetings so members can stay in touch, and offers these tips:

- *Focus on values and relationships, not rules, meetings, and details.*
- *Keep it simple. Have fun and make it joyful.*
- *When others are speaking, practice active listening. Pay attention to the speaker, and make eye contact. Don't cross your arms defensively or distract from the conversation.*
- *If a problem arises, don't let it simmer; be open and talk about it. Try to see the problem from the other person's point of view. Empathize with them and take responsibility for your actions. Remember to begin sentences with "I" rather than "you." It's less defensive.*
- *When a problem can't be resolved by compromise, take a time-out. Consider classes in mediation, nonviolent communication, or creative problem solving.*

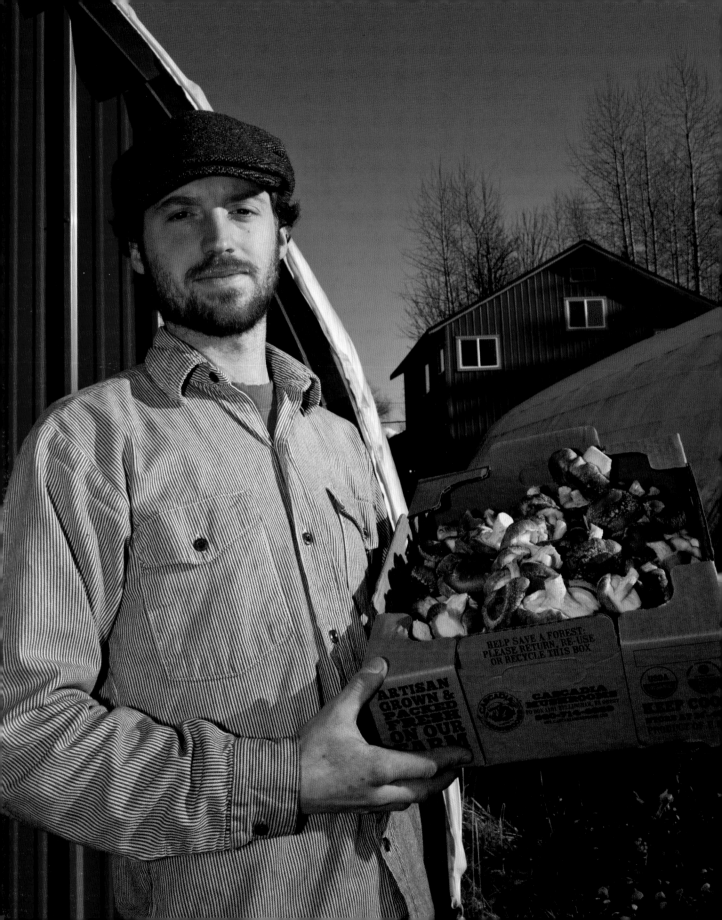

HELP SAVE A FOREST.
PLEASE RETURN, RE-USE
OR RECYCLE THIS BOX

ARTISAN
GROWN &
PACKED
FRESH
ON OUR
FARM

CASCADIA
MUSHROOMS

a hobby mushrooms into a farm

alex winstead
bellingham, washington

"MUSHROOMS ARE AMAZING. They are an incredible food source and one of nature's greatest medicines as well." Alex Winstead gets excited when he talks about the hobby that has now turned into his livelihood. "Mushrooms have a huge role in nature," he says, as "the first step in a chain of events that create soil."

Mushrooms are interesting organisms, neither plant nor animal. Unlike plants, they grow without sunlight or carbon dioxide, mostly hidden from view. The part we know as the mushroom is simply the fruiting part of a mycelium, the much larger organism that grows underneath the soil. In addition to their well-known uses for cooking, they have a role in helping the environment. Mushrooms are now being used in research labs to break down toxins and remove biocontaminants such as *E. coli* from soil and water. They also have medicinal uses such as fighting various cancers.

Alex started learning about mushrooms in an independent study class while getting his degree in environmental sciences at the Evergreen State College in Olympia, Washington. After graduating, he spent a couple of years working on a commercial mushroom farm. In 2005 he moved to Bellingham, where he noticed there was no local mushroom producer. He started growing mushrooms in his basement and garage and selling them at the local farmers market. The response was encouraging. He had other jobs—landscaping, meat cutting, farm work—to pay the rent, but he wanted to expand his mushroom business. He liked the creativity and the immediate feedback he received for growing food—much different than just studying mushrooms at a university or in a lab.

In 2008 he found out about a USDA loan program that helps beginning farmers borrow money to buy land, equipment, and supplies. The loan terms specify that farmers must have been in business for three years and have a business plan that maps out production goals, cash flow, and pricing. At the same time he was enrolled in a program combining classroom training with farm

Alex Winstead shows off fresh shiitakes at Cascadia Mushrooms in Bellingham.

mentoring, offered through the organization Food to Bank On. He learned the business side of farming and in the end was able to get a low-interest, fixed-rate, 40-year USDA loan to buy property, purchase equipment, and even build housing.

Alex bought a 2½-acre property at the edge of Bellingham. He built two greenhouses and a warehouse for his farm operation using a technique called post-frame construction. Popular during the Depression, the technique saves money by forgoing the foundation and using a third less lumber. Instead, 10 to 12 posts are driven five feet into the ground, and then the framing is built around the posts. Alex says the building is strong and well insulated, and with the money he saved he was able to add a second level to the warehouse, so he can live there too.

Alex's farm, Cascadia Mushrooms, is now in its sixth year of business. He grows his mushrooms organically and sustainably, using only green power. He focuses on

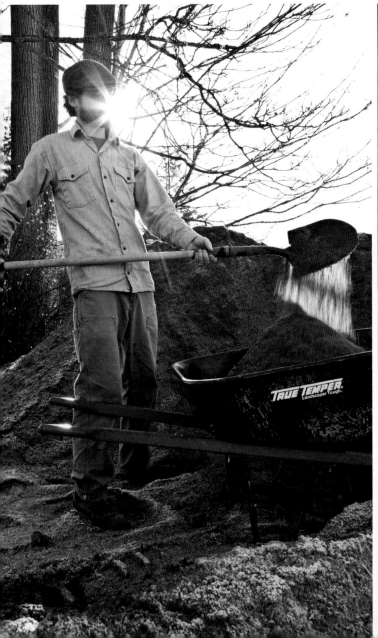

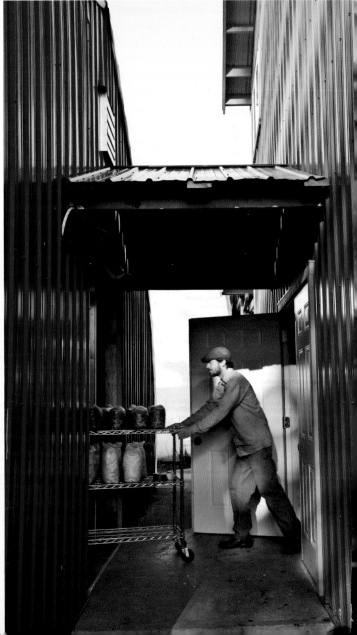

shiitake, blue oyster, lion's mane, wine cap stropharia, reishi, and turkey tail varieties, selling them to local restaurants, retailers, and farmers markets.

His growing method is a long, multistep process. He starts with sawdust from local mills, which he mixes with bran and water. The mixture is put in heat-tolerant bags and then sterilized in an autoclave—basically a huge pipe-shaped pressure cooker, like that used by hospitals to sterilize instruments, only much bigger. It's his biggest

piece of equipment. "A lot of farmers are proud of their tractors. This is my version of the big tractor."

After the bags have spent a day in the pressure cooker, they go straight to the clean room, where HEPA filters clean dust and contaminants from the air down to less than a micron. The tops of the bags are opened and the sawdust mixture is inoculated by mycelium spawn, then immediately resealed and moved to the incubation room.

The culture stays in the incubation room for anywhere from six weeks to three months, depending on the species, at a steady temperature of around 75 degrees F. As the spawn starts decomposing the sawdust, it first turns white, then brown and lumpy, and forms a skin. Like animals, the spawn requires oxygen, so a breathing patch is put on the sealed bag.

OPPOSITE, LEFT TO RIGHT The process of growing mushrooms starts with loading sawdust onto a wheelbarrow. Alex transfers the spawn into the humid fruiting room. ABOVE, LEFT TO RIGHT Cinnamon cap, shiitake, and oyster mushrooms are all grown by Alex.

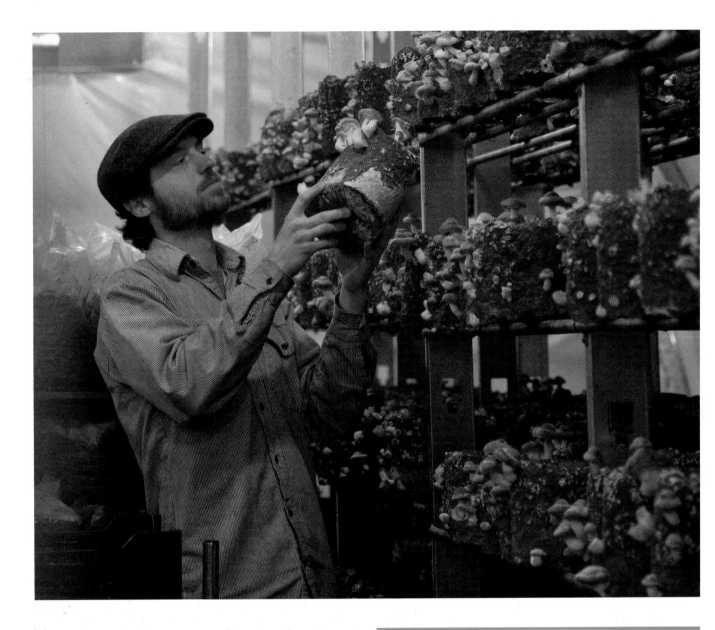

Finally, after the skin appears, the bags are moved to the more humid fruiting room, where the 65-degree temperature and high humidity trigger them to produce mushrooms. The bags are then removed and the mushrooms are harvested over a period of three weeks.

ABOVE Alex checks the fruiting shiitake mushrooms.

RESOURCES

Cascadia Mushrooms:
www.cascadiamushrooms.com
USDA Farm Service Agency (much information, including farm loan programs): www.fsa.usda.gov /FSA
Sustainable Connections (help and classes for farmers): http://sustainableconnections.org

Another aspect of Alex's business involves helping people to grow their own mushrooms. They can be grown outdoors or indoors, but they do require spawn to get them started. You can buy spawn from your local mushroom grower or from Alex's website. He says you can also encourage mushrooms to grow in your yard simply by spreading wood mulch. You won't be able to eat the mushrooms that grow, but the fungi will break down the wood mulch and improve the soil.

Growing shiitake mushrooms on logs outdoors
Shiitakes are a delicious high-protein, high-fiber alternative to meat that can take a year or two to produce but then will continue producing for up to four years.

Start with a freshly cut green log or stump that is at least 3 to 4 feet long and ideally 3 to 6 inches in diameter. Drill holes that are 5/16 inch wide and 3/4 to 1 inch deep, then hammer in the shiitake plugs till they are flush with the wood. Cover with wax to seal in the spawn.

Stack the logs in a semishady part of your yard, and be sure to check them periodically for moisture. They need to be kept moist at all times.

After one or two years, as the wood starts to rot, mushrooms will fruit. They will continue to produce until the logs rot down to the ground.

Growing wine cap stropharia mushrooms in mulch
Wine caps are some of the easiest mushrooms to grow. Start with three parts wood chips and one part garden soil. Mix in the spawn and spread the mixture 2 to 3 inches deep in shaded beds. Keep the mix damp, and within two to three months, beautiful portobello-size burgundy mushrooms will begin appearing weekly from spring to fall.

Growing mushrooms indoors
Kits for growing shiitake and oyster mushrooms can be bought online or from growers. They contain sawdust bricks that have been inoculated with spawn. Kits are a high-yielding, easy-to-maintain mushroom-growing method that just requires room temperature and light misting every day.

BELOW, LEFT TO RIGHT To grow shiitakes on a log in your backyard, you'll need a freshly cut log, a drill fitted with a 5/16-inch bit, shiitake-inoculated plugs, and a hammer. After drilling holes in the log, hammer the plugs flush, and then seal each hole with wax.

itty-bitty farm in the city

heidi kooy
san francisco, california

HEIDI KOOY'S 1,000-SQUARE-FOOT backyard is a tiny, terraced experiment in farming located in the Excelsior neighborhood of San Francisco. Her adventure began three years ago with "a nagging obsession to own a chicken." Since truly free-range, "guilt-free" eggs were priced at $7.50 a dozen in her local stores, raising chickens seemed an option worth considering. She spent nearly a year fantasizing before finally investigating the legality of the idea. "To my utter shock," she wrote in her blog, "not only was it legal, urban chickens were like...the new black!" She found many blogs and websites devoted to raising city chickens, and discovered that goats were legal in San Francisco too.

She started with three chickens in 2009 and acquired two baby Nigerian Dwarf goats, Ethel and Lucy, a couple of months later; thus was born her backyard farm, Itty-Bitty Farm in the City, chronicled in her blog of the same name. As the animals settled in, she continued fine-

Heidi Kooy carries orchard grass to her goats in her Excelsior neighborhood backyard in San Francisco.

tuning the yard. She put a 4-foot-tall retaining wall near the bottom of the sloping yard and made the area into an animal pen. The baby goats frolicked and grew. Heidi's neighbors allowed the goats to roam in their yard, giving them added room to range.

The chickens didn't fare as well, but through many mishaps, she learned the ins and outs of raising them. She learned the hard way how important it is to make sure chicks are vaccinated, after an unscrupulous breeder sold her unvaccinated chickens and her flock succumbed to Marek's disease. She learned the price of a crushed chicken toe when she had to make an emergency visit to the veterinarian, and then suffered the heartbreak of having to kill an animal to put it out of its misery.

After the goats grew up, Heidi had Lucy bred, then began trying to milk her. Heidi "knew from the start that Lucy would probably be difficult to milk. She has never taken kindly to having her undersides touched." Indeed, Heidi's efforts to milk the goat provoked all kinds of naughty behavior: bucking, sitting, knocking over the milk jar. Heidi found this particularly annoying since her Swiss heritage included a long line of dairy farmers.

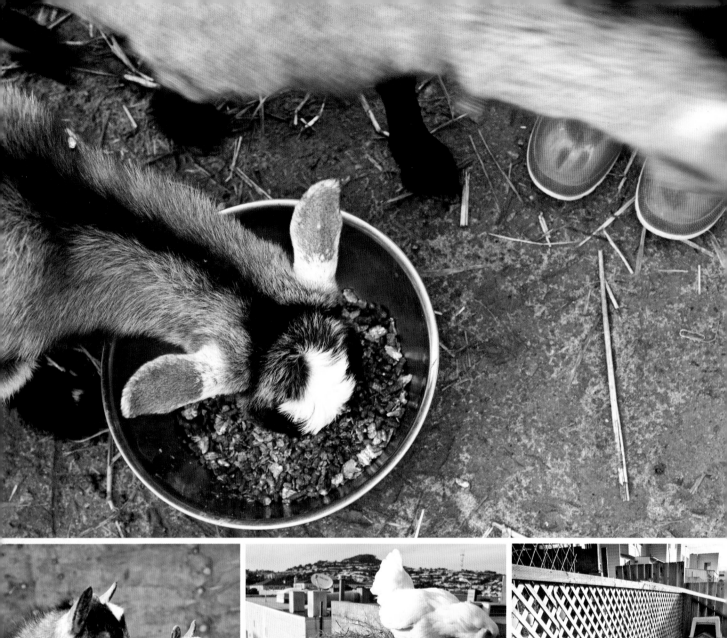

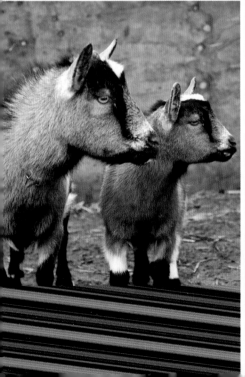

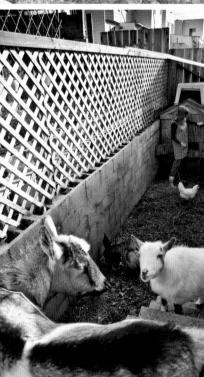

She finally found a milking contraption called the Henry Milker that saved her "milky doe from becoming dinner," and began collecting about 5 cups of milk a day from Lucy for drinking and making feta and ricotta cheese.

In the rest of her terraced yard, Heidi grows vegetables and fruit trees. Her northwest backyard is not the easiest growing location, but she finds ways to make it work. She's learned that many plants that grow well in

OPPOSITE, CLOCKWISE FROM TOP Heidi feeds her goats a grain mix blended especially for lactating goats. The goat pen and chicken coop are located at the bottom of her terraced yard. The pen has scenic views of the city. Mother-and-daughter Nigerian Dwarf goats live on Heidi's tiny backyard farm. RIGHT A hen walks along the fenced pen.

Purchasing Chickens

Here are Heidi's top five "hard-learned" tips, from her blog:

- *Purchase birds from a reputable breeder. Ask around. Don't go with any Tom, Dick, or Harry. Who knows what kind of nasties they have infesting their operation?*
- *Buy vaccinated birds. It's not a 100 percent guarantee, but it could save you some heartache.*
- *The bird should look healthy: bright eyes, plucky spirit, no drippy nose or eyes. It should have meat on its breast (the keel or breastbone should not stick out so much that it feels like a spatula), no pasted-up vents, and no signs of mites. Have a chicken-owning friend come with you. He or she will know what a healthy chicken looks like.*
- *Gain some general knowledge of common poultry issues—mites, illnesses, treatment for injuries, appropriate feed and supplements—so you can keep your birds healthy.*
- *See #1.*

RESOURCES

The Itty-Bitty Farm in the City:
http://ittybittyfarminthecity.blogspot.com

Russia also do well in her neighborhood. "Kale reigns supreme," she says. She put in a greenhouse on the top level so she can grow tomatoes and short-season cucumbers. She also has had good luck with containers on her front patio, where it's sunnier and the walls of her white house add more reflective light. Her favorite source for seeds is Baker Creek, where she always finds "weird, experimental" heirlooms to try.

Heidi is the first to admit that keeping goats and chickens might not make a lot of sense, considering all the work they require, but she loves the connection to animals that it brings her. She also believes that everyone should grow vegetables, even if it's just on a balcony or in a window box, because it makes us appreciate where our food comes from and how much work is involved in producing what we tend to take for granted.

Heidi's 1,000-square-foot lot may not be the acreage one usually associates with the word "farm," but "you'd be surprised what you can pack into such a tiny space." These days her family continues along the path to a sustainable future, having recently installed a solar energy system and acquired a hybrid car.

BELOW Heidi trims her goats' hooves with special hoof trimmers that she purchased at her local feed store. She learned how to do it herself online. OPPOSITE Heidi prepares a bed for planting. She's found that many plants that grow well in Russia also do well in her neighborhood.

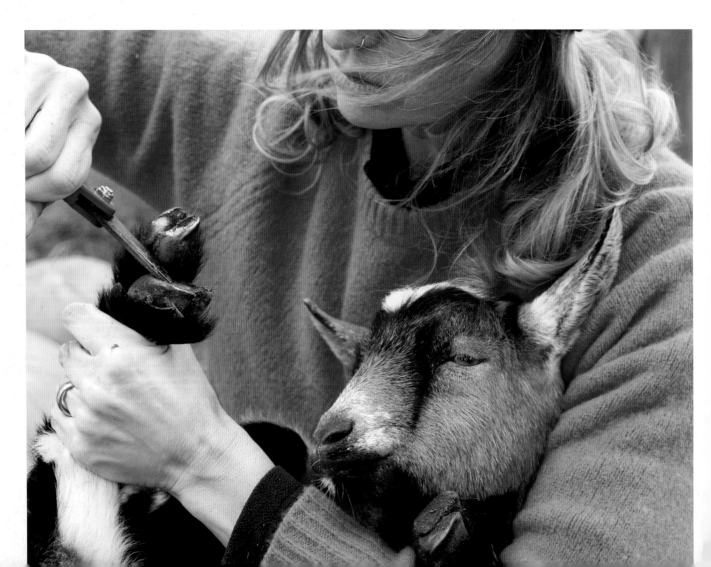

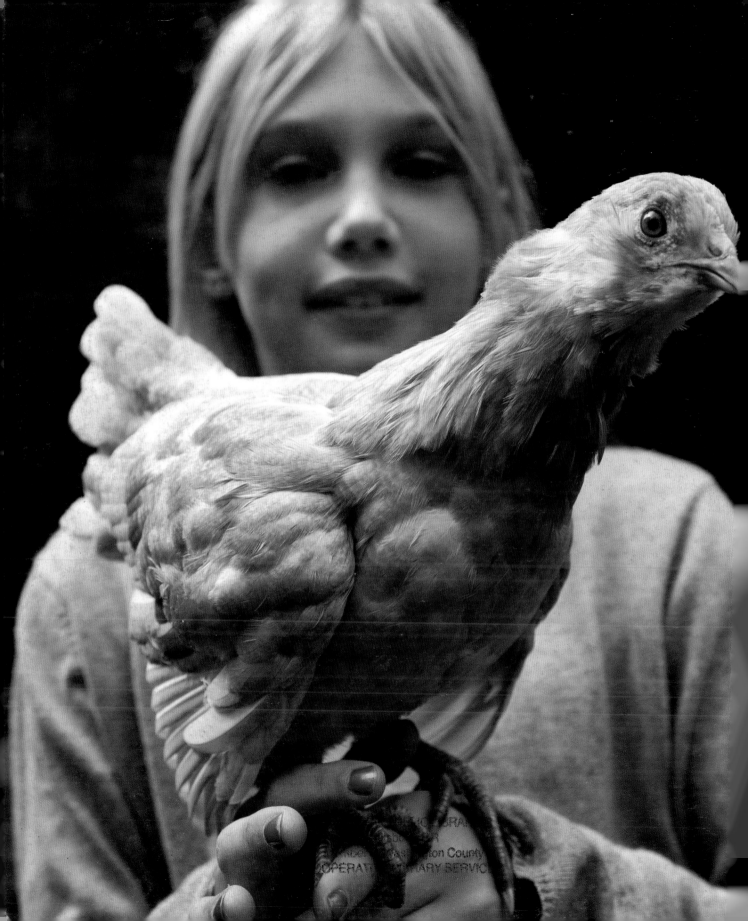

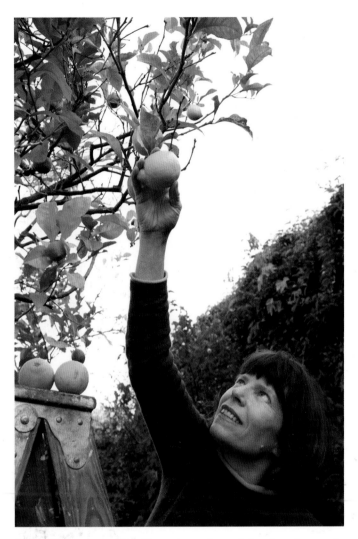

Lori Eanes is a San Francisco–based food and people photographer. Her work has appeared in cookbooks such as *One Bite at a Time* (Celestial Arts) and *Hot Chocolate* (Ten Speed Press), and in publications such as *Sierra*, the *Wall Street Journal, Oakland Magazine,* and *San Francisco* magazine.

LAST PAGE Nine-year-old Katie Gunderman holds a pullet in her Alameda backyard.

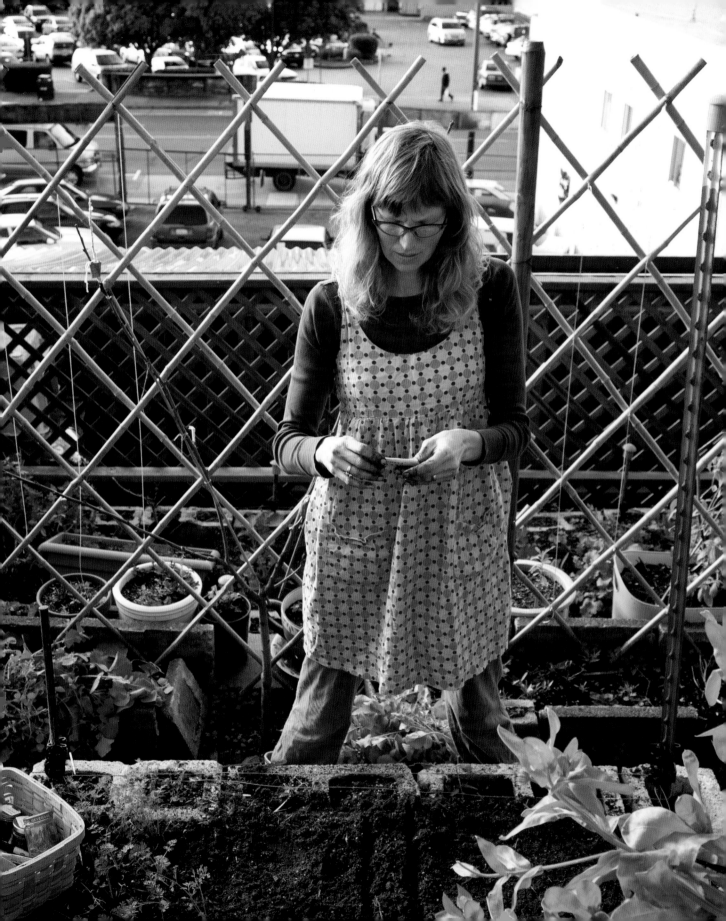